Denim.
Fashion's Frontier

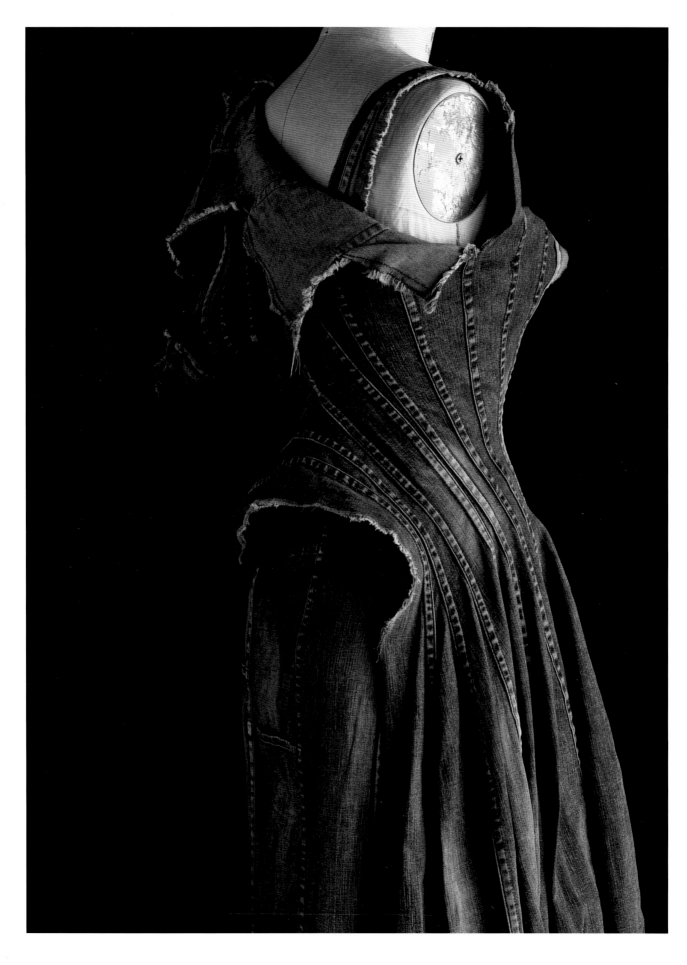

Denim.
Fashion's Frontier

Emma McClendon

Yale University Press, New Haven and London, in association with The Fashion Institute of Technology, New York

Designed by Paul Sloman & Antonia Edwards / +SUBTRACT

Printed in Italy by Conti Tipocolor, S.p.A.

Library of Congress Cataloging-in-Publication Data
Names: Fashion Institute of Technology (New York, N.Y.). Museum,
creator. |
 McClendon, Emma, editor, author.
Title: Denim : fashion's frontier / Emma McClendon.
Description: New Haven : Yale University Press, 2016. | Includes
 bibliographical references and index.
Identifiers: LCCN 2015039602 | ISBN 9780300219142 (alk. paper)
Subjects: LCSH: Fashion design–United States–History–
Exhibitions. |
 Denim–History–Exhibitions. | Jeans (Clothing)–History–
Exhibitions.
Classification: LCC TT502 .F2836 2016 | DDC 746.9/2–dc23
LC record available at http://lccn.loc.gov/2015039602

Frontispiece: Detail of Junya Watanabe, dress,
repurposed blue denim jeans, Spring 2002, Japan.
The Museum at FIT 2010.37.12, museum purchase.
Photograph by William Palmer.

Contents.

Foreword.
Fred Dennis

When The Museum at FIT's assistant curator of costume, Emma McClendon, suggested denim as a subject of study for our Fashion and Textile History Gallery, I knew immediately that it was a great idea. Denim is an inarguably popular topic. Plus, we have a large number of excellent denim pieces in our collection. This is important because, in order to keep the History Gallery open to the public nearly year-round, we have stipulated that its exhibitions will draw objects only from our permanent collections, and not be supplemented by loans. Emma wanted not only to explore the iconic jeans and jackets worn by the giants of popular culture – James Dean, Marilyn Monroe, and Marlon Brando – but also to trace denim's evolution over the last 100 years and more, its uses in both high and low fashion, and its importance to textile, fashion, and global brand markets. I knew that our denim collection was well suited to all of these tasks.

As Emma was conducting her internal research, she discovered something that I already knew: that a preponderance of the denim pieces in our collection were donated by or purchased expressly for the museum by Richard Martin, a past director of the museum. Richard was one of my first and most important mentors at The Museum at FIT, which was known during his tenure as "The Design Laboratory at the Fashion Institute of Technology."

Richard came to fashion and arrived at FIT in 1980 (I got here in the middle of the decade). Along with Harold Koda and Laura Sinderbrand, he began to change the scope and vision of fashion exhibitions, as well as the manner in which fashion was collected and what was considered worth collecting. An art historian and one-time editor in chief of *Arts Magazine*, Richard's background in art, especially modern and contemporary art, had a direct influence on the material MFIT acquired during the 1980s and early 1990s. In addition to high art and fashion, Richard was interested in sub-culture styles, street art, and style-tribes, especially the art and fashions emerging from New York's downtown and East Village, as well as London's punk and anti-fashion

Detail of Levi Strauss & Co., "507" model jacket, blue denim, ca. 1955, USA. The Museum at FIT 89.50.1, Gift of Richard Martin. Photograph by Eileen Costa.

scenes of the early 1980s (in fact, MFIT's continuing commitment "to collect fashion that moves fashion forward" still ranges from haute couture to street style). Material that Richard collected, primarily from unknown designers, made possible in 1986 The Design Laboratory's important exhibition, *The East Village*.

Another example of Richard's prescience as an interpreter of culture was evident in his passion during the mid-1980s for collecting T-shirts. He saw that the T-shirt had become a kind of billboard for statements of political and social reform, and on many a Monday morning, he walked in with a stack of T-shirts to add to the collection. Thus, in 1992, when the Democratic National Convention was held in New York, The Design Laboratory was able to mount an exhibition called *Vote*, encouraging people to do just that, regardless of political allegiance.

But it was earlier than that, shortly after his arrival at FIT in 1980, that Richard began to think about denim's contributions to fashion. The famous Calvin Klein Brooke Shields ads were just being launched. Denim-mania had not yet hit, and high fashion designers had not yet begun to introduce their own jeans or denim lines. Japan had begun to take denim seriously, though, and so, too, had Richard Martin. He applied his keen curatorial sense to building a collection of denim. The museum acquired rare pieces—jeans, jackets, and overalls from as far back as the previous century—as well as some early designer pieces by Claire McCardell and Yves Saint Laurent.

One of Richard Martin's many legacies, then, is The Museum at FIT's rich and abundant denim collection. *Denim: Fashion's Frontier* would not have been possible without his adventurous vision of fashion as art.

Fred Dennis
Senior Curator

Introduction.

Denim: Fashion's Frontier.
Emma McClendon

"I have often said that I wish I had invented blue jeans: the most spectacular, the most practical, the most relaxed and nonchalant. They have expression, modesty, sex appeal, simplicity – all I hope for in my clothes." – Yves Saint Laurent, 1983[1]

In 1983, at the time of his grand retrospective at The Metropolitan Museum of Art in New York, the designer Yves Saint Laurent declared his love for the classic blue jean. Today, the appeal of jeans continues to grow. According to the anthropologists Daniel Miller and Sophie Woodward, "On any given day, nearly half the world's population is in jeans,"[2] which would mean that denim is, by far, the most worn textile on the planet. Cotton Inc. claims that in the United States alone, the average person owns approximately seven pairs of jeans and fifteen items of denim clothing.[3] How did this simple cotton fabric become a global phenomenon? The following text and its accompanying exhibition, which was organized exclusively from The Museum at FIT's permanent collection, explores the multifaceted history of denim – and its relationship with high fashion – in order to shed new light on how it has come to dominate the clothing industry and the way people dress around the world.

Considered tough and durable, denim began as an ideal fabric for workwear – most famously in the clothing made by Levi Strauss & Co. (Levi's®) for the fortune hunters of the nineteenth-century California Gold Rush. Over the last two centuries, however, denim has become a symbol of youth, rebellion, sex, and the ever-ephemeral quality of "cool." Denim is inextricably linked to the romance of the "Old West," the legendary figure of the cowboy, and the "American Spirit" in general. Once a stigmatized marker of social class, it is now an accepted basic of everyday clothing, and has transitioned into high fashion. Vintage denim provides a continual source of design inspiration – some brands obsessively replicate vintage pieces, while others stylize vintage elements in a historical pastiche. Stiff and hard, or tattered and distressed, denim today bridges the

Handsewn men's work pants, blue brushed cotton and denim, ca. 1840, USA. The Museum at FIT P86.64.3, museum purchase. Photograph by Eileen Costa.

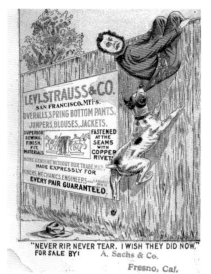

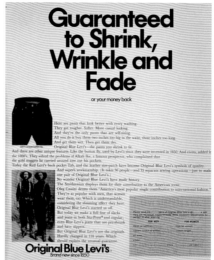

gap between high fashion and workwear, past and present, menswear and womens-wear, personalization and homogenization.

Denim's evolution has been linked to its proliferation within certain genres of film, television, and music, as well as its adoption by various socio-political movements. Most casual observers will recognize the influence of Hollywood figures like John Wayne, James Dean, Marlon Brando, Marilyn Monroe, and Clint Eastwood on the popularization of denim. They will likewise understand that the appearance of denim on covers of albums by the Rolling Stones and Bruce Springsteen aligned jeans with succeeding generations of music. And it is widely accepted that the adoption of denim by the counterculture movement of the 1960s created a vogue for faded and worn jeans.

The advertising and marketing strategies of denim companies also played a crucial role in denim's shifting cultural identity. Advertising by Levi's® reveals that the company both supported and advanced the continuously evolving social attitudes towards denim. During the late nineteenth and early twentieth centuries, Levi's® advertisements featured practical (and sometimes humorous) images of its work clothes, designed to demonstrate their durability. The company's slogan during the 1880s and 1890s touted that its denim "waist overalls," as they were known, "Never Rip, Never Tear." Levi's® even advertised the product's durability with the guarantee that customers could get a new pair for free if their old pair ripped. (Yet by the 1990s, when there was a demand for worn, torn, and faded denim, Levi's® "jeans" were now "Guaranteed to shrink, wrinkle and fade. Or your money back.") During the 1930s, the visual vocabulary of Levi's® ads appealed to the fast-growing cultural phenomenon of "Wild West" films and dude ranch vacations, and after World War II, denim was depicted as the ideal fabric for leisure activities and the suburban lifestyle.[4]

Levi's® is by no means the only denim company to employ such a variety of promotional strategies. Similar shifts can be seen in the advertisements of H. D. Lee

Levi Strauss & Co. advertisement, ca. 1890. The Levi Strauss & Co. Archives.

Levi Strauss & Co. advertisement, ca. 1990. The Levi Strauss & Co. Archives.

Mercantile Co. (Lee), beginning in the early twentieth century. Later arrivals, such as Calvin Klein and Jordache, likewise recognized the power of advertisements for promoting jeans sales when they introduced overtly sexualized campaigns during the late 1970s. As the journalist James Sullivan has pointed out, "[T]he blue jeans trade was among the first to recognize that it was selling an idea as much as it was selling the product itself."[5] These companies acknowledged denim's function as a cultural symbol and capitalized on it to sell their products.

Denim's ability to connect to a societal ideal is rooted in the fabric's immediately recognizable visual quality. A majority of people worldwide would likely identify denim by its blue color, its rough texture, and the five-pocket "jean" style with which it is associated. This common familiarity is perhaps why a basic definition of denim rarely appears in books about the textile's broad cultural history. In the words of Daniel Miller and Sophie Woodward, "[D]enim is the subject of that felicitous phrase, 'the blindingly obvious'. That is, certain things have become so deeply taken for granted and omnipresent that we have become blind to their presence and importance."[6] Denim's "obviousness" undermines academic considerations of it, and overlooks the nuances ingrained in the textile itself and its history.

At the most basic level, denim can be defined as a warp-faced, twill textile woven from cotton threads with the warp threads dyed blue from indigo and the weft threads left undyed or white. The "warp-faced" structure ensures that the blue-dyed warp threads appear most prominently on the top or "face" of denim fabric, while the white weft threads (sometimes called filling) appear on its reverse side. The cotton threads used for the warp are traditionally dyed with indigo through a procedure known as "rope dying" (also called "chain dying"). In this process, groups of cotton thread are passed through vats of indigo dye that have been treated with a reducing agent, turning the dye a greenish-yellow. After the threads pass through the dye, they are then drawn up into the air (a step known as "skying") in order to oxidize the indigo dye and turn it back to blue. To achieve a rich, deep blue, the dye must be built up in multiple coats. The nature of this process ensures that the indigo will only penetrate the topmost layer of the cotton threads. This gives denim a unique quality – as it ages, the blue surface of the fabric begins to brush away, increasingly exposing the threads' white core.[7]

This definition seems straightforward enough, but it does not account for the countless synthetic and stretch fibers that have been incorporated into denim, nor for the vast array of colors of denim. Today, "denim" has grown within the clothing industry into an entire category that includes a wide variety of products, from pants to dresses and tops. Many of these products are identified as "denim" by consumers and retail ad-copy even when they are constructed of plain weave textiles that merely resemble denim, such as chambray. Denim companies will also experiment with the construction of the textile to create variations of the classic fabric. A prime example is the work of the renowned Japanese denim company KAPITAL, which uses the traditional Japanese techniques *kakishibu*, *sumi* and *sashiko* to create its "Century Denim" (seen on page 202), methods that completely alter the weave structure and dye process of the fabric. Indeed, the denim expert and professor at the Fashion Institute of

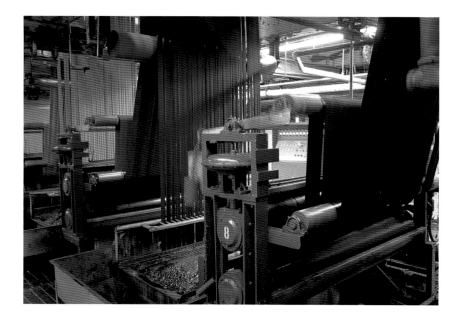

Technology Jeffrey Silberman contends, "There is no such thing as a *typical* denim fabric."[8] Now that it is produced in countries across the world, on many different types of equipment, and from many different types of material, denim's physical identity is murkier than ever.

Trying to define denim brings to mind a paradox first presented by Plutarch in the first century, then revisited by countless thinkers from Hobbes to Barthes, when grappling with issues of identity. According to the paradox, the ship of famed Greek hero Theseus was preserved by the Athenians for centuries, but over time, various components of the ship – planks, masts, oars, etc. – began to degrade with age and had to be replaced. Eventually, the Athenians had replaced the entire ship with new parts. Can this still be considered the ship of Theseus, or has it been transformed into a wholly new entity? On the one hand, the ship is physically different from the one that came before it, but on the other, its identity is inextricably linked to the legacy of the original.[9]

Such is the issue with denim. Over time, almost all of its definable parts have changed – color, weave structure, equipment, production process, material – but we still identify the new products as "denim" (even stretch denim and chambray shirts), broadening the textile's cultural identity while maintaining a connection to its legacy.

Denim's legacy, however, much like its basic physicality, is not easily delineated. There is a great deal of folklore surrounding denim's origins as a textile. The most widely told version of the story claims that it was first produced in France in the town of Nîmes, where it was given the name "serge de Nîmes." According to this history, the name "denim" derives directly from the term "de Nîmes." This same version of the story typically contends that denim was first brought to the United States by Levi Strauss after he arrived in San Francisco in the 1850s and realized that the prospectors of the

Modern day long chain indigo dye range at Cone Denim's iconic White Oak Mill in Greensboro, NC. Long chain dyeing, the gold standard in indigo dyeing, was first developed at the White Oak plant in the early 1920s. Courtesy of Cone Denim LLC, a division of International Textile Group.

Gold Rush needed pants sturdy enough to withstand the harsh environments and hard labor of the mines. Other stories claim Christopher Columbus was the first to bring the textile to America when he sailed across the Atlantic in a ship with sails made from blue denim. Still another tale credits Italian sailors from the city of Genoa as the first importers of blue denim, who wore the cloth as pants while on duty. In fact, some contend that when Levi Strauss ordered "de Nîmes" from Nîmes, it was brought over by Italian sailors. In this version, the word "jeans" derives from the term "Gênes," the French word for Genoa. James Sullivan cites evidence of the terms "jean" and "denim" appearing on import manifests from Italy as early as the eighteenth century, and proposes there might be a sliver of truth to the claim that "jean" derives from "Gênes."[10] Otherwise, almost all of the folklore surrounding denim's origins has been dismissed.

Current research suggests that denim may have, in fact, been an English textile that was given a French name in order to endow it with a certain cachet. Indeed, Val Beattie and Pennie Alfrey make an excellent case for this in their exhibition and book *Denim: The Fabric of Our Lives*, citing the innovations of the English industrial revolution – particularly its technological developments in cotton spinning, such as the "Spinning Jenny" – as the foundation of the textile's development.[11] Having a sturdier cotton thread enabled manufacturers to produce a durable textile using cotton as the warp *and* weft threads (previously, cotton threads had been too weak to function as the warp thread of a textile). Moreover, England's colonies in America and India would have provided their textile industry with immense reserves of cotton and indigo from which to produce blue denim.

Although the precise location of denim's origin may never be determined, a few things seem certain: by the late nineteenth century, a fabric called "denim" was being produced in a number of different locations around the world, including the United States. Moreover, it was *not* first used by Levi Strauss during the Gold Rush. Indeed, the oldest garment featured in this volume – a pair of work trousers – dates from the 1840s. The use of blue denim to patch the knees and thighs in this piece shows that denim was already well known to be tough and durable. However, denim was not used just to make workwear *pants*; it was used for jackets, bib-overalls, prison uniforms, and naval uniforms. It also appeared in women's workwear.

One aim of this book and the accompanying exhibition is to go beyond conventional assumptions about the history of blue jeans to consider the broader evolution of denim clothing – for both men and women. Histories of denim often dismiss high-fashion uses of the textile, treating them as trivial and frivolous. Such histories are also prone to disregarding denim's use in womenswear in favor of the cultural evolution of men's workwear garments, particularly blue jeans. In fact, the term "denim" is often used interchangeably with "jeans" – making denim's evolution seemingly indistinguishable from that of the five-pocket, riveted pant. When these histories do interweave examples of denim womenswear, such as Claire McCardell's "Popover" dress of the 1940s, they are often treated as isolated incidents, not necessarily connected to contemporary developments, nor even to each other.

This leads to a gendered interpretation of denim's history – one that identifies it as a *man's* textile, originally used for that most masculine of garments (pants), while

dismissing denim's appearances in womenswear as peripheral. In fact, however, womenswear designers have had a marked impact on denim's uses throughout the clothing industry. Returning to McCardell, her work with denim during the 1940s had a direct influence on the new "leisure wear" lines that Levi's® introduced during the 1950s, to such an extent that Levi's® used the same visual composition of one of McCardell's most famous portraits to advertise its new "Ranch Pants" in 1954.

The legacy of McCardell's work would inspire generations of designers to create their own versions of denim shirtdresses and playful summer ensembles. Yet McCardell's designs did not happen in isolation. She drew on a tradition of using denim in womenswear that dates back to the nineteenth century. Women's workwear was not as industrialized and, therefore, not as publically advertised as men's workwear, but that does not make it less historically significant. The tradition of using denim in women's workwear carried through the early twentieth century and interwar period, into the "play clothes" and leisure wear of the 1930s, decades before McCardell's wartime "Popover" and beach coordinates graced the pages of *Harper's Bazaar.*

This can be seen in a number of the examples included within this volume, such as a woman's denim work jacket from the mid-nineteenth century, as well as the two women's ensembles from the 1910s (seen on pages 48 and 52, respectively). Of these, one ensemble is fashionable outdoor wear, while the other is a workwear ensemble. Interestingly, they both follow the same overall silhouette, suggesting a desire to emulate high fashion elements in women's workwear.

During the interwar years, the Great Depression helped to establish blue jeans as a symbol of a uniquely "American Spirit." As Sandra Curtis Comstock has described, "Depression-era events and experiences repeatedly drew upon blue jeans as a mnemonic leitmotif linking different social categories of people in ways that encouraged the public to see jeans as quintessentially American for the first time."[12] At the same moment, denim's cultural associations shifted with the emergence of two distinct genres of lifestyle clothing: "Western wear" and "play clothes."

Western wear grew out of the popularization of "cowboy" and "Western" themed films. The wardrobes worn by the stars of these films, such as John Wayne, drew on a romantic view of the "Old West" of the nineteenth century. Fringed jackets, waistcoat-styled vests, button-front shirts with elaborately decorated yokes and pearl buttons, and bandanas tied around the neck, as well as wide-brim "Stetson" hats, became the "uniform" of these Hollywood cowboys. Within this stylistic lexicon, denim, and particularly denim jeans, were crucial. John Wayne would not appear on screen without his Levi's 501® jeans; apocryphally, in order to prepare the jeans for a film shoot, Wayne would submerge them in the ocean for several days to give them the right amount of wear.[13]

This style of dress spread beyond Hollywood when it moved off of the film screen and onto the dude ranch. Ranchers in states such as Nevada and Montana, in desperate need of income following the onset of the Great Depression, found that they could rebrand their ranches as resorts and capitalize on the popularity of "cowboy" films. The dude ranch trend had begun in the early twentieth century, but it exploded during the 1930s, with affluent East Coast vacationers willing to pay premium prices for an authentic, yet relaxing, "Old West" adventure. Around the country, fashion publications

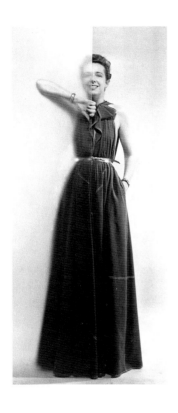

As featured in

Mademoiselle...

January, 1954

Elegantly structured Levi's

They seem to grow in the West—not a half-inch too much in any direction. They're made in a formal, narrowly striped fabric, an acetate and rayon ruled in California wine and black. By Levi Strauss, $8.95. Carson's, Chicago

began advising consumers and retailers alike on all the accouterment needed for these new westward excursions.

Levi's® was at the center of this craze. The fact that its products were available only in stores west of the Mississippi River helped to authenticate its Western cachet. To take full advantage of the new dude ranch market, Levi's® unveiled a "Lady Levi's®" line targeted at both the women working on the ranches and those who wanted to visit them. This new style of jeans had a more feminine cut around the waist and was made from "sanforized" or pre-shrunk denim, but otherwise it largely resembled its menswear counterpart, the 501®.

Vogue introduced the Lady Levi's® jeans in its May 1935 issue. The article gave readers a look at "dude wrangling" vacations and declared, "Deep down in every American's breast… is a longing for the frontier, perhaps the most powerful of American motivations . . ."[14] To prepare for one of these adventures, readers were advised: "True Western chic was invented by cowboys, and the moment you veer from their tenets, you are lost. Your uniform for a dude ranch . . . is simple-but-severe blue jeans or Levis . . . With these jeans go a simply tailored flannel or plaid cotton shirt, or possibly a Brooks sweater; a plain silk kerchief knotted loosely; a studded leather belt; high-heeled Western boots; a Stetson hat; and a great free air of Bravado."[15] Thus the woman's Western wear look was codified.

Likewise, the retail publication *Apparel Arts* was advising America's menswear purveyors that "Western details and styles appeal to men everywhere because they are rugged and are cut for action and comfort."[16] The same article inserted a tinge of fantasy into its description of the new clothing category, explaining, "Present day ranchers and cowboys wear clothing that has the same features and design as the first pioneers and frontiersmen that settled the old West."[17] As a case-in-point, "the Levi's® of today are the same as the originals that were made for miners and cowboys."[18]

Recognizing this broadening market of affluent consumers, Levi's® itself took out advertisements in the pages of *Apparel Arts*. These advertisements adopted the cowboy and cowgirl as the company's official brand mascots under slogans such as, "First choice of the cowboy" and "An old Western custom." Set against the backdrop of an open plain, the Levi's®-clad men and women in these advertisements ride horses, wrangle cattle, and ride off into the sunset – always with a clearly visible Levi's® signature leather label and red tab on the backs of their jeans.

To advertise their products, most denim companies had by this time entirely switched over from working-class images to cowboy iconography. Around 1924, when Lee debuted its version of five-pocket, riveted jeans, the company called them "cowboy pants," in order to associate them with movie Westerns. In 1944, they changed the name to "Lee Riders" and emphasized their "authentic" cowboy design details, such as the hidden back rivets that would not scratch saddles and the u-shaped crotch that made it easier to ride a horse. This association between denim and cowboys has remained one of the strongest cultural links with the textile, and many companies still employ it as an advertising technique.

Outside of the dude ranch, a growing interest in athleticism and physical fitness led to the development of a new range of clothing known as "play clothes." For women, play clothes featured a variety of styles designed for different leisure activities, including tennis, golf, and days at the beach. The design of these new "play clothes" drew heavily on menswear, but the looks were given feminine twists. Such details included high-rise, A-line shorts, cut well above the knee that would cinch at the wearer's natural waist, as well as skirts that could be worn over shorts and swimsuits. The most common style of play clothing, however, was what eventually became known as the "play-suit." It combined the high-rise shorts and a menswear-inspired collared shirt into a single piece.

Different types of cotton were common in play clothes, from piqué weaves to seersucker, and, of course, denim, which was perfect for active clothing because of its durability and ease-of-care. Designers looked beyond the western plains to the shores of California for a lifestyle that would align with the new play clothes. As one *Vogue* article from 1934 remarked, "Sunning, swimming, and tennis, the birthrights of California women, deeply affect their fashions… Every type of shorts, play-suits, slacks, pyjamas, and beach dresses thrives there."[19] Another article from 1940 declared, "Thanks to such natural conveniences as climate, topography, and the Pacific Ocean, every one plays in California… That's why California is a natural source of good play-clothes design."[20] The broader use of denim for both cowboy and play clothes prompted high fashion

designers to experiment with the material. One example is Elsa Schiaparelli's playful homage to rodeo shirts in her elegant, haute couture daywear (seen on page 70).

With the onset of World War II, denim's social position shifted yet again. Working men around the country joined the war effort and went abroad, often taking their denim blue jeans with them. This spurred the growth of secondhand denim markets around the world. These would eventually give rise to large centers of denim production and denim design – most notably in Japan, where American G.I.s continued to be stationed after the war, sustaining a regular supply of secondhand jeans.

On the home front, women went to work in increasing numbers to keep supply chains functioning. Women worked in munitions factories and held positions that had previously been held by men. The all-in-one denim jumpsuit became their unofficial uniform, immortalized in the figure of "Rosie the Riveter."

Many of the women who went to work in the factories had given up housekeeping posts to do so. This left affluent women to tend to their households themselves, which called for a new practical wardrobe. The first designer to capitalize on this new market was Claire McCardell with her denim "Popover" dress. As the war continued, other designers unveiled denim work clothes for fashionable housewives, including Elizabeth Phelps with her label, "Deep Country Clothes." These wartime styles formed the foundation on which other denim companies, including Levi's®, would base their post-war, sportswear lines targeted at the new suburban community. But before they did so, another influence shaped the cultural view of denim in 1950s America – the biker gang.

As World War II came to a close and the troops returned home, many young veterans, disillusioned by the realities of their homecoming and the new American Dream of suburban normalcy, took to the streets on motorcycles. They adopted the look of the lone outlaw of "Old West" films by wearing jeans, but they replaced the cowboy's fringed suede jacket with a black leather "Perfecto" jacket, and the horse with a Harley. "Biker" gangs began generating social unrest in different parts of the country during the late 1940s, but with the debut of *The Wild One* in 1953 starring Marlon Brando, the figure of the denim-clad rebel generated cultural excitement that bordered on hysteria.

According to the menswear expert G. Bruce Boyer, Brando's famous retort – "What've ya got?" – when asked what he was rebelling against, "was the coolest, hippest utterance ever made . . . Brando's denim jeans and black leather jacket identified him as a challenger of society as much as his sneer of insolence."[21] *The Wild One* caused such a stir when it was released that it was banned from theaters in the United Kingdom.[22] In 1955, another pivotal film reinforced the connection between disenfranchised youth and jeans – this was *Rebel Without a Cause*, starring James Dean. During the years that followed, jeans themselves became a center of controversy. They were banned from school districts and there was a general public outcry against denim as a symbol (and even a cause) of teenage unrest.

Denim sales dipped during the mid-1950s as a result of this negative cultural reaction.[23] To combat the "anxieties over juvenile delinquency," a group of denim mills and manufacturers banded together to found The Denim Council.[24] The Special Collections Library of the Fashion Institute of Technology contains the papers of The

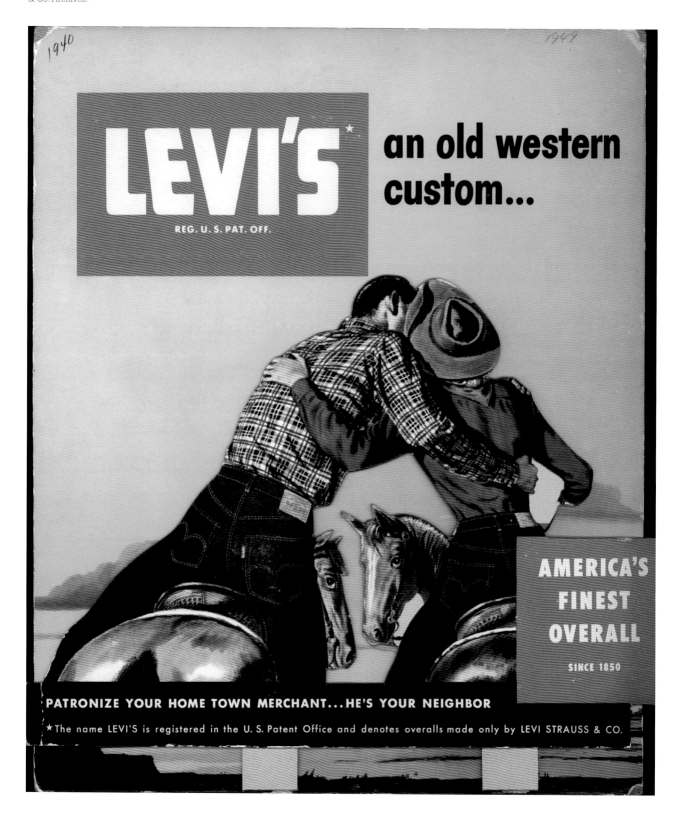

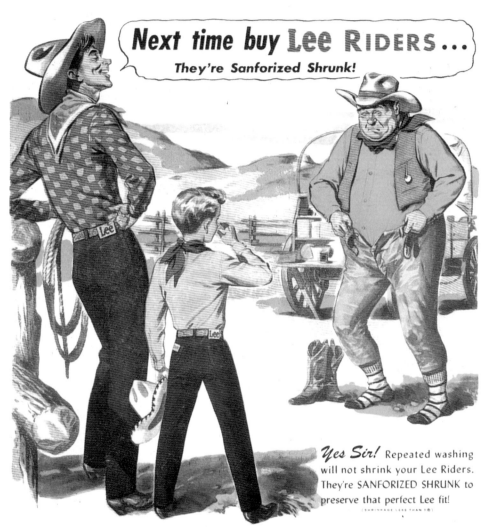

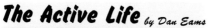

The Active Life *by Dan Eams*

SKY DIVING

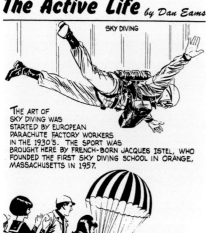

THE ART OF SKY DIVING WAS STARTED BY EUROPEAN PARACHUTE FACTORY WORKERS IN THE 1930'S. THE SPORT WAS BROUGHT HERE BY FRENCH-BORN JACQUES ISTEL, WHO FOUNDED THE FIRST SKY DIVING SCHOOL IN ORANGE, MASSACHUSETTS IN 1957.

TODAY, MORE THAN 100,000 ENTHUSIASTS ARE "JUMPING" TO JOIN THIS FAST-GROWING SPORT. BLUE JEANS, COMBAT BOOTS, AND CRASH HELMETS ARE WORN FOR PROTECTION WHEN THEY LEAP INTO THE "WILD BLUE."

The Active Life *by Dan Eams*

SPELUNKING

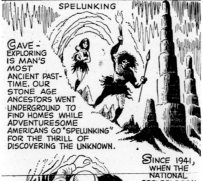

CAVE-EXPLORING IS MAN'S MOST ANCIENT PAST-TIME. OUR STONE AGE ANCESTORS WENT UNDERGROUND TO FIND HOMES WHILE ADVENTURESOME AMERICANS GO "SPELUNKING" FOR THE THRILL OF DISCOVERING THE UNKNOWN.

SINCE 1941, WHEN THE NATIONAL SPELEOLOGICAL SOCIETY WAS FOUNDED, THOUSANDS OF "SPELUNKERS" IN BLUE JEANS HELMETS AND RUBBER-SOLED SHOES PROBE EARTH'S SECRETS. THESE DARING SPORTSMEN HAVE UNCOVERED SUCH HIDDEN BEAUTIES AS CARLSBAD AND THE CAVERNS OF LURAY,

The Active Life *by Dan Eams*

CURLING

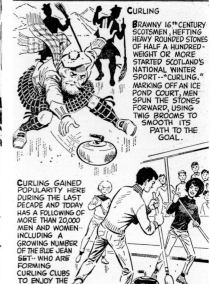

BRAWNY 16th CENTURY SCOTSMEN, HEFTING HEAVY ROUNDED STONES OF HALF A HUNDRED-WEIGHT OR MORE STARTED SCOTLAND'S NATIONAL WINTER SPORT--"CURLING." MARKING OFF AN ICE POND COURT, MEN SPUN THE STONES FORWARD, USING TWIG BROOMS TO SMOOTH ITS PATH TO THE GOAL.

CURLING GAINED POPULARITY HERE DURING THE LAST DECADE AND TODAY HAS A FOLLOWING OF MORE THAN 20,000 MEN AND WOMEN-- INCLUDING A GROWING NUMBER OF THE BLUE JEAN SET-- WHO ARE FORMING CURLING CLUBS TO ENJOY THE ZESTFUL WINTER PASTIME.

How It All Began *by Dan Eams*

THE ORIGIN OF DUNGAREES

IN THE LITTLE SEAFARING TOWN OF DHUNGAREE, INDIA A COARSE COTTON FABRIC WAS WOVE' AND USED FOR TENTS AND SAILS. SAILORS SOON MADE WORK TROUSERS FROM THE MATERIAL AND CALLED THE TROUSERS "DHUNGAREES"

MILLIONS OF AMERICANS, AS MEMBERS OF THE U.S. NAVY, COAST GUARD AND MERCHANT MARINE HAVE BEEN WEARING DUNGAREES AS A STANDARD WORK UNIFORM. THESE DUNGAREES PROVED SO COMFORTABLE AND DURABLE IN THE SERVICE, THAT THEY NOW ARE WORN BY MILLIONS OF CIVILIANS FOR WORK AND PLAY.

How It All Began *by Dan Eams*

BLUE JEAN SILHOUETTE

WHEN THE CALIFORNIA GOLD RUSH OF 1849 WAS ON, MINERS KNEELING WHILE PANNING FOR GOLD PREFERRED THEIR BLUE DENIM JEANS TO BE BAGGY. LATER, COWBOYS WANTED BLUE JEANS TO BE SLIM-CUT SO THEY WOULD FIT UNDER THE HEAVY CHAPS THEY WORE TO PROTECT THEIR LEGS FROM SAGEBRUSH AND CACTUS.

TODAY, AROUND THE WORLD, THE STRESSES IN FASHION ON YOUTHFUL LINES MAKE TRIM-FITTING BLUE JEANS POPULAR WITH EVERYONE FOR WORK, RECREATION, RELAXATION.

How It All Began *by Dan Eams*

IN THE MIDDLE AGES, FRENCH CLOTHMAKERS PERFECTED AN INCREDIBLY DURABLE COTTON CLOTH AND NAMED IT "SERGE DE NIMES" FOR THEIR TOWN. THIS SAME CLOTH WAS USED FOR SAILS BY COLUMBUS ON HIS FAMOUS 1492 VOYAGE.

IN AMERICA, 400 YEARS LATER, "DE NIMES" RENAMED DENIM, WAS THE FAVORITE FABRIC FOR THE DUNGAREES OF COWBOYS, FARMERS, MINERS AND WESTERN HOMESTEADERS.

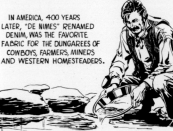

PRODUCING 250 MILLION YARDS A YEAR, THE U.S. IS NOW WORLD'S GREATEST MANUFACTURER AND EXPORTER OF BLUE DENIM.

Denim Council. These include press clippings, reports, and records dating as far back as its inception in 1955. The Council was "founded for the promotion of the sale of all blue denim goods."[25] It went about achieving this goal by establishing a "National Denim Week," sending kits with sales tips to retailers around the country, making a film titled "Blue Jeans" that by 1959 appeared on over 70 television channels, and even lobbying Eleanor Lambert (a pioneering force in the promotion and development of the American fashion industry) to allow them to hold denim presentations during New York Fashion Week.[26] The Denim Council also ran a series of cartoons in daily newspapers across the country, beginning in the 1960s.

These cartoons followed two distinct themes. The first, titled "Active Life," claimed that denim, particularly in the form of blue jeans, was the perfect thing to wear for a variety of different activities, from hiking and biking to water-skiing and skydiving. Even curling makes an appearance in these "Active Life" cartoons. The playful images were designed to align denim with the new leisure lifestyle of postwar suburbia. Denim companies targeted this consumer base by introducing entire ranges of denim sportswear. These products often came in colorful palettes, widening denim offerings beyond the *blue* jeans of teenage rebels.[27]

The second Denim Council cartoon series was titled "How It All Began." The images in this series were devised to educate readers about denim's origins. The stories told by the different illustrations are similar to the origin myths outlined earlier – one can see Columbus's sails, cowboys of the Old West, gold miners, Italian sailors, and even the mention of French textile mills in Nîmes. The cartoons were carefully constructed to endow denim with a rich and storied past full of romantic and heroic associations. The existence of these cartoons exposes a previously unknown element in the evolution of denim folklore, and reveals that The Denim Council was likely a pivotal source of the mythology that still surrounds denim today.[28]

By the start of the 1960s, denim sales were once again on the rise across the country. Levi's® alone had sales that doubled between 1963 and 1966 to reach 152 million US dollars annually.[29] This growth is thanks at least in part to the efforts of The Denim Council. Its "National Denim Week," "Denim Days," and sales kits, as well as its presentations on television networks around the country, had helped to recode the textile as fashionable and family friendly. Designers such as Bonnie Cashin and Lily Pulitzer (two of the most renowned sportswear designers of the time) regularly began integrating denim into their womenswear collections. Nevertheless, from the 1950s on, denim's cultural identity would be dominated by its association with counterculture and street style movements, such as the biker rebel. As the fashion historian Ted Polhemus has pointed out, "jeans have become the most ubiquitous street style garment."[30]

During the 1960s, denim became closely connected with the counterculture "hippie" movement. The young members of this group looked to clothing as a frontier for political activism. Denim was an important element in that activism – both for its working-class associations and as a rejection of the growing materialism of postwar American culture. The natural cotton fiber and indigo dye of denim seemed to be ideal tools for subverting the new-age plastics that embodied society's growing consumerist

[top] "Active Life" cartoons by Dan Eams, 1962–67. The Denim Council Papers, images courtesy of Fashion Institute of Technology | SUNY, FIT Library Special Collections and College Archives.

[bottom] "How It All Began" cartoons by Dan Eams, 1962–68. The Denim Council Papers, images courtesy of Fashion Institute of Technology | SUNY, FIT Library Special Collections and College Archives.

bent. Long hair and blue jeans became a *de facto* uniform for the movement, signaling the wearer's anti-establishment mentality.

Ultimately, the aesthetic of the counterculture movement was swallowed up by the very consumerist-driven industry that the style was protesting against. This was perfectly expressed in a Levi's® advertisement from 1970 that used a panorama shot of the crowd at the Woodstock Art & Music Fair of the previous year to market its products. In fact, illustrated within this volume is a pair of shorts from about 1970 that use this same Woodstock image as a decorative print, effectively turning the hippies themselves into a fashion product.

As the counterculture moved into the mainstream, the hippies' use of denim helped push denim in general, and blue jeans in particular, into the vocabulary of everyday clothing. The hippies' unique approach to denim also established certain stylistic treatments of the fabric within the fashionable lexicon of Western clothing. Such treatments included the use of patchwork and embroidery to decorate denim, and the use of rough, distressed, or frayed denim. The counterculture movement also gave rise to the popularity of flared or "bell-bottom" jeans, which hippies first acquired from Army/Navy surplus stores. In turn, their practice of wearing pre-owned jeans led to the trend for softened and faded denim in the decades to come.

As *Vogue* declared in its January 1970 issue, a dominant trend for the coming year was the way "'The Beautiful Hippies' make their own special mélange with the things they love most."[31] The following year, *Vogue*'s January 1971 issue featured an article titled "The Blue Denim Look." This article demonstrated the continued influence of the counterculture movement, claiming, "From San Francisco to Southampton to St. Tropez to Sardinia, it's boys and girls together in low-slung jeans, good shirts, bare feet."[32] Jeans were now mainstream, fashionable, and global.

During the early 1970s, the denim market exploded. A barrage of new denim-focused labels appeared on both sides of the Atlantic, including Landlubber, Faded Glory, UFO, and Fiorucci, to name but a few. Western wear details from the 1930s and 1940s experienced a renaissance, and homages to the patched, flared, and faded hippie jeans rose to the highest levels of the fashion industry in the work of *haute couturier* Yves Saint Laurent and innovative menswear designer John Weitz.

Traditional dress codes had begun to break down, and denim was suddenly appropriate for all occasions. Denim appeared in every category of clothing from men's suiting to women's footwear, and even bathing suits. In honor of denim's sartorial dominance, New York's prestigious Coty Awards bestowed its 1971 Fashion Critic's Award on Levi's®. Ironically, Levi's® received this award at the same moment it and its fellow American heritage brands were fading from the forefront of the denim market. By 1975, a slew of boutique brands had begun to outsell the "big three" of jeans – Levi's®, Lee, and Wrangler. The heritage brands countered with new product lines targeted at the fashionable market, relying on fitted and flared styles, and often foregoing their traditional design details for new decorative elements, such as patchwork motifs and decorative embroidery. This effort did little to turn public interest back to their brands, however, and during the second half of the 1970s, the jeans market

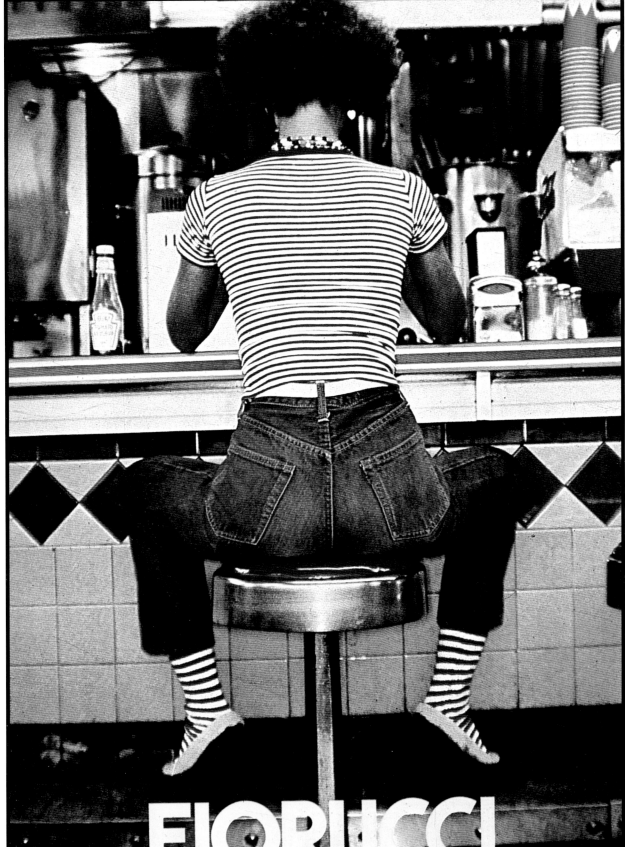

shifted even further from its American workwear roots to focus, instead, on designs coming out of Europe.

"European," "French," and "Italian" jeans became a cultural obsession. When Fiorucci, the Italian jeans company, opened its first New York store in 1976, it instantly became a social hub, and Fiorucci's signature "Safety Jeans" were soon fixtures at the nightclub Studio 54. The new European jeans styles were defined by their dark wash, high rises, decorative back pockets, tight fit, and high price tag – but the fit was key. These jeans were marketed first and foremost to women. The fit of the jeans was so tight that it became commonplace for women to have to lie down in order to zip them up – sometimes employing friends to help in the process. This practice was so ingrained in the new style of jeans that some stores, such as the French Jeans Store in Manhattan, actually installed sofas so that clients could lie down while trying on styles.[33]

To advertise their products, the designers of these tight-fitting jeans flagrantly imbued denim with sex. Such advertisements would often focus on a rear view of the model to show the company's signature back-pocket stitching and to further emphasize their jeans' snug fit. As Roberta Sassatelli explains in her discussion of Italian jeans companies, "Since the early 1970s the Italian fashion industry has made the link between women, jeans and sexuality quite explicit, with a particular emphasis on very tight jeans 'enhancing' the female shape in a series of images taken from behind."[34] Valerie Steele links this sexualization of denim to 1970s queer culture and iconography: "The seventies was the great era of gay liberation. You had the development of the 'macho' look… of blue jeans and bodybuilding so that you filled out your t-shirt with muscles, and your jeans were really tight over your butt and tight in front. That was a big part of gay style and then gradually it spread."[35]

Whatever the source, one designer's marketing approach has come to typify the sexualization of the denim industry – Calvin Klein. The most famous Calvin Klein Jeans advertisement was a 1980 television commercial featuring the young actress Brooke Shields seductively sprawled across the screen. As the camera pans slowly up her open legs, she purrs: "What comes between me and my Calvins? Nothing."[36] The implication that the fifteen-year-old Shields was not wearing any underwear under her skin-tight jeans caused a national scandal, and the commercial was promptly banned from several networks.[37] In 1991, Klein caused scandal again when he created a supplement for *Vanity Fair* magazine filled with racy images of models in (or simply holding) the designer's jeans. The supplement shocked and confounded industry insiders and consumers, with *Time* magazine deriding it as "a jumbled pastiche of naked bodies, black leather jackets, Harleys, and tattoos . . . Oh yes, there are even a few incidental photographs of jeans, most of which are being wrestled off taut bodies or used as wet loin cloths."[38] To this day, Calvin Klein Jeans advertisements continue to employ sex as a marketing tool to grab consumer attention, be it in the pages of a magazine or on a ten-story-tall billboard.

In design, Klein's jeans followed the same silhouette as the sexy "European" style, complete with its high rise, dark wash, tight fit, and decorative back pocket stitching. Klein openly acknowledged his indebtedness to his European predecessors, citing Fiorucci jeans as a direct influence on his designs.[39] Klein's "designer" designation, however, set the denim market on a new course as it entered into the 1980s. Many

other fashion designers followed his example by launching separate "Jeans" lines. Such designers included Bill Blass, Versace, and Moschino. These "Jeans" lines were often licensed out to separate manufacturers and would come to include a wealth of products aside from jeans. In fact, by the 1990s, the term "Jeans" had essentially become a stand-in for a younger, cheaper diffusion line.

Designers continued to experiment with denim during the 1980s, producing a variety of looks that combined aspects of denim's cultural history with signature elements of their own aesthetic. (We will see this later in this book in the work of Donna Karan, Franco Moschino, and Ralph Lauren on pages 134, 136 and 138.) Each of these designers drew on different aspects of denim, from its Western wear heritage to its modern sex appeal, often experimenting with types of denim – stretch denim, brightly colored denim, and distressed denim. Their work was representative of a significant shift in denim during the 1980s that placed new focus on the treatment of the textile itself.

To understand this shift, one must keep in mind that denim is naturally a tough and stiff material. This is what made it so durable and ideal for workwear. Over time, denim softens as it is worn and washed, and its color fades from blue toward white because of the nature of the rope dying process outlined earlier. During the 1980s, this natural wear process was artificially accelerated, as "finishing" took over the denim industry. Stonewashing, acid-washing, and the strategic placement of rips and tears became common features of denim across the market. The purpose behind finishing was to give denim a softer hand, or feel, and to make garments appear much older (or at least more worn) than they actually were. It was also used to add new decorative effects to the textile.

The process of distressing denim distinguishes it within the clothing industry. No other fabric is treated in this way at all levels of the market. Pre-washing and abrading denim physically weakens the material, but the weakness adds to the perceived value of the textile. This is a complete reversal of traditional clothing values.

In the United States, the desire for faded and aged denim grew out of the counterculture trend of wearing pre-worn jeans. In Japan – now a modern hub of high-end denim production – it was tied to the fact that denim was originally introduced through secondhand channels. Japan is arguably the most important producer of denim in the world today, yet the fabric was virtually unknown there until after World War II, when American G.I.s brought their blue jeans with them on their tours of duty. The Korean War continued this exposure into the 1950s. For many years, the only source of denim in Japan was directly from the G.I.s. In fact, blue jeans were originally known as *jipan* (or "G-pan") in Japan because of this association.[40] Thus, when jeans started to be produced in Japan decades later, there was a consumer desire for it to feel like the secondhand denim of the past.

The 1980s demand for softer denim grew so large that stonewashing became a standard practice across the industry. In stonewashing, manufacturers wash loads of unworn jeans with a special type of volcanic stone known as pumice to break down the fabric and make it softer before the products go on the market. The new, softer denim jeans were the antithesis of the rock-hard "French" jeans that required one to lie down in order to zip up.

There are many legends about who first "invented" stonewashing. Some attribute its emergence to Marithé + François Girbaud, a French duo whose eponymous jeans line drew a devoted consumer following during the 1980s. Others say Adriano Goldschmied – one of the founders of Diesel, now known as the "godfather of denim" – invented the process. Some claim stonewashing was first used by the famed Hollywood cowboy and rodeo outfitter Nudie Cohn. Still others credit the Japanese company Edwin with the innovation. Whoever was the first to use it, stonewashed denim quickly became ubiquitous. When the Berlin Wall came down in 1989, news reporters could not help but comment on the fact that the East Berliners were all clad exactly like the West Berliners – in stonewashed jeans.[41]

Although the term "stonewashed" is heavily associated with the 1980s, almost all denim currently available on the market has been prewashed – most of it with some form of pumice. The stones vary in size based on the weight of the denim, and chemicals and enzymes are now added to the pumice to create different effects, but largely the process has stayed the same.

Today, once jeans have been washed, they will typically be "finished" with sandpaper and other tools, which are used to add abrasions. These details are carefully mapped out to mimic natural wear patterns found on denim that has actually been worn. Natural wear patterns appear on denim based on the stress points created by the body and lifestyle of the wearer; how the wearer sits, what he or she keeps in her pockets, etc., create fading unique to that individual. In fact, the imprints a person's physical form and habits leave on denim can be so unique the FBI developed a forensic technique to identify criminal suspects by the wear patterns on a pair of jeans.[42] Artificial wear patterns, in contrast, will be standardized across a product line, appearing in the same places and in the same forms on every garment. Today, common manufactured wear patterns include the "whisker" effect that radiates out from the center fly of jeans, as well as fading and/or fraying along the top of the thigh and around the pockets.

The shift toward "finishing" gave rise to a new sector of laundries or "wash houses" in the denim industry, exclusively dedicated to creating the finish on jeans and other denim products before they go on the market. These facilities can be colossal, churning literal tons of jeans per day. The amount of water and chemicals used in this process has positioned denim as one of most environmentally detrimental industries on earth; as a result, there is concerted effort to develop more "eco-friendly" processes. New techniques include the use of lasers to create whiskering and fading effects, as well as the use of ozone (or O_3) gas instead of water to "wash" the garments, which drastically reduces overall energy and water waste.[43]

When creating abrasions on denim, designers of the 1980s sometimes went beyond replicating subtle details to create more drastic visual effects. This gave rise to torn and shredded denim as an important fashion trend. It was worn by pop stars like Madonna, and fashion designers such as Katharine Hamnett experimented with the style to create provocative runway collections. The growth of the torn denim or "rag" aesthetic is often linked back to the ripped jeans worn by biker gangs during the 1950s – a look that was appropriated by the hippies of the 1960s, and then by the punks and rockers of the 1970s and early 1980s to display a hard-edged, anti-establishment mentality. By the

Bruce Weber, photograph from the Calvin Klein Jeans supplement for *Vanity Fair*, October 1, 1991. The same image was later used for Calvin Klein Jeans advertisements and posters.

end of the 1980s, even heritage brands were ripping their jeans. Levi's®, for example, had an entire line of artfully torn and distressed denim. The company advertised this new line on models in black leather jackets and "engineer" boots astride motorcycles.[44] This trend for torn denim continued well into the 1990s, particularly in tandem with music-driven street styles such as "Raggamuffin" and "Grunge."

Of course, the "rag" look was not exclusive to the denim industry. High fashion designers began to experiment with a new technique of "deconstruction" during the 1980s as well. Such designers as Rei Kawakubo of Comme des Garçons and Vivienne Westwood would famously deconstruct, or take apart, traditional garments and then reconstruct them leaving frayed edges, seams, and other typically-hidden construction details exposed as decorative elements. As Louise Mitchell recounts, Kawakubo even treated holes as a form of adornment: "[her] clothes appeared ragged and were embellished with intentional flaws such as slashes and holes."[45] Kawakubo generally rendered her clothes in black wools, cottons, and linens, but her design ethos could easily be used to describe the denim industry's new approach.

While Levi's® and other heritage brands were continually looking forward to keep up with the latest trends in the United States and Europe, Japanese retailers were looking back to Levi's® storied past for products and inspiration. A demand for vintage pieces from Levi's®, Lee, and Wrangler had been growing in Japan since the end of World War II, but it reached its height during the late 1980s and first half of the 1990s. At the center of this market was Levi's 501® style, because it was considered the most "authentic" and "original" blue jean. As Philomena Keet describes in her study of Japanese denim, "At this point the locus of the 'real thing' was firmly placed in these old American Levi's®."[46]

To obtain such historic pieces, a near army of "pickers" was dispatched from Japan to the U.S. during the late 1980s to seek out pre-worn and "deadstock" examples of historic styles in flea markets, vintage shops, and the basements of old, run-down department stores. The "red-line" selvedge 501s® became highly coveted, and pieces bought in the U.S. would be shipped back to Japan with an astronomical mark-up. A pair of 501s® that cost $9, for example, could end up being sold for ¥3,600 (around $600 at today's exchange).[47] Yet as W. David Marx observes in his book *Ametora: How Japan Saved American Style*, "[A]lmost no one realized the value of old Levi's® or Lee jeans . . . the general zeitgeist of the late 1980s America had little interest in the Americana revival happening in Japan."[48]

By the start of the 1990s, the supply for Japan's vintage and deadstock market had begun to slow. To satisfy consumer demand a group of companies sprang up in Osaka – now known as the "Osaka Five" – that strove to replicate vintage 501s® down to the most minute details. These companies, including Evis (later Evisu), Studio D'Artisan, and Denime, looked at vintage garments as literal blueprints. The designers of these companies would meticulously take historic blue jeans apart, even going so far as to pick apart the threads to recreate every detail precisely. The products these companies produce have come to be known as "new vintage."

"New vintage" gave rise to an entire industry in Japan dedicated to the production of historic materials that were no longer being produced in the United States – most

importantly, selvedge denim. Today, selvedge denim is the most highly sought after and discussed detail in the high-end jeans market. Selvedge denim is distinguishable by a white stripe of threads that runs along both edges of a bolt of the fabric, which can then be used along the inner seam of a jeans pant leg (die-hard connoisseurs, often referred to as "denim heads," will cuff their pant legs up to reveal the selvedge edge as a signal to other denim *cognoscenti*). Selvedge denim is produced on a type of shuttle loom that can only make fabric in widths of roughly 29 inches. In the wake of the growing demand for denim during the 1960s, American denim mills gradually switched the types of looms they used to larger machines. These new machines produced fabric in double that width, so that companies could manufacture jeans faster to meet product demand. By 1983, all the denim used in Levi's 501s® was made on these larger machines – the "red line" selvedge was officially a "vintage" detail.[49] At the same time, Japanese mills based in the town of Kojima successfully engineered versions of the historic looms, in order to begin producing an exact replica of the historic textile no longer available in America.

During the 1990s, Evisu created its own denim mythology by claiming to have bought the original shuttle looms from the famed Cone Mills White Oak plant (the exclusive supplier of Levi's® denim for much of the twentieth century) when it switched to the larger machines – thereby endowing Evisu products with an even greater "authentic" cachet, but this is pure storytelling. The denim shuttle looms in Japan were skillfully re-engineered from domestically made looms. The Japanese were able to achieve such exact replicas of historic Cone denim only after nearly a decade of research and experimentation.[50] To believe Evisu's mythology is to dismiss the painstaking work and dedication that went into founding the Japanese denim industry.

At the start of the new century, the vintage denim market experienced a lull due to the rise of the "premium" jeans coming out of Los Angeles. By 2006, historic pieces were no longer commanding the prices they had been ten years earlier.[51] Nevertheless, the Japanese interest in vintage details and historic means of production had a profound impact on the jeans industry as a whole. Designer attitudes began to shift to "vintage" as a primary source of inspiration, and the industry grew increasingly obsessed with its own past.

Today, most jeans companies keep an archive of vintage pieces. These archives include a wide range of styles that date from throughout the twentieth century, serving as inspiration for wear patterns and design details. As Andrew Olah of Olah Inc. explains, "[G]enerally speaking what you see in The Gap or American Eagle is a copy of a vintage wash that somebody wore. They will go to a vintage store or a used clothing store, they will buy a jean that has been worn by somebody, and they will copy that wash and then make 20 million of them…that is what our business has really come to."[52] Textile mills bemoaned the reinterest in historic details. In the last fifteen years, designers have started regularly requesting fabric that includes "slubs" and other flaws common in vintage pieces, which the mills had worked tirelessly for a century to remove.

An interest in recreating vintage elements is not exclusive to the jeans industry. Historical pastiche, or homage, had become an important design strategy across high

fashion by the beginning of the twenty-first century. Many link this trend to the emergence of vintage shopping as a fashionable activity during the 1970s. In contemporary high fashion, denim often appears as a vehicle of pastiche – a visual tool to draw a link between an ensemble or even an entire collection and a particular period in fashion history. In these instances, designers draw on denim's multifaceted cultural coding, looking at the denim aesthetic of different subcultures, street styles, and even historic fashion designers from the past. For example, a deconstructed dress by Japanese designer Junya Watanabe from 2002 (seen later in this book on page 182), plays on the aesthetic of the 1960s counterculture movement. Likewise, an ensemble by Belgian designer Dries Van Noten (on page 198) makes an instantly recognizable reference to Yves Saint Laurent's denim safari jackets of the 1970s. In these examples, the designers have combined well-known historic elements with contemporary details to create an object that is simultaneously rooted in both cultural moments – past and present.

The employment of denim in this regard underscores the textile's ability to represent a cultural moment. Indeed, within each period of the last two hundred years denim has taken on particular forms – beyond jeans – that have captured the cultural imagination and linked the textile to social groups, classes, and phenomena. As a result, a particular denim style becomes shorthand for a period in history. As Daniel Miller and Sophie Woodward have said, "[J]eans seem to have taken on the role of expressing something about the changing world that no other clothing could achieve."[53] It is not only jeans that have this ability, but denim in general. Denim's symbolic nature makes it a powerful tool within fashion.

Denim is now a global textile. It is produced, sold, and worn in countries around the world. Within the fashion industry, denim comprises an entire category of garments with trade fairs, buyers, and industry reports dedicated exclusively to the wide range of "denim" products now available. The mills, farms, factories, laundries, design companies, and distributors – not to mention the retailers and consumers – involved in the denim industry form a complex matrix that crisscrosses the globe. Although denim became endowed with a distinctly American identity during the twentieth century, its cultural significance has expanded exponentially as it has spread around the world. The current work by the Global Denim Project to bring together academic work from across the globe is broadening the discourse on denim to examine its history, both culturally and physically, in different countries.

How denim has grown to become the most universally worn and recognized textile on the planet cannot be fully understood from its history in the United States and Europe alone, nor from its history as one type of garment – the five-pocket, riveted jean. Furthermore, recognizing the parallel trends of "distressing" and "deconstruction," and "vintage reproduction" and "historical pastiche," we can see a correlation between the histories of denim and fashion. Denim and jeans do not exist in a vacuum, and their history should not be considered in this way. By widening the discussion of denim to include the myriad of garments contained within this volume, this book and its accompanying exhibition aim to shed new light on the evolution of denim from workwear to luxury item, and from the quintessential American fabric to a textile, truly, of the world.

[page 34] Detail of Susan Cianciolo, dress, Cone Mills denim, cotton tape, 2006, USA.
The Museum at FIT 2015.41.2, Gift of Anonymous. Photograph by Eileen Costa.

Notes.

1 Yves Saint Laurent, quoted in *Yves Saint Laurent*. New York: The Metropolitan Museum of Art and Clarkson N. Potter, Inc. Publishers, 1983, p. 23.

2 Daniel Miller and Sophie Woodward, "Introduction," *Global Denim*. Oxford and New York: Berg, 2011, p. 1.

3 "Denim Jean Ownership and Preferences" chart, in article "Apparel Consumers in India," *Cotton Incorporated's Lifestyle Monitor* website. First accessed, August 1, 2014, via URL <http://lifestylemonitor.cottoninc.com/apparel-consumers-in-india/>

4 Historic advertisements accessed in the Levi Strauss & Co. Archives, San Francisco, California, on July 14–15, 2015.

5 James Sullivan, *Jeans: A Cultural History of an American Icon*. New York: Gotham Books, 2006, p. 118.

6 Miller and Woodward, *Global Denim*, p. 2.

7 N. Meksi and M.F. Mhenni, "Indigo dyeing technology for denim yarns" and "Weaving technologies for manufacturing denim," in *Denim: Manufacture, Finishing and Applications*, ed. Roshan Paul, Cambridge, United Kingdom: Woodhead Publishing, 2015, pp. 69–102 and 159–86.

8 Jeffrey Silberman, "A Brief Look at Denim," course documents for "The Denim Project" capstone in the Textile Development and Marketing Department at the Fashion Institute of Technology, 2007, p. 3.

9 Plutarch, trans. John Dryden, *Plutarch's Lives Volume 1*. New York: Random House, Modern Classics Library, 2001, pp. 1–25.

10 Sullivan, "'The Sans-culottes: Before the Blue Jeans" in *Jeans*, pp. 9–22.

11 Pennie Alfrey and Val Beattie, *Denim: The Fabric of Our Lives* (co-authors) Phil Cosker and Paul Atkinson. Sleaford, United Kingdom: the Hub, National Centre for Craft and Design, 2008.

12 Sandra Curtis Comstock, "The Making of an American Icon: The Transformation of Blue Jeans during the Great Depression," in *Global Denim*, p. 25.

13 Story recounted by John Wayne's son Michael, in Sullivan, *Jeans*, pp. 57–58.

14 Burt Struthers [Maxwell Struthers Burt], "Boccaccio In Chaps," *Vogue*, May 15, 1935, pp. 72–73, and 122.

15 Ibid.

16 "Fashion Round-Up," *Apparel Arts*, vol. 16, no. 4, p. 196, accessed in Fashion Institute of Technology | SUNY, FIT Library Special Collections and College Archives.

17 Ibid.

18 Ibid.

19 "Presenting Chic California," *Vogue*, July 1, 1934, pp. 24–27.

20 "California Plays Up," *Vogue*, February 1, 1940, pp. 92–93.

21 G. Bruce Boyer, discussion with author, June 11, 2015.

22 Sullivan, p. 91.

23 Ibid., p. 108.

24 Ibid.

25 Denim Council, "Denim Digest report," 1955, vol. 1, The Denim Council Papers, Fashion Institute of Technology | SUNY, FIT Library Special Collections and College Archives.

26 Denim Council, "National Denim Week Kit," 1959, vol. 1, The Denim Council Papers, Fashion Institute of Technology | SUNY, FIT Library Special Collections and College Archives.

27 Denim Council, "Active Life" cartoons, 1962–1967, vols. 1 and 2, The Denim Council Papers, Fashion Institute of Technology | SUNY, FIT Library Special Collections and College Archives.

28 Denim Council, "How It All Began" cartoons, 1961–1968, vols. 1 and 2, The Denim Council Papers, Fashion Institute of Technology | SUNY, FIT Library Special Collections and College Archives.

29 Sullivan, p.109.

30 Ted Polhemus, *Street Style: From Sidewalk to Catwalk*. London: Thames and Hudson, 1994, p. 24.

31 "Fashion Forecast: 1970," *Vogue*, January 1, 1970, p. 94.

32 "The Blue Denim Look," *Vogue*, January 15, 1971, pp. 34–47.

33 Tommy Hilfiger, quoted in *Blue Gold*, film, directed by Christian D. Bruun (2015: New York: Light Cone Pictures).

34 Roberta Sassatelli, "Indigo Bodies: Fashion, Mirror Work and Sexual Identity in Milan," *Global Denim*, p. 127.

35 Valerie Steele, quoted in *Blue Gold*, film, directed by Christian D. Bruun (2015: New York: Light Cone Pictures).

36 Brooke Shields, Calvin Klein Jeans commercial, directed by Ricard Avedon, 1980, accessed online via URL <https://www.youtube.com/watch?v=YK2VZgJ4AoM>

37 "Sultry Jeans Ad Banned By WABC, WCBS-TV," *New York Times*, November 20, 1980, p. D1.

38 Alex Prud'Homme, "Advertising: What's It All About, Calvin?" *Time* magazine, (Vol. 138, No. 12), September 23, 1991.

39 Elio Fiorucci, quoted in *Blue Gold*, film, directed by Christian D. Bruun (2015: New York: Light Cone Pictures).

40 W. David Marx, *Ametora: How Japan Saved American Style*, New York: Basic Books, 2015, pp. 76–77.

41 News anchor Tom Brokaw remarked on the how the East Berliners were wearing acid-washed jeans in an interview for the 25th anniversary of the fall of the Berlin Wall, on the "Today Show" on NBC, Nov. 9, 2014; François Girbaud also described the impact of seeing the East Berliners in their stonewashed jeans in a discussion with the author, May, 15, 2015.

42 Kristen Philipkoski, "FBI Tracks the Denim Trail" in *Wired* magazine, April 6, 1998, accessed first online on June 15, 2015 via URL < http://archive.wired.com/science/discoveries/news/1998/04/11459>

43 B. Garcia, "Reduced water washing of denim garments," in *Denim: Manufacture, Finishing and Applications*, pp. 405–23.

44 Historic advertisements accessed in the Levi Strauss & Co. Archives, San Francisco, California, on July 14–15, 2015.

45 Louise Mitchell, "Rei Kawakubo" in *The Cutting Edge: Fashion from Japan*, ed. Louise Mitchell, Sydney: Powerhouse Publishing, 2005, p. 53.

46 Philomena Keet, "Making New Vintage Jeans in Japan: Relocating Authenticity," *Textile*, vol. 9, issue 1, Oxford: Berg, 2011, pp. 44–61.

47 Marx, p. 195.

48 Marx, original manuscript for *Ametora: How Japan Saved American Style*, New York: Basic Books, 2015.

49 Marx, p. 199.

50 Ibid., p. 216.

51 Sullivan, p. 185.

52 Andrew Olah, in conversation with the author, June 9, 2015.

53 Miller and Woodward, p. 4.

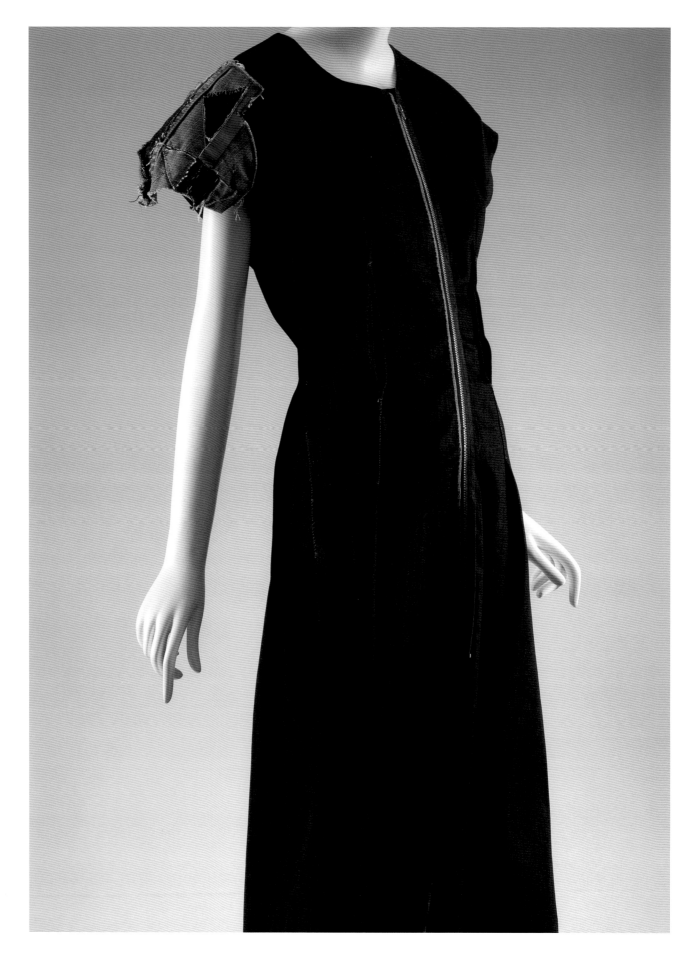

Catalogue.

Levi Strauss & Co. 501® jeans.
Blue denim,
ca. 1953, USA

- -

Levi Strauss & Co.'s 501® model of jeans has been called "the best selling garment of all time."[1] First dubbed lot 501® in 1890, the style of these jeans originates in Levi's 1873 patent and has not changed greatly in more than 150 years. The key feature of the Levi's® work pant that set it apart from other denim work trousers of the time was the inclusion of copper rivets at the garment's stress points—points that can be seen carefully outlined in the patent on the following pages. Now a mainstay of jeans around the world, the specific placement of these rivets was first devised by Nevada-based tailor Jacob Davis. Davis had been purchasing denim fabric from the San Francisco dry goods store owned by Levi Strauss. He wanted to take out a patent on his riveted pants, but could not afford it on his own, so he approached Strauss about taking out a joint patent. Once the patent on the riveted pants was secured, Strauss began manufacturing them under his own name, with Davis at the helm as head tailor of the company's in-house production. He added a few details to brand the pants as his own, such as the double arches (or "arcuate") stitches on the back pocket, and a leather label at the waistband, which would eventually come to feature the company's famous "two horses" logo.[2]

A few stylistic differences can be seen between the patent illustration and the 501® here. For example, the jeans, or "waist-overalls" as they were officially called until the 1950s, originally had four pockets instead of the classic five. The first 501® also had suspender buttons and a cinch-back strap across the center back of the waistband, which allowed the wearer to adjust the fit – this was a particularly important feature during the nineteeth century, when the style was worn much looser, often over the wearer's day clothes. The cinch strap was part of the 501® model until World War II, when it was eliminated as a result of textile rationing. During World War II, the rivet placed at the base of the fly was also removed – again, owing to rationing (although according to Levi's® folklore the "crotch rivet" was removed after an unfortunate mishap when a wearer stood too close to a campfire, and the copper rivet conducted rather too much heat).[3]

Today, vintage 501® jeans that include any or all of these historic traits are highly sought by collectors, due to their cachet as the original riveted jean. Reverence for the 501® model has spurred the growth of a global vintage market for heritage brand denim.

[following pages] Levi Strauss & Co. and Jacob Davis' original patent for riveted work pants, 1873. The Levi Strauss & Co. Archives.

1 James Sullivan, *Jeans: A Cultural History of an American Icon.* New York: Gotham Books, 2006, p. 32.

2 Lynn Downey, "A Short History of Denim," San Francisco: Levi Strauss & Co., 2014, first accessed online on June 3, 2015 via URL <http://www.levistrauss.com/wp-content/uploads/2014/01/A-Short-History-of-Denim2.pdf>

3 Tracey Panek, Levi Strauss & Co. Historian, in discussion with the author, July 14, 2015.

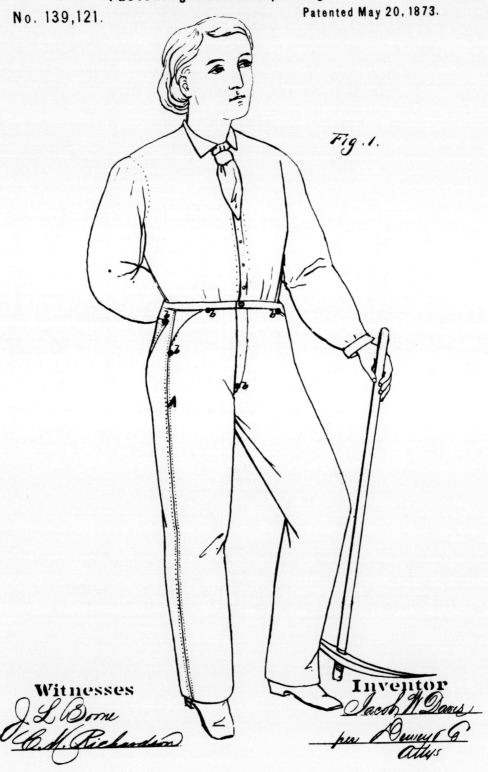

J. W. DAVIS.
Fastening Pocket-Openings.

No. 139,121.

Patented May 20, 1873.

Fig. 1.

Witnesses

J. L. Borne

E. M. Richardson

Inventor

Jacob W. Davis

per Dewey & Co

Attys

UNITED STATES PATENT OFFICE.

JACOB W. DAVIS, OF RENO, NEVADA, ASSIGNOR TO HIMSELF AND LEVI STRAUSS & COMPANY, OF SAN FRANCISCO, CALIFORNIA.

IMPROVEMENT IN FASTENING POCKET-OPENINGS.

Specification forming part of Letters Patent No. **139,121**, dated May 20, 1873; application filed August 9, 1872.

To all whom it may concern :

Be it known that I, JACOB W. DAVIS, of Reno, county of Washoe and State of Nevada, have invented an Improvement in Fastening Seams; and I do hereby declare the following description and accompanying drawing are sufficient to enable any person skilled in the art or science to which it most nearly appertains to make and use my said invention or improvement without further invention or experiment.

My invention relates to a fastening for pocket-openings, whereby the sewed seams are prevented from ripping or starting from frequent pressure or strain thereon; and it consists in the employment of a metal rivet or eyelet at each edge of the pocket-opening, to prevent the ripping of the seam at those points. The rivet or eyelet is so fastened in the seam as to bind the two parts of cloth which the seam unites together, so that it shall prevent the strain or pressure from coming upon the thread with which the seam is sewed.

In order to more fully illustrate and explain my invention, reference is had to the accompanying drawing, in which my invention is represented as applied to the pockets of a pair of pants.

Figure 1 is a view of my invention as applied to pants.

A is the side seam in a pair of pants, drawers, or other article of wearing apparel, which terminates at the pockets; and *b b* represent the rivets at each edge of the pocket opening. The seams are usually ripped or started by the placing of the hands in the pockets and the consequent pressure or strain upon them. To strengthen this part I employ a rivet, eyelet, or other equivalent metal stud, *b*, which I pass through a hole at the end of the seam, so as to bind the two parts of cloth together, and then head it down upon both sides so as to firmly unite the two parts. When rivets which already have one head are used, it is only necessary to head the opposite end, and a washer can be interposed, if desired, in the usual way. By this means I avoid a large amount of trouble in mending portions of seams which are subjected to constant strain.

I am aware that rivets have been used for securing seams in shoes, as shown in the patents to Geo. Houghton, No. 64,015, April 23, 1867, and to L. K. Washburn, No. 123,313, January 30, 1872; and hence I do not claim, broadly, fastening of seams by means of rivets.

Having thus described my invention, what I claim as new, and desire to secure by Letters Patent, is—

As a new article of manufacture, a pair of pantaloons having the pocket-openings secured at each edge by means of rivets, substantially in the manner described and shown, whereby the seams at the points named are prevented from ripping, as set forth.

In witness whereof I hereunto set my hand and seal.

JACOB W. DAVIS. [L. S.]

Witnesses:
JAMES C. HAGERMAN,
W. BERGMAN.

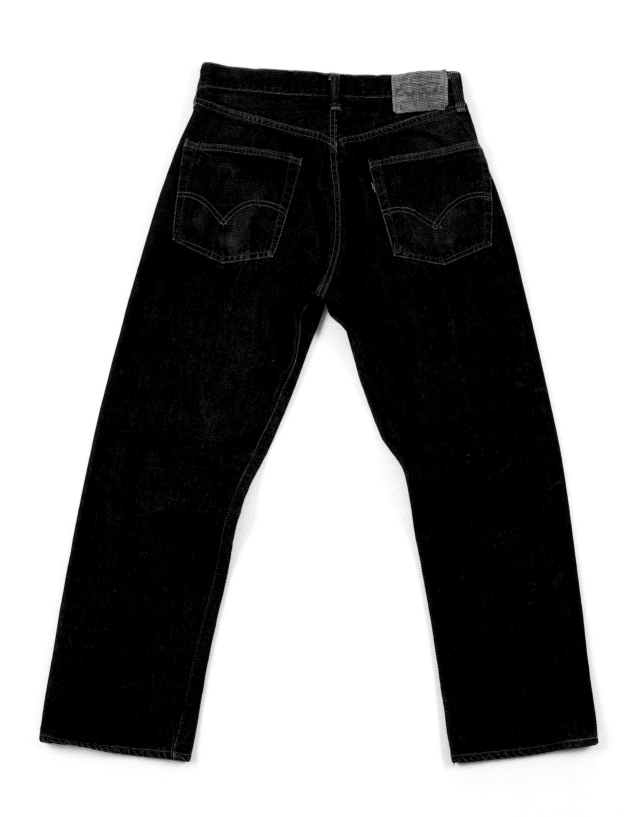

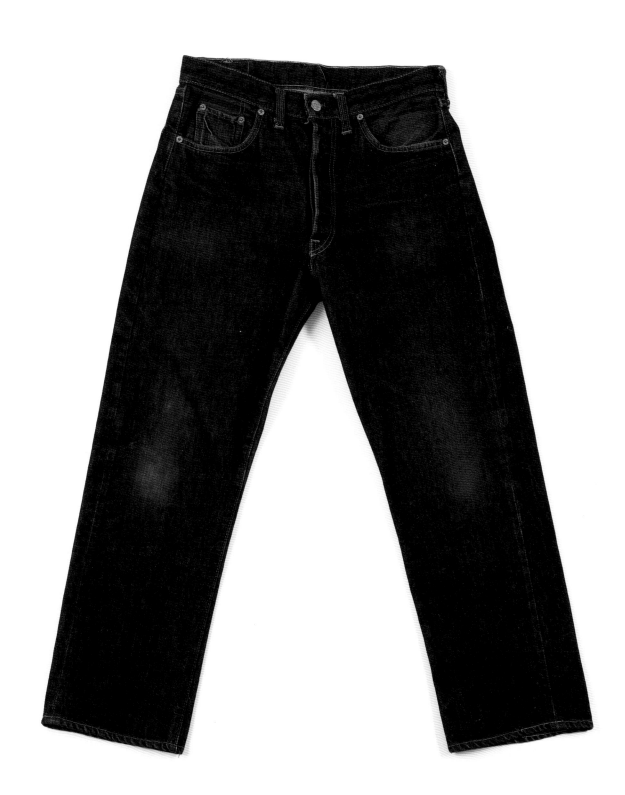

Man's work pants.
Blue brushed cotton and denim,
ca. 1840, USA

--

These man's pants are entirely hand-stitched. They are principally made from a brushed, or "napped" cotton, similar to modern-day corduroy, but they have been patched across both knees and thighs with denim, on the inside as well as the outside of the legs. This suggests that whoever wore these pants worked heavily on his knees and took great care to mend them when they began to tear. The use of denim to reinforce the primary stress points demonstrates that the textile was by this time known for its durability and workwear applications. The lack of machine-stitching, as well as the high-rise cut of the pants—complete with a front flap opening rather than a central fly—indicates that these pants pre-date the introduction of the sewing machine (around 1850). They are thus an extremely rare precursor to the modern blue jean, made roughly thirty years before Levi's® patent in 1873.

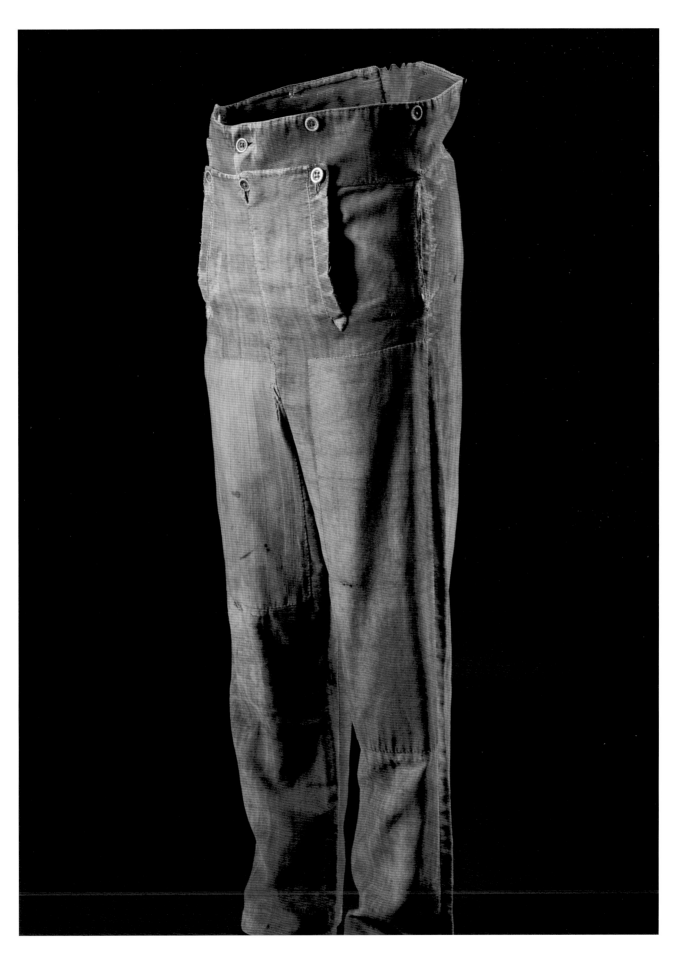

Woman's jacket.
Blue denim,
ca. 1850, USA

Although denim is typically thought of as originating in men's wear, it was also common in women's workwear during the nineteenth century. This "jacket" would have been worn over a woman's work dress or blouse, most likely while she labored outdoors. The construction of the jacket shows the influence of fashionable garments on women's workwear, albeit in a rudimentary sense. With tucks at its base and at its cuffs, the jacket would have cinched slightly at the wearer's wrists and at her natural waistline, in effect mimicking the hour-glass silhouette dominant in fashion of the period.

Also of note, this piece has been carefully patched by hand at the back (similar to the patches seen on the pants on page 43). The circular shape of the patch seen here is representative of an approach to mending prevalent in workwear until the 1950s. Denim garments were not disposable. Although the textile was considered ideal for "low-maintenance" clothing because it could withstand the strain of hard labor and did not need to be washed regularly, such denim work clothes were kept for decades, and carefully cared for if they became damaged. This approach stands in stark contrast to the practice of distressing and recreating wear patterns that occurs in much of the denim industry today.

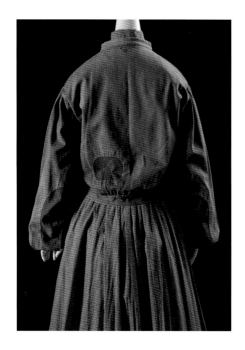

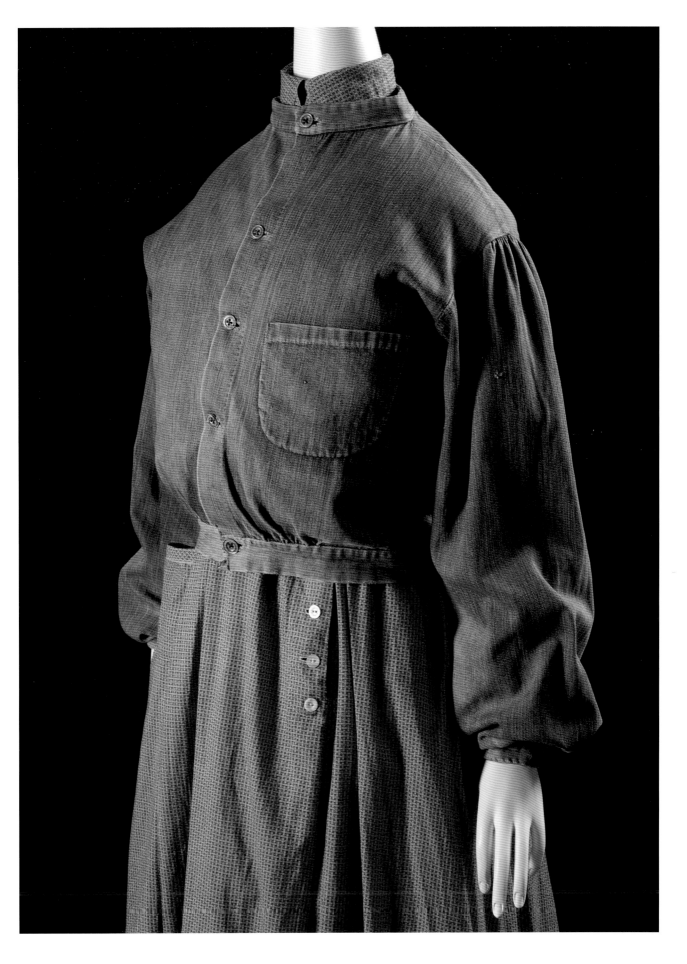

Prisoner uniform.
Grey denim and linen,
1913, USA

- -

The hat, jacket, and pants of this prison uniform are entirely made from a grey denim. The uniform was donated to The Museum at FIT by Lithgow Osborne, son of Thomas Mott Osborne, who was the warden of Sing Sing prison in New York during the early twentieth century. Thomas Osborne founded the Mutual Welfare League (MWL) in 1915. Now known as the Osborne Association, the League's goal was to help rehabilitate men emerging from incarceration and generally reform the country's criminal justice system.[1] An early MWL pin can be seen on the uniform jacket. Thomas Osborne acquired this uniform while posing as a prisoner as part of an undercover operation organized to expose the conditions in the prison system before he was appointed warden of Sing Sing. The use of denim for prisoner uniforms was standard throughout the American correctional system for the first half of the twentieth century. This was a major factor in denim's increased association with rebels and criminals during the 1950s. In fact, Elvis Presley wore a nearly identical ensemble (albeit much tighter) of black denim in the 1957 film, *Jailhouse Rock*.

1 "Osborne Celebrates the 100th anniversary of the creation of the Mutual Welfare League," The Osborne Association website, January 23, 2015, first accessed July 22, 2015 via URL < http://www.osborneny.org/post.cfm?postID=479>

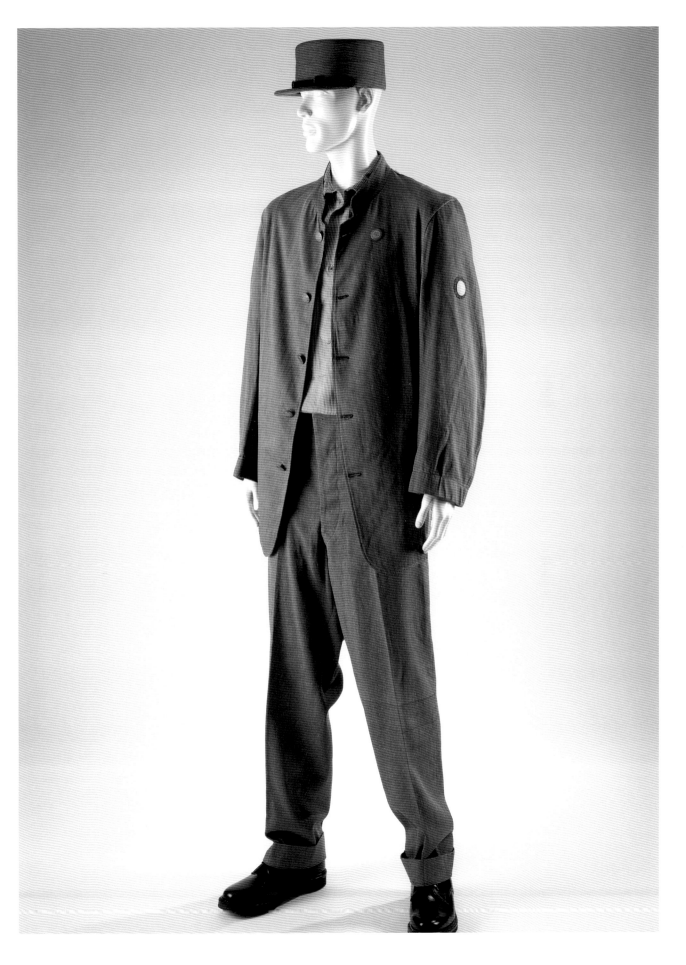

Walking Suit.
Off-white striped denim,
ca. 1916, USA

--

This denim suit follows the lines of the fashionable silhouette of the 1910s, with its raised waistline, elongated, tunic-like jacket, and skirt that falls just above the ankles. Design elements, such as the mitering at the waistband and the militaristic shape of the cuffs, were drawn directly from the haute couture of the period, as can be seen in the following sketches. Rendered in tough and durable denim, this suit was most likely intended to be worn on more vigorous outdoor outings than its French couture equivalents. Another explanation for the use of denim in this suit is that during World War I, luxurious textiles were in increasingly short supply. This gave rise to a trend toward the use of more utilitarian textiles in women's clothing. As Birgit Haase describes, "Simplicity and functionality were the fashion watchwords of the day, not least in the face of the growing number of working women on the home front."[1] The use of denim also aligns with Adelheid Rasche's assertion that during World War I, "as far as their everyday lives were concerned, women required primarily practical street clothing and indoor dress in order to meet their domestic obligations and activities on behalf of the war effort."[2]

1 Birgit Haase, "Modern Ambivalence: Women's Fashions during the First World War from the German Perspective," in *Wardrobes in Wartime 1914–1918*. Berlin: Kunstbibliothek, 2014, p. 25.

2 Adelheid Rasche, "Introduction" in *Wardrobes in Wartime 1914–1918*. Berlin: Kunstbibliothek, 2014, p. 14.

[following pages]
Max Meyer, sketches of haute couture models, 1918. Images courtesy of Fashion Institute of Technology | SUNY, FIT Library Special Collections and College Archives.

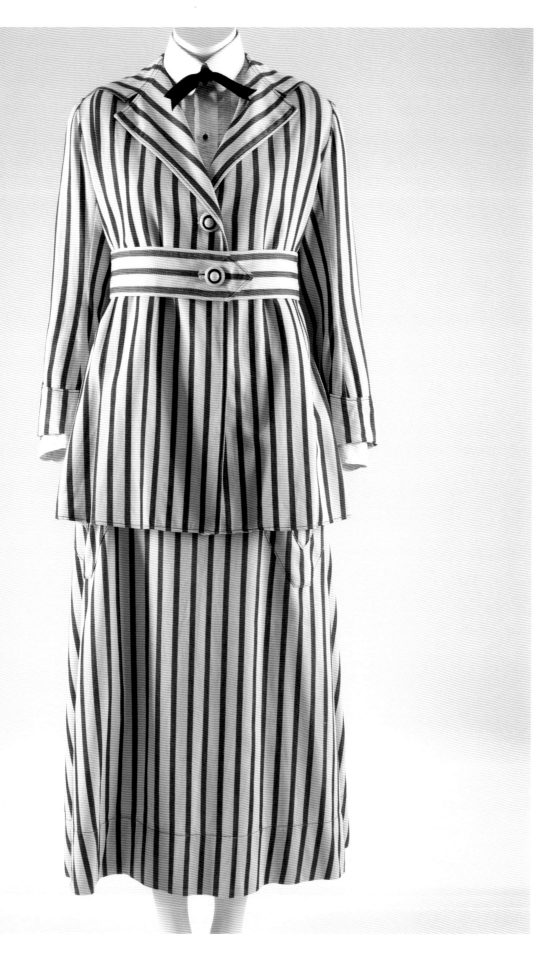

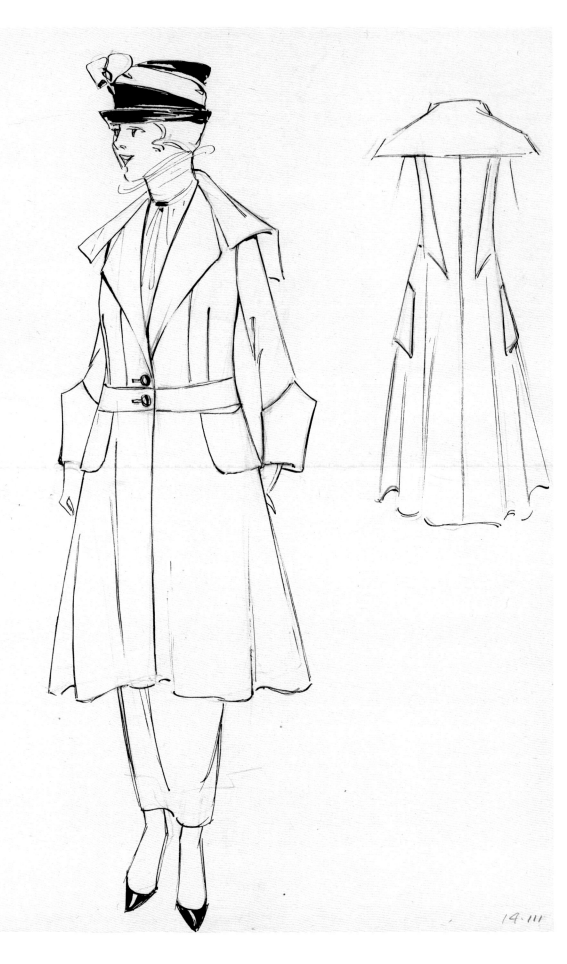

Premet 122

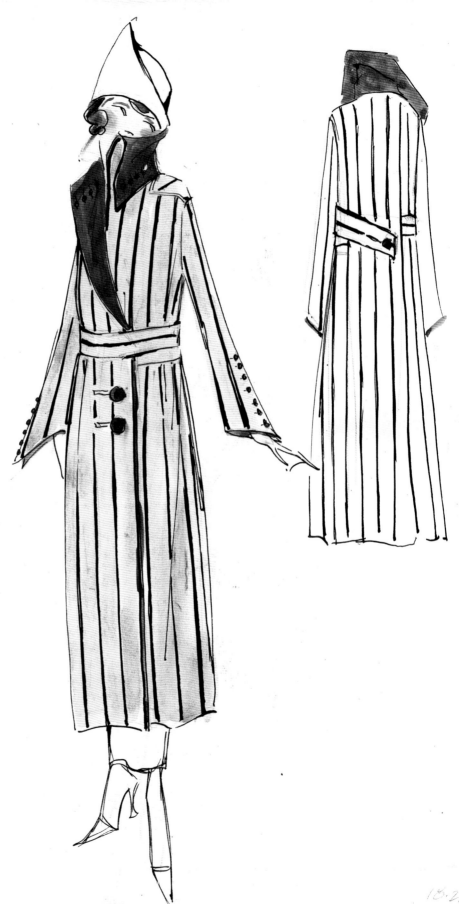

FP

Work ensemble.
Blue chambray,
1912–15, Canada

--

This workwear ensemble follows the same silhouette as the striped walking suit previously discussed. Here again, we see the use of a tunic-like blouse, cinched just below the bust, worn over an ankle-length skirt. Although it is fabricated from linen instead of cotton, the use of interwoven white and blue threads identifies this textile as a chambray, which was a fixture of men's workwear at the time and a close relative of denim, as will be discussed shortly. Taken in tandem with the woman's nineteenth-century jacket (seen on pages 44 and 45), this ensemble suggests continuing interest in mimicking fashionable forms in women's workwear. Such experimentations likely set the example for the practical-yet-fashionable denim styles the designer Claire McCardell introduced during World War II.

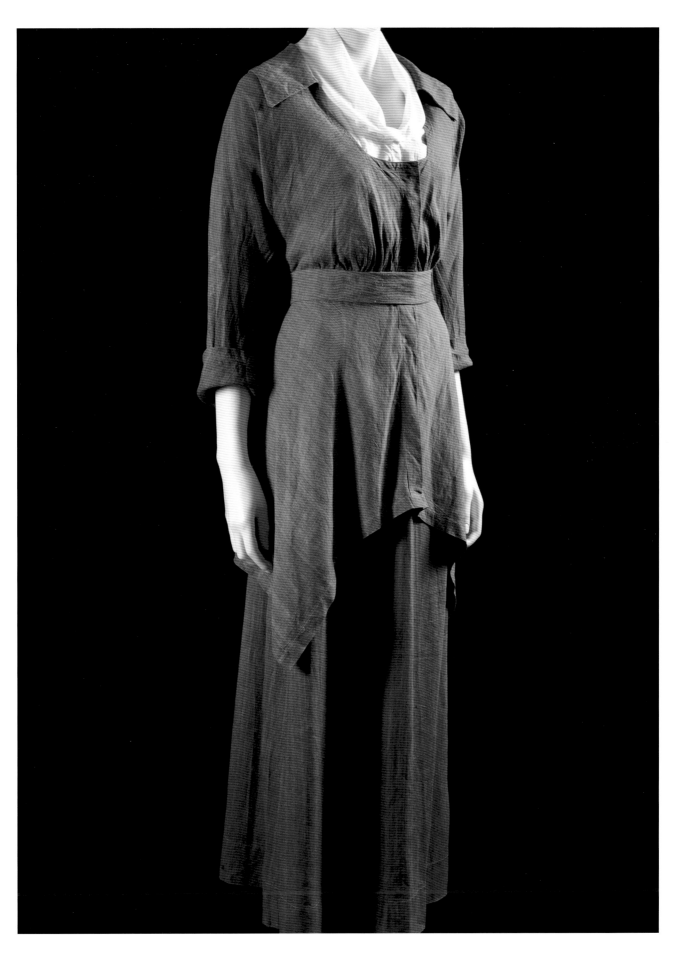

Sailor ensemble.
Blue denim,
ca. 1925, USA

A prominent theory within the mythology surrounding denim's origin claims that the textile was first used to outfit sailors. According to the legend, the name "jeans" derives from the term "bleu de Gênes," or "blue of Genoa," in reference to the blue flared pants worn as far back as the seventeenth century by Italian sailors from the city of Genoa. The denim sailor ensemble seen here dates from the 1920s. The U.S. Navy first introduced flared pants in 1905, and denim during World War I.[1] Sailor's flared pants were designed in this way – giving ample room around the ankle – to make them easier to roll up when "swabbing" the deck. The Navy's flared pants were a direct precursor to the "bell-bottom" jeans that emerged from the counterculture movement of the 1960s. In fact, many of the original hippies bought their first flares from Army/Navy surplus stores. By the early 1970s, during the height of the Vietnam War protests, the association between bell-bottoms and the counterculture movement was so extreme that the Navy discontinued its use of flared pants.[2]

[1] James Sullivan, *Jeans: A Cultural History of an American Icon*. New York: Gotham Books, 2006, p. 135.

[2] Ibid.

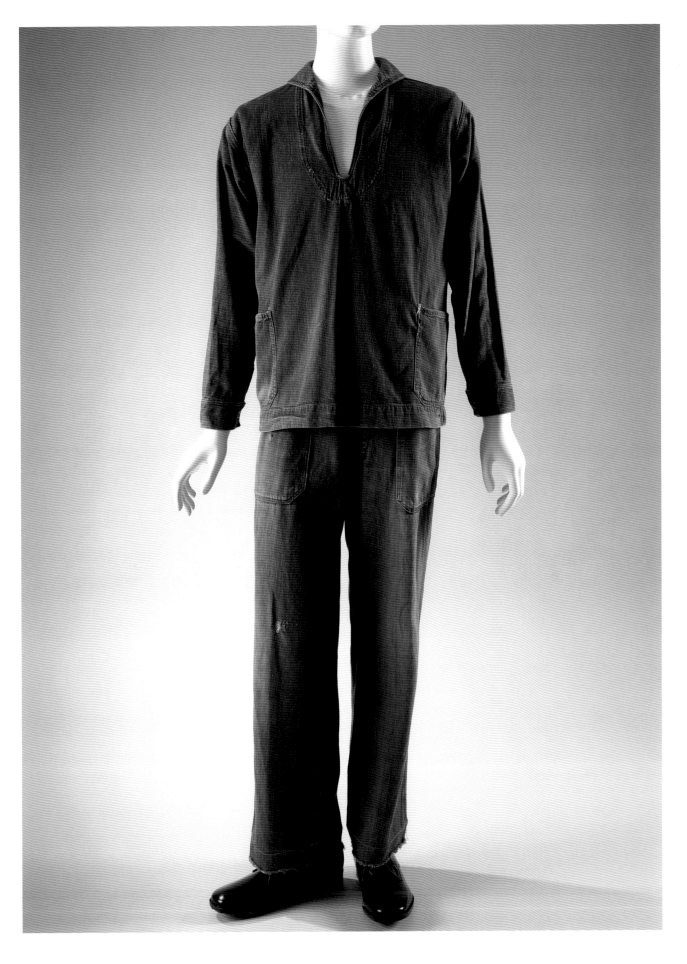

Man's work shirt.
Blue chambray,
ca.1940, USA

--

The chambray shirt has been a workwear staple for as long as blue jeans. Made from plain-weave blue and white threads, it served as a lighter weight equivalent to denim, its warp-faced, twill-weave cousin. Where denim is sturdy, chambray is breathable, making it a perfect fabric for work shirts. In fact, it became such an unofficial uniform for laborers that the term "blue collar" became a euphemism for "working class." Chambray can be woven from cotton or linen. It is also not exclusively blue, and to-day appears in a wide variety of colors. Like denim, a defining feature of chambray is that the warp thread is colored, while the weft thread is white.

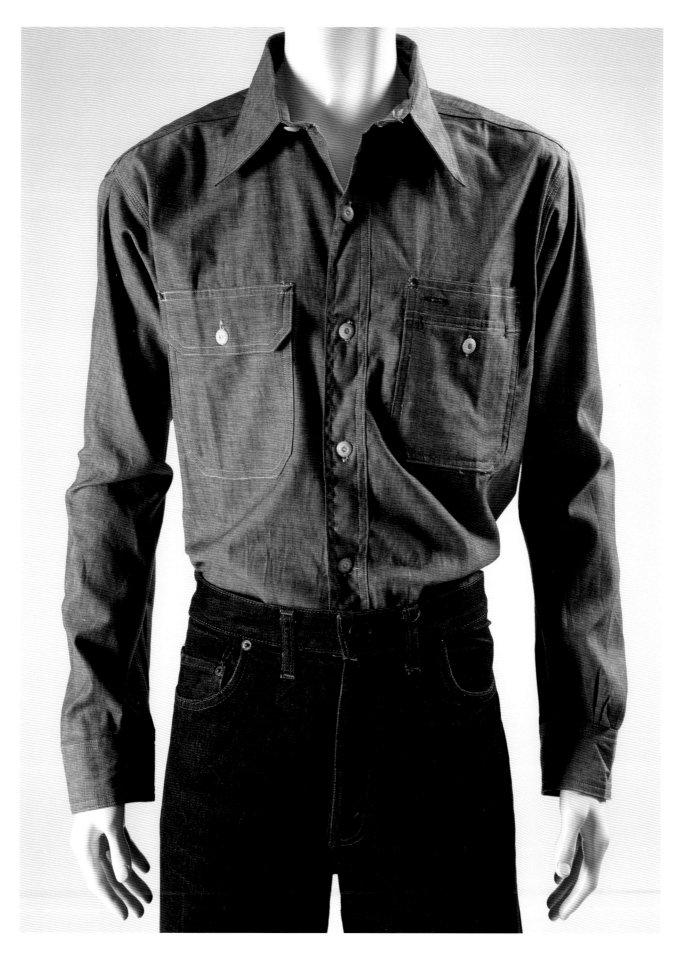

H.D. Lee Mercantile Co. "Lee Riders" jeans.
Blue denim,
ca. 1946, USA

--

"Lee Riders" were H.D. Lee Mercantile Co.'s (known today simply as "Lee") answer to Levi Strauss & Co.'s 501® style. They were introduced around 1924 as the "101 Cowboy Pant," almost exactly fifty years after Levi's® took out the original patent on its riveted jeans. According to Graham Marsh and Paul Trynka, many of the top workwear companies worried about introducing copper riveted, five-pocket blue jeans before the 1920s because they feared the original 1873 Levi's® patent had not yet run out. Levi's® had helped instill this fear with what Marsh and Trynka refer to as its "modern zeal" for bringing legal action against copyists during the late nineteenth century, but by the 1920s, jeans were an open market.[1]

Lee's "Cowboy Pant" went through many stylistic changes before being renamed "Lee Riders" in 1944. Through this evolution, a few distinctive elements emerged, such as the "Lazy-S" stitching on the back pockets, a zipper fly, a "U-Shaped Saddle Crotch" (for ease-of-horse-riding), and the use of "sanforized," or pre shrunk, denim. All of these features were highlighted in advertisements, which were geared as much toward the new group of city-dwellers going on dude ranch vacations as they were toward actual farm hands.

1. Graham Marsh and Paul Trynka, *Denim: From Cowboys to Catwalks.* London: Aurum Press Limited, 2002, pp. 51–55.

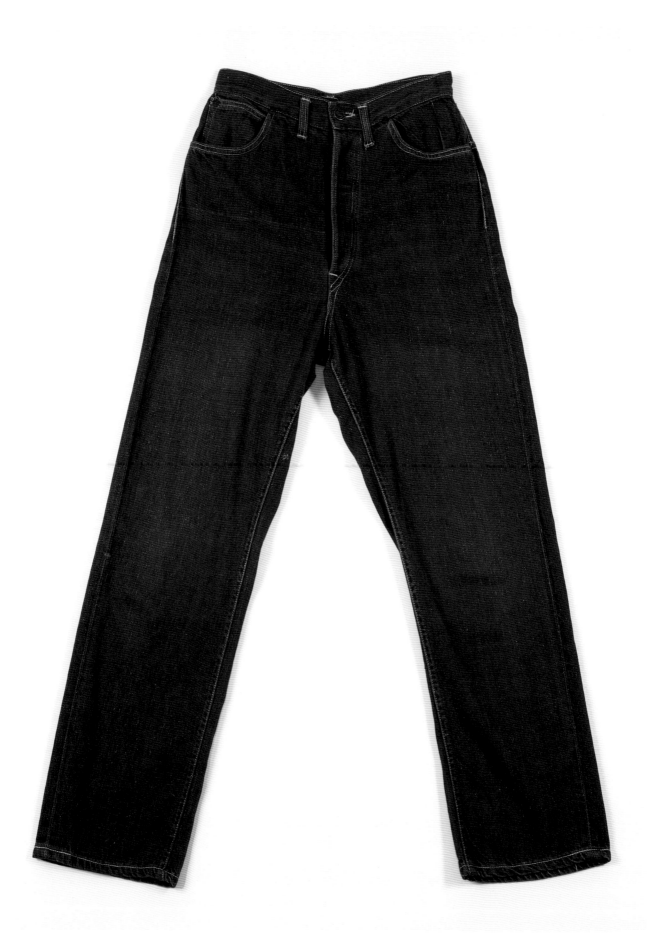

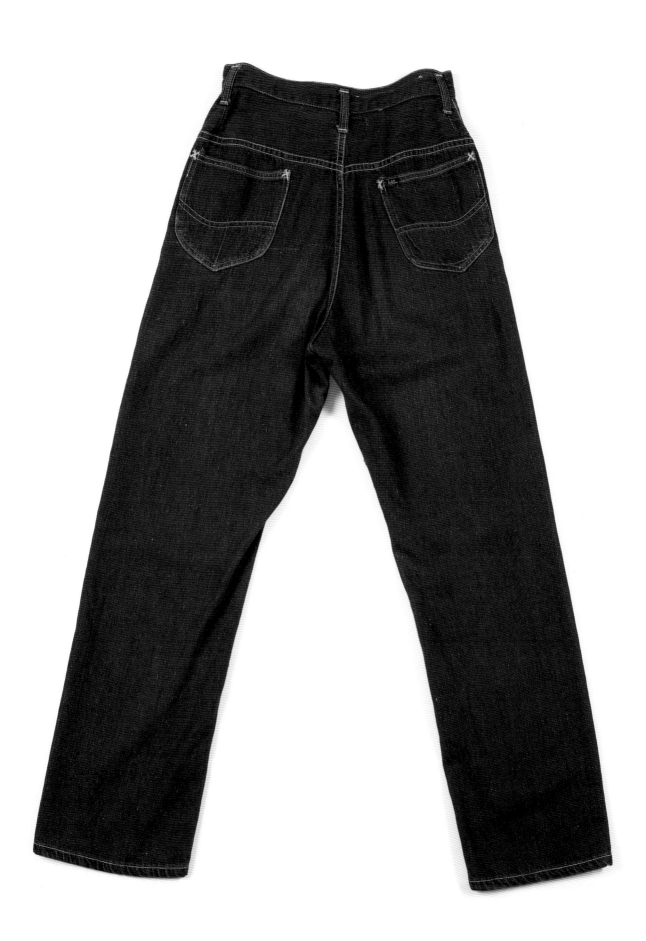

Levi Strauss & Co. "507" model jacket.
Blue denim,
ca. 1955, USA

- -

Levi Strauss & Co. first introduced its denim jacket in 1905, giving it lot number 506. It is also referred to as the "Type I" or "Number 1" jacket. Interestingly, Levi's® originally marketed it as a "blouse." In 1953, Levi's® introduced a second jacket model, known as the 507, which can be seen here. The biggest differences between the 506 and the 507 were that the original version had one front patch pocket instead of two, and a cinch-back strap instead of two side straps to adjust the fit. Present on both models after 1936 was the bright red "LEVI'S" tab affixed to the front left pocket, created to brand Levi's® products in the wake of countless copies that emerged during the 1930s dude ranch era. The bright red color stood out from the blue denim, so that people could identify true Levi's® products at a glance.[1]

1 For further information on Levi's® jacket models see: *Graham and Trynka*, p. 51 and p. 66; also see Alexander Ramos, "Levi's Denim Trucker Jacket Overview: Type I, II, and III," *RAWR DENIM*, March 6, 2013, first accessed July 22, 2015 via URL < http://www.rawrdenim.com/2013/03/levis-denim-trucker-jacket-review-type-i-ii-and-iii/>

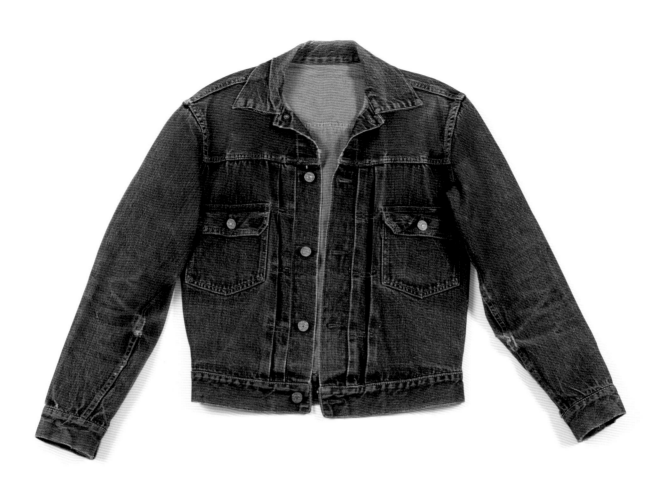

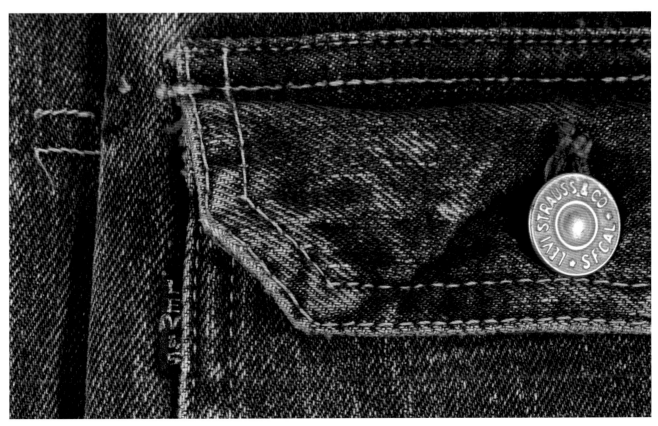

"Play" ensemble.
Blue striped denim,
ca.1940, USA

- -

During the 1930s, an increased interest in exercise and athleticism for women led to the development of a new vocabulary of clothing known as "play clothes." This new category became so important that chic, outdoorsy department store Abercrombie & Fitch in New York devoted an entire floor to the new styles, dubbing it the "Play Floor."[1] Cotton was a popular textile for women's play clothes – including men's cotton shirting and chambray, as well as denim, as in the example seen here. The integration of denim into this genre of women's clothing led to the development of certain denim styles that have remained sportswear staples, from high-waisted denim shorts to one-piece denim "play-suits". Styles such as these became fixtures of Claire McCardell's work, and Levi Strauss & Co even introduced its own versions as part of a women's sportswear line during the 1950s.

1 "Play Hours" catalog, New York: Abercrombie & Fitch, 1940, accessed in Fashion Institute of Technology | SUNY, FIT Library Special Collections and College Archives.

[page 66]
Illustration in Abercrombie & Fitch "Play Hours" catalog, 1940. Image courtesy of Fashion Institute of Technology | SUNY, FIT Library Special Collections and College Archives.

[page 67]
Levi Strauss & Co. advertisement for its "Casuals" leisurewear line, 1955. The Levi Strauss & Co. Archives.

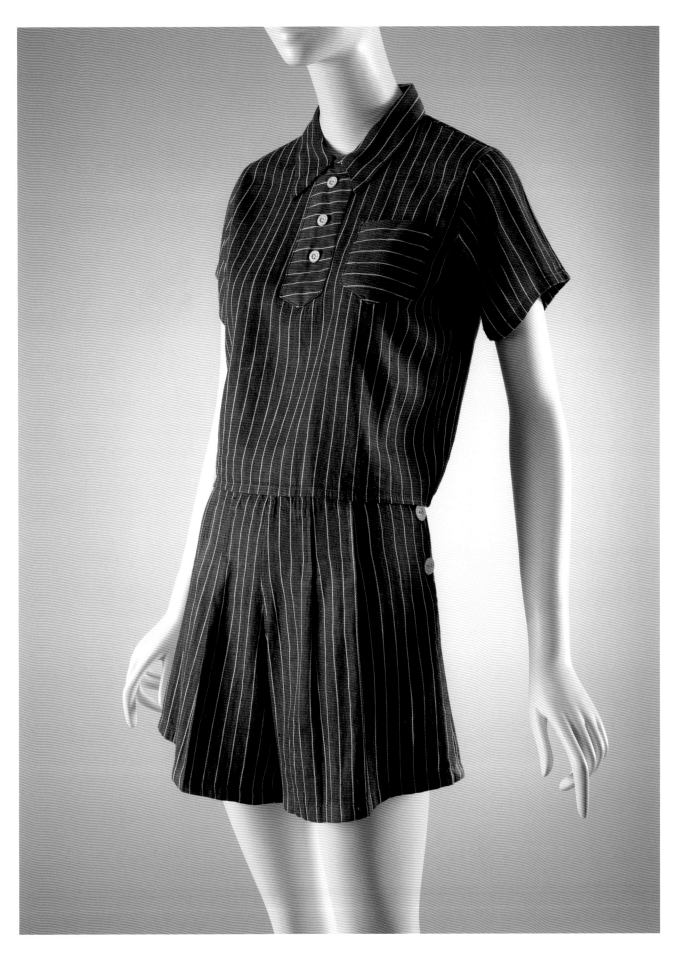

WOMEN'S PLAY CLOTHES

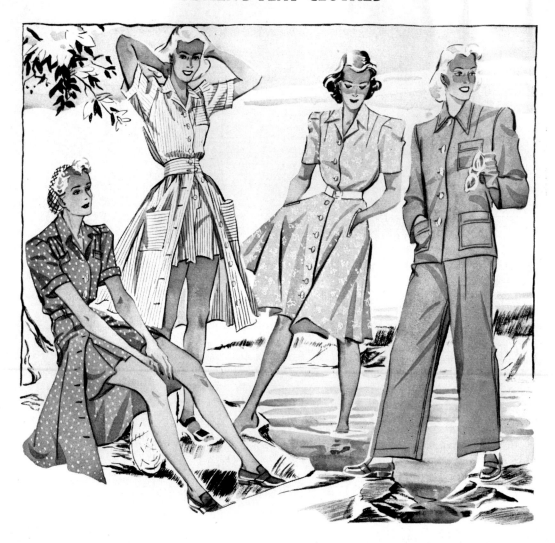

(Left Figure). This classic play suit is made of washable polka-dot rayon. It has one-piece shorts and a matching skirt that is gored. Appropriate short sleeves and convertible collar. The colors are copen blue, navy or aqua with white dots. Sizes 12 to 42.

$12.75

(Left Center Figure). Another one-piece play suit that's made of cotton cord shirting. The collar is convertible and the full shirred skirt has exceptionally large pockets. Your choice of red or blue with white stripes. Sizes 12 to 18. $6.95

(Right Center Figure). This gayly patterned play dress is made of tyrol cotton print. It has a very full skirt and inverted pockets. Also short sleeves and solid colored belt to contrast. In copen blue or coral shades with white print. Sizes are 12 to 18. $13.75

(Right Figure). A practical denim outfit to wear as a knock-about suit in the country, at your camp this summer, or for sailing. It consists of a carefree shirt jacket, a pair of slacks, or a suspender skirt. Choice of colors include solid navy, faded blue or buoy red. Sizes are 14 to 20. The Coat. $2.75
Slacks. $2.75 Suspender Skirt. $2.75

real eye-openers ... the marvelous new mix-or-match LEVI'S Casuals ... a complete leisure-time wardrobe for the young in heart! Your favorite fun-time fabrics ... denim, poplin, sailcloth and kayak cloth ... All Sanforized, of course ... in a rainbow of color-fast, harmonizing heavenly hues!

denim ... shorties, shorts, bermudas, pedal pushers, culottes, playsuit, ranch pants, skirt, sun bra, casual jacket, sleeveless shirt, frontier jacket ... about $1.95 to $5.95

poplin ... shorts, bermudas, pedal pushers, smoothies (slim, trim pants), halter, sun bra, bolero ... about $1.95 to $4.95

sailcloth ... shorts, bermudas, pedal pushers, toreadors, halter, bolero ... about $2.95 to $4.95

kayak cloth ... bermudas only ... about $4.95

LEVI'S
Casuals
S A N F O R I Z E D

Brooks Brothers man's shirt.
Blue denim,
ca. 1940, USA

This pajama-style denim shirt by Brooks Brothers was meant to be worn loose, untucked from the wearer's pants or shorts. Designed in this way, it is ideal for the beach or while vacationing in the country. Shirts like this first began to emerge during the 1930s as part of the new "play clothes" category. Since then, they have remained a feature of "Ivy Style" American dressing. As *Apparel Arts* observed in its April–May 1939 issue, there was a general "wail that was heard…when shirtless bathing outfits began to be the order of the day in beach wear. To many it meant only one thing – lost sales… [but] we devised beach wardrobes… [and today] beach shirts, robes, neckerchiefs, and other such related accessories have assumed an importance that never existed before."[1] The use of denim in this particular example points to a wider use of the fabric in fashionable men's leisure wear, beyond the "cowboy" clothing marketed with dude ranch vacationers in mind.

1 Quote taken from a report on beach attire, in *Apparel Arts*, April–May 1939 issue, p. 56. Fashion Institute of Technology | SUNY, FIT Library Special Collections and College Archives.

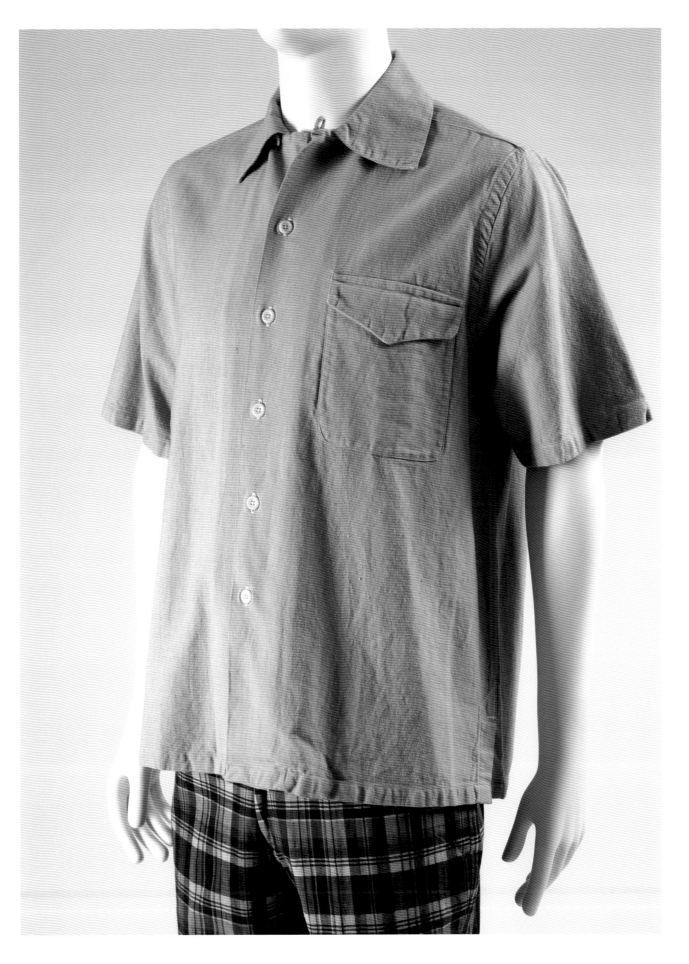

Elsa Schiaparelli blouse.
Blue cotton and pearl,
ca.1947, France

- -

Elsa Schiaparelli was one of the most important couturiers of the interwar period. She is best known for her work with Surrealist artists such as Salvador Dalí and Jean Cocteau, and she developed a reputation for experimentation and playfulness in the details of her designs. During the 1930s and 1940s, she often pushed the boundaries of high fashion, by, for example, experimenting with workwear fabrics, such as blue denim. In this blouse, shown here, Schiaparelli mimics the appearance of denim with a high-end cotton textile woven from white and blue threads. It is, in essence, an example of haute couture chambray. However, unlike its "blue collar" siblings, the construction of this chambray blouse is incredibly intricate. Schiaparelli has included a complex series of darts across the wearer's chest to give the garment a unique shape. She has likewise included gussets under each arm to maximize the range of motion for the wearer. Adding to the couture quality of the garment, the buttons are made of tinted pearl. This detail plays on the design of rodeo shirts, which often featured decorative pearlescent buttons, and which were produced by companies like Levi's® to outfit dude ranch vacationers. By combining design elements of the chambray work shirt with those of rodeo shirts, Schiaparelli has made a couture homage to Americana.

Jumpsuit.
Blue denim,
ca. 1942, USA

Lee introduced its denim jumpsuit in 1913. It was called the "Union-All" because, according to an early Lee advertisement, it combined the chambray work shirt and denim pants "all in one piece (like your union underwear)."[1] The "Union-All" quickly became Lee's best-selling product. It was an ideal uniform for a variety of laborers, from mechanics to factory workers, because it did not have any shirt-tails or belts that could get caught in machinery. Lee supplied "Union-Alls" to factories around the country, and the style was adopted by the U.S. military for its mechanic and supply units.

During World War II, many women had to step into factory and munitions supply jobs previously held by men. In the U.S. alone, three million women joined the work force.[2] The particular "Union-All"-style denim jumpsuit shown here quickly became the emblem of these new workers – immortalized by the character "Rosie the Riveter," who appeared on posters and in songs to boost women's morale throughout the war.

1 "At Last! A Nation's Need is Supplied" advertisement by H. D. Lee Mercantile Co., 1917, reprinted in Graham Marsh and Paul Trynka, *Denim: From Cowboys to Catwalks*. London: Aurum Press Limited, 2002, p. 29.

2 Jennifer D. Keene, Saul T. Cornell, and Edward T. O'Donnell, *Visions of America: A History of the United States*, vol. 2 (2nd edition). New York: Pearson, 2012, pp. 697–98.

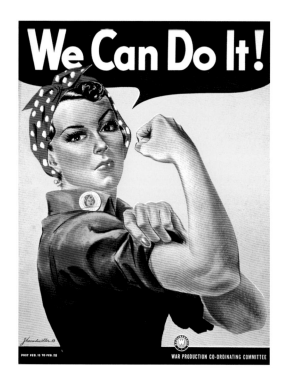

"We Can Do It!" poster by Westinghouse for War Production Co-Ordinating Committee, 1942, figure pictured often identified as wartime folk-heroine "Rosie the Riveter."

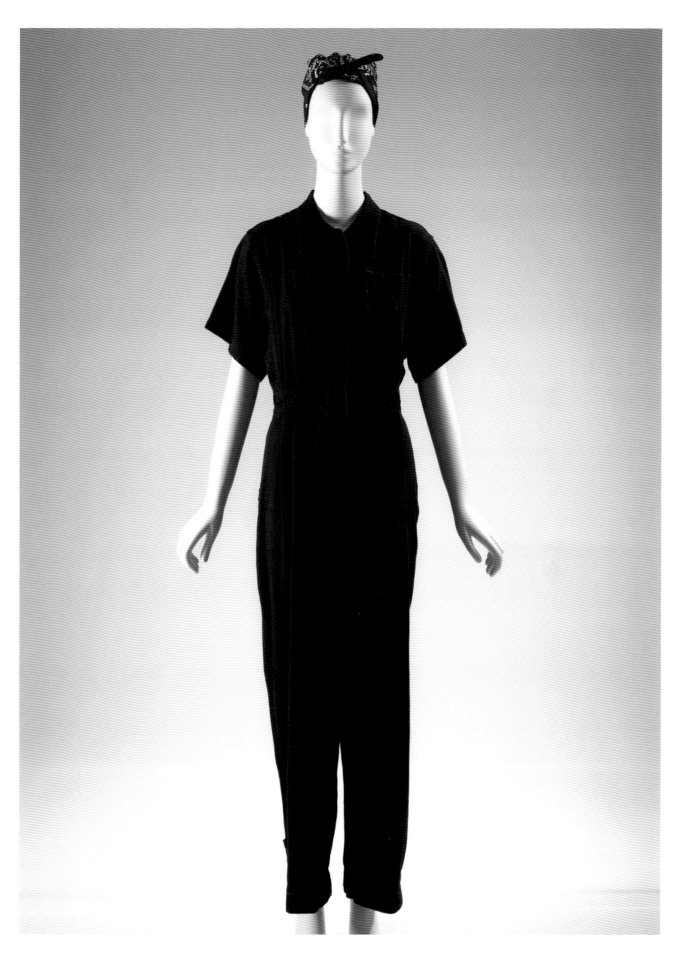

Claire McCardell "Popover" dress.
Blue denim and red cotton (reproduction),
ca. 1942, USA

In 1942, at the height of World War II, Claire McCardell was asked to design a fashionable yet practical garment for the modern housewife. The request came from Diana Vreeland and Carmel Snow – the fashion editor and editor-in-chief of *Harper's Bazaar*, respectively. Her solution was the denim "Popover" dress seen here. Made of indigo-dyed denim, it was durable and easy to clean. Drawing on the tradition of women's workwear, the silhouette of her design followed the lines of a traditional shirt-waist dress, but featured a wrapped front and an oven-mitt that could be tucked into a large side pocket – out of the way but always at the ready. The original design debuted in *Harper's Bazaar* with the tag-line, "I'm doing my own work."[1] It sold for $6.95 and was a huge success. In fact, it was so successful that McCardell patented it in November 1942, and the "Popover" style became a fixture of her subsequent collections. She regularly reinvented it in a variety of materials and even elongated it as an eveningwear look.[2]

1 *Harper's Bazaar*, November, 1942, p. 54.
2 Kohle Yohannan and Nancy Nolf, *Claire McCardell: Redefining Modernism*, New York: Harry N. Abrams, Inc. Publishers, 1998, p. 67.

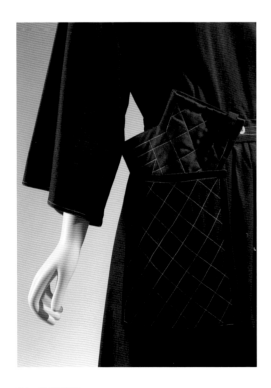

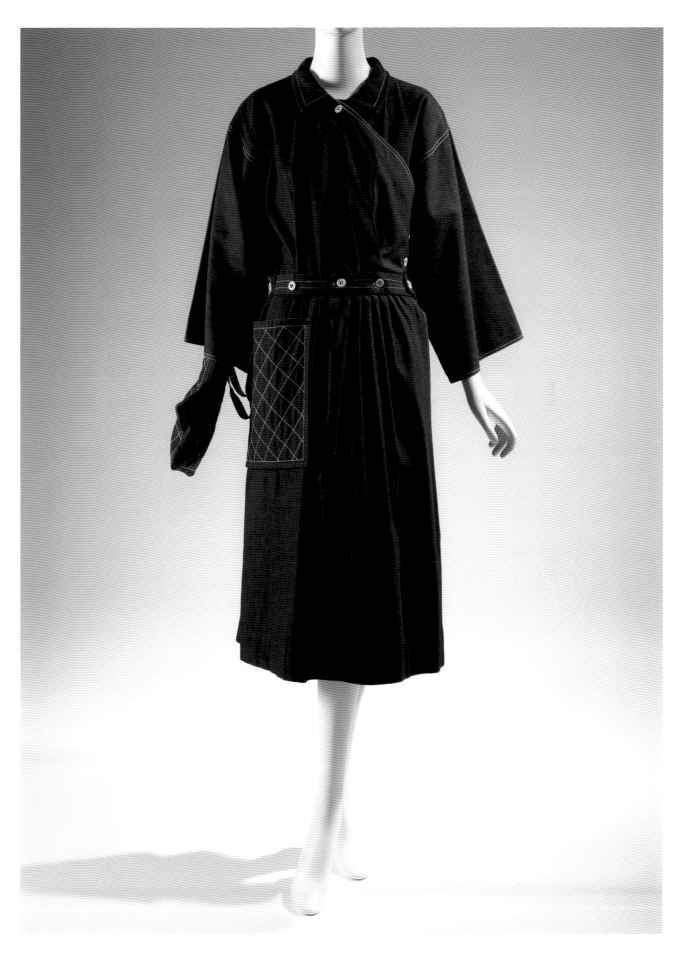

Louise Dahl-Wolfe, photograph
of a model wearing Claire
McCardell's denim "Popover"
dress in *Harper's Bazaar*,
November, 1942.

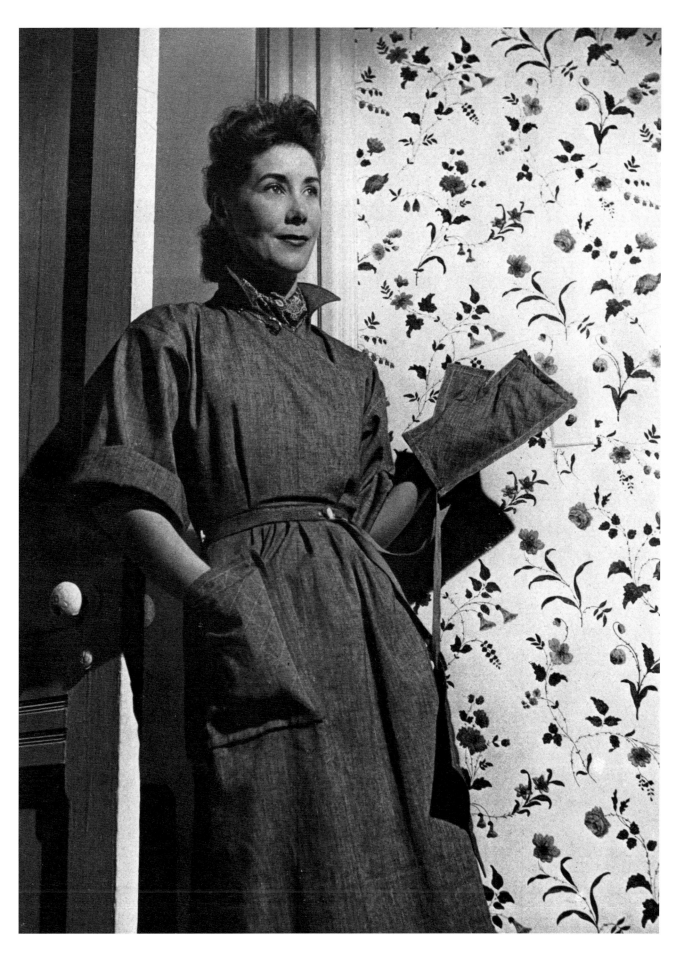

Claire McCardell beach ensemble.
Blue chambray,
1945, USA

- -

Following on the success of her denim "Popover" dress in 1942, Claire McCardell began introducing denim into her collections in a variety of ways, most often as beachwear, building on the tradition of "play clothes." Here we have two examples. The first is an ensemble rendered in a lightweight, breathable, blue chambray. The look bears all the signature elements of McCardell's work: it is sporty, yet chic, with an emphasis on functionality. It takes influence from menswear in the cut of the shirt, and it offers the wearer an interchangeable wardrobe of separates to fit a variety of beach-going vacations. The second is McCardell's feminine play on the denim jacket (see page 81) – which by this time was already a staple of men's workwear. For her fashionable beach-goer, McCardell has lightened the shade of blue denim for the jacket, cropped the length, added elastic at the back waist to create a cinching effect, and completed the piece with a deep cut v-neck down the front, ending at a center zip. Denim continues to be a popular fabric for summer fashions, largely thanks to the example set by McCardell.

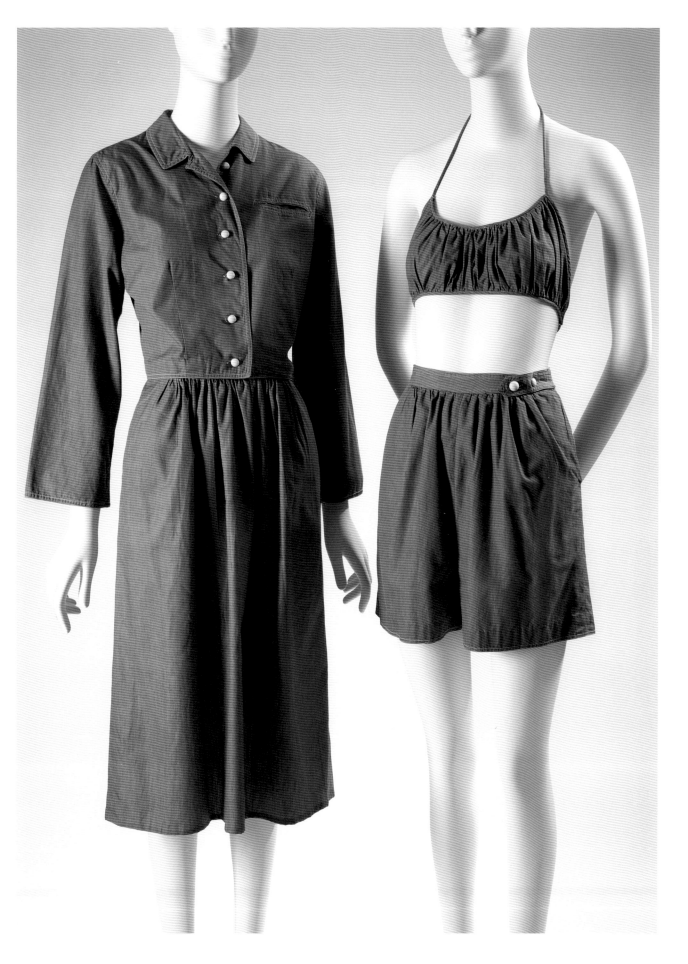

Claire McCardell jacket.
Blue denim,
ca. 1953, USA

--

See previous entry.

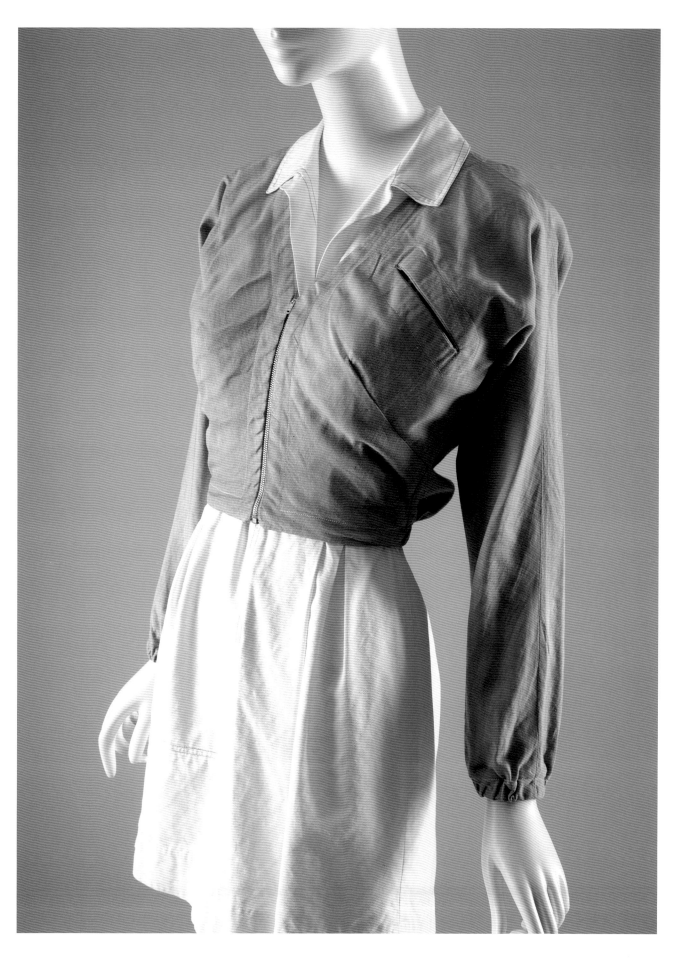

Woman's skirt.
Blue denim and stuffed appliqués,
ca. 1952, USA

--

During the 1950s, the "teenager" emerged as a powerful cultural force in the United States. Jeans became a symbol of the angst-ridden teenage trouble-maker, as immortalized by James Dean's character from the 1955 film, *Rebel Without a Cause*. Meanwhile, the "Poodle Skirt" quickly became the go-to for girls at school dances or "sock hops" around the country. The "Poodle Skirt" – so named for the distinctive use of appliqués to decorate the skirt, which were often (though not exclusively) in the shape of perfectly groomed poodles – was a simple circle-skirt that was designed to cinch the wearer's natural waist and fall just below the knee. It mimicked the fashionable "New Look" silhouette introduced by the French haute couturier Christian Dior in 1947, but the "Poodle Skirt" could be made at home, usually from inexpensive felt or cotton fabric, and personalized with appliqués. In this particular example, the wearer chose to decorate her skirt with vegetables. More significantly, she selected a blue denim textile as the main fabric, thus fusing two teenage trends in a single garment.

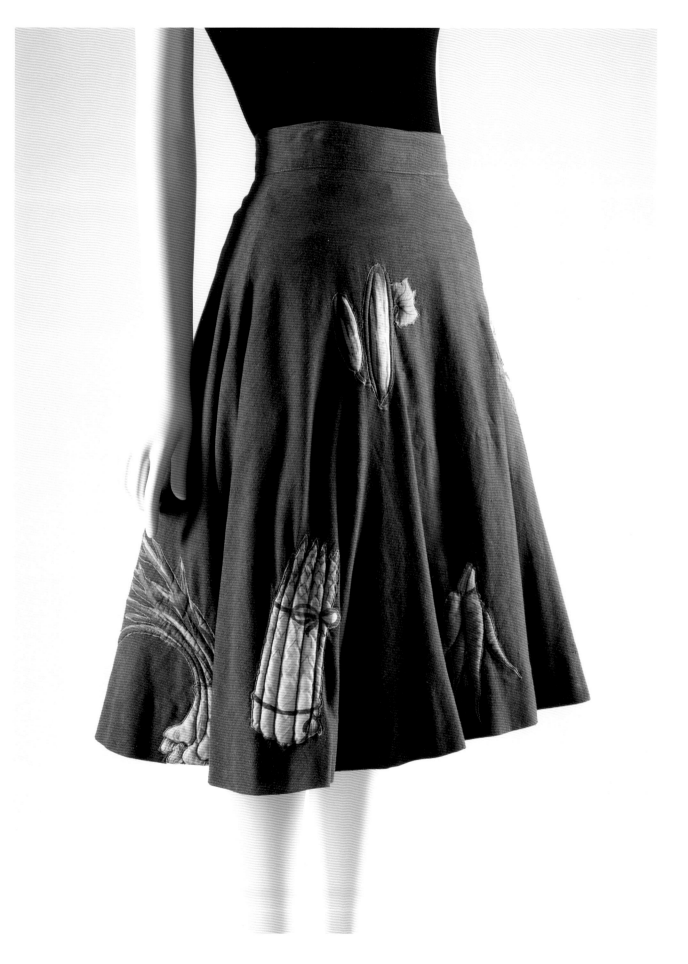

Phelps Deep Country Clothes skirt and shorts.
Navy striped denim,
ca. 1950 and ca. 1954, USA

"Deep Country Clothes" was a specialty line of separates created by fashion designer Elizabeth Phelps during the 1950s. The line was featured across the fashion press in publications such as *Vogue*, *Harper's Bazaar*, and *Glamour* and sold at high-end department stores, including Lord & Taylor in New York. Designated as "occupational leisure-wear," the line was aimed at the fashionable housewife because, according to an advertisement from 1950, "when women have work to do – in the garden, working around the house or preparing for a cocktail party – they can still look smart."[1] Denim was one of the main fabrics for the line. A major selling point was that Phelps used zippers, rivets, and/or wrap-around styles for her skirts and shorts, such as those seen here, so that wearers would not need to fumble with hook-and-eyes or buttons. Phelps' indebtedness to Claire McCardell is immediately apparent both in the design and marketing strategy of the line, but Phelps also drew on men's workwear with her use of metal rivets. The emergence of a label such as this shows how denim was recoded during the 1950s to align with the more affluent lifestyle of postwar suburbia.

1 Phelps Deep Country Clothes advertisement originally printed in *Women's Wear Daily*, March 29, 1950, p. 32.

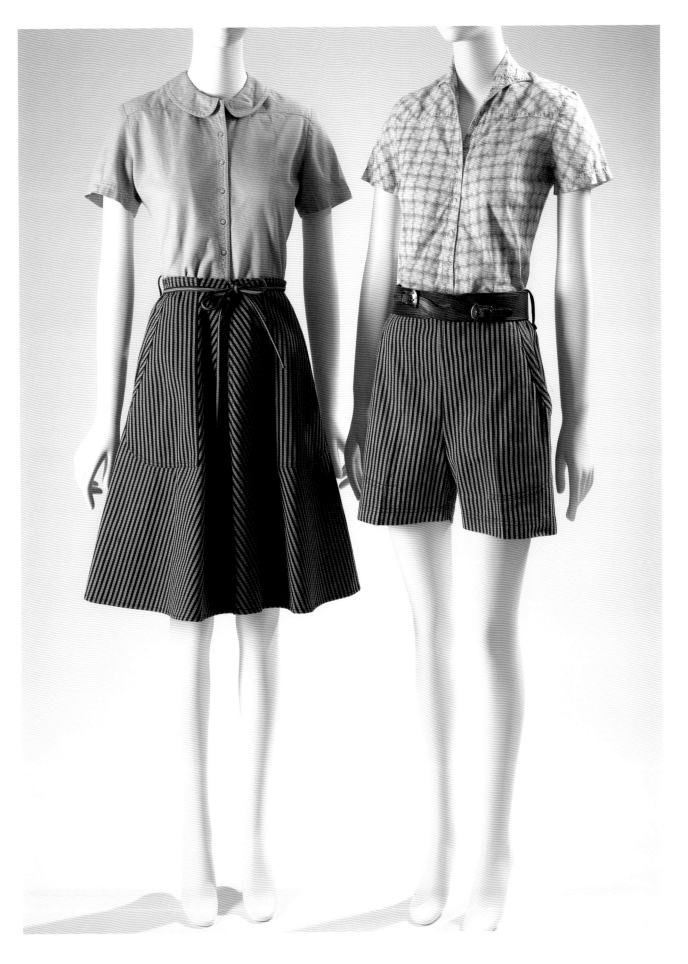

Levi Strauss & Co. "Ranch Pants."
Blue denim,
ca. 1955, USA

During World War II, Levi's® discontinued the "Lady Levi's" range it had introduced during the dude ranch vacation craze of the 1930s. After the war ended, Levi's® unveiled its "Ranch Pant" style for women. The "Ranch Pant" featured a new side zipper and a slimmer, fashionable silhouette. Like "Lady Levi's" before it, the "Ranch Pant" was made from pre-shrunk or "sanforized" denim to ensure it would retain its original fit. The pants also featured "frontier" pockets. These were essentially side slit pockets that could be opened further by snaps positioned along the front waistband. These snaps were covered with a shimmery pearlescence – a decorative element taken directly from the rodeo shirts the company had also introduced during the dude ranch era. Although the "Lady Levi's" line had been marketed to women who either worked on a ranch or wanted to dress appropriately for a ranch retreat, the new "Ranch Pants" were promoted as fashionable leisure wear. The "Ranch" name was the only link the pants had to the romance of the Old West; they were more likely to be seen on suburban lawns.[1]

1 "California Ranch Pants" advertisements, 1952–1968, accessed in the Levi Strauss & Co. archive, July 14–15, 2015.

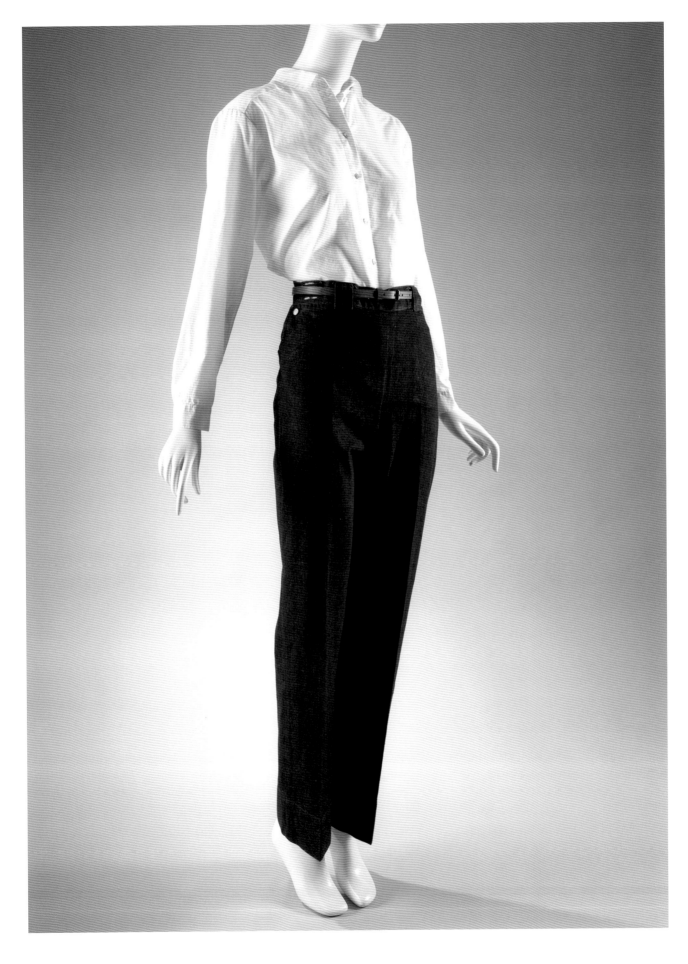

Levi Strauss & Co. advertisement for
its "Denim Family" line featuring its
"Ranch Pants," ca. 1953. The Levi
Strauss & Co. Archives.

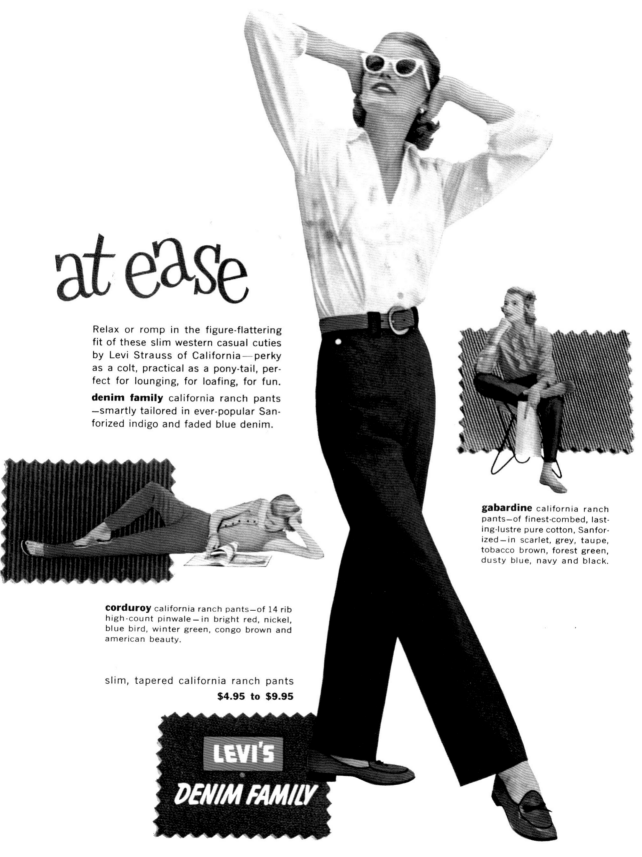

at ease

Relax or romp in the figure-flattering fit of these slim western casual cuties by Levi Strauss of California—perky as a colt, practical as a pony-tail, perfect for lounging, for loafing, for fun.

denim family california ranch pants —smartly tailored in ever-popular San-forized indigo and faded blue denim.

gabardine california ranch pants—of finest-combed, last-ing-lustre pure cotton, Sanfor-ized—in scarlet, grey, taupe, tobacco brown, forest green, dusty blue, navy and black.

corduroy california ranch pants—of 14 rib high-count pinwale—in bright red, nickel, blue bird, winter green, congo brown and american beauty.

slim, tapered california ranch pants
$4.95 to $9.95

LEVI'S
DENIM FAMILY

MADE ONLY BY LEVI STRAUSS OF CALIFORNIA • SAN FRANCISCO 6

Bonnie Cashin beach ensemble.
Blue denim, cotton, leather, and straw
1960, USA

- -

Bonnie Cashin was one of the great American sportswear designers of the twentieth century. Like Claire McCardell, Cashin had an interest in functionality, but she was not afraid to experiment with materials and design details. She became particularly well known for a distinctive brass clasp that she used on both her clothing and on an accessory line she designed for Coach. Cashin was also known for her use of leather, which in her clothing would often appear as patches or piping. By this time, denim had become a classic fabric for beachwear, thanks to the tradition established by 1930s "play clothes" and the work of Claire McCardell. Cashin has given this chic beach ensemble her personal touch by including both a brass clasp at the neck of the denim coat and light blue leather trim to adorn its edges.

On the following page, a Bonnie Cashin sketch from 1960 shows how the designer further experimented with traditional denim workwear. In the sketch, we see a fashionable housewife wearing bib-overalls while carrying a steaming-hot cake tin. Two swatches affixed to the top-left of the sketch show that the overalls would have been a bright blue, but a close inspection reveals that the overalls were intended to be bright blue *leather*, rather than denim. It is a direct homage to McCardell's wartime "Popover," but Cashin has given it, nearly two decades later, an unlikely modern twist.

[following page]
Bonnie Cashin, sketch, 1960.
Image courtesy of Fashion
Institute of Technology | SUNY,
FIT Library Special Collections
and College Archives.

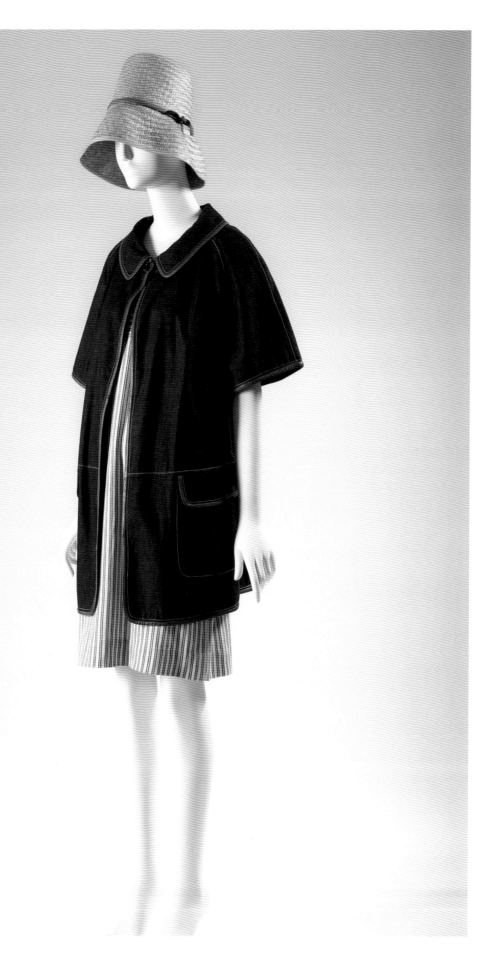

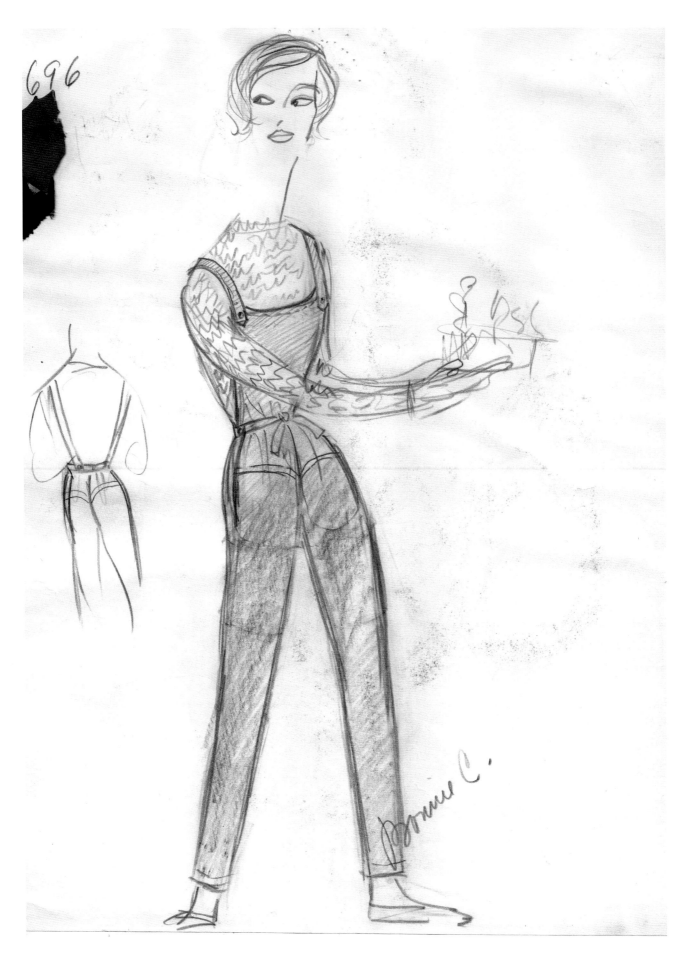
696

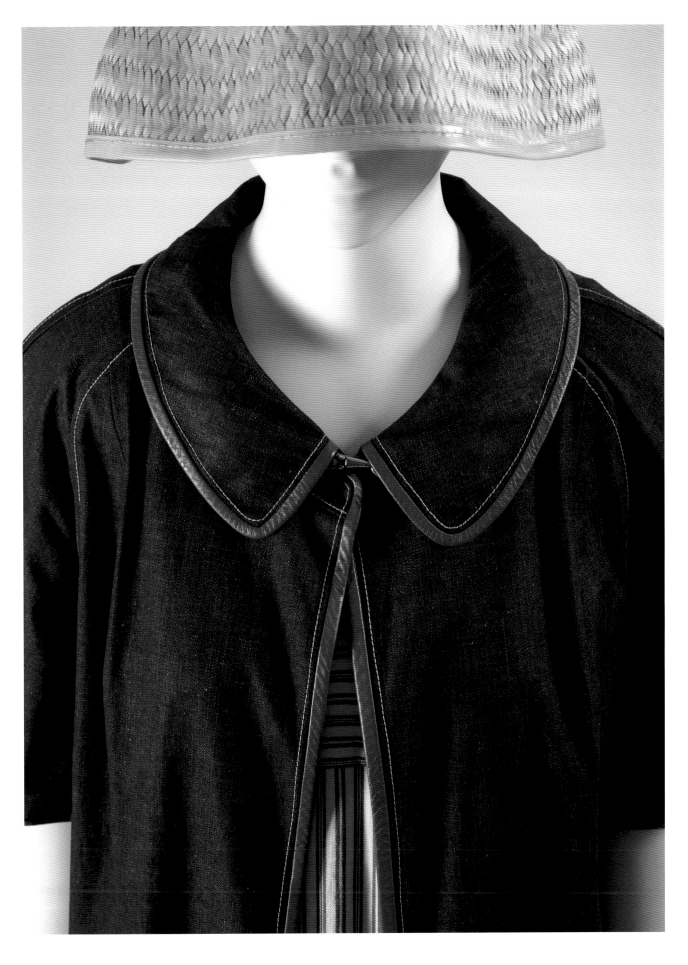

Man's jacket.
Blue denim, wool, and black corduroy, ca. 1959, USA

- -

Lee first introduced its "Storm Rider" jacket in 1933. The jacket was essentially the same as Lee's 101J style (which was a slimmer version of the Levi's® 506 jacket), but the "Storm Rider" featured a blanket lining and corduroy collar. Designed to be worn for work in cooler climates, the jacket became a signature of Lee's denim range, sparking copies and adaptations around the world. The popularity of the style skyrocketed when Marilyn Monroe was photographed wearing a Lee "Storm Rider" on the set of the 1961 film *The Misfits*.[1] The version seen here dates from around the time of the film. Although the length, silhouette, and front details of the jacket are markedly different from the Lee version (including the position of the pockets and the use of snaps instead of metal buttons), the all-important blanket lining and corduroy collar remain the same.

1 Graham Marsh and Paul Trynka, *Denim: From Cowboys to Catwalks*. London: Aurum Press Limited, 2002, p. 79.

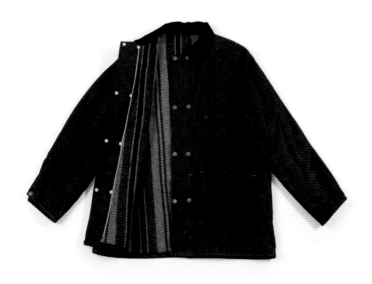

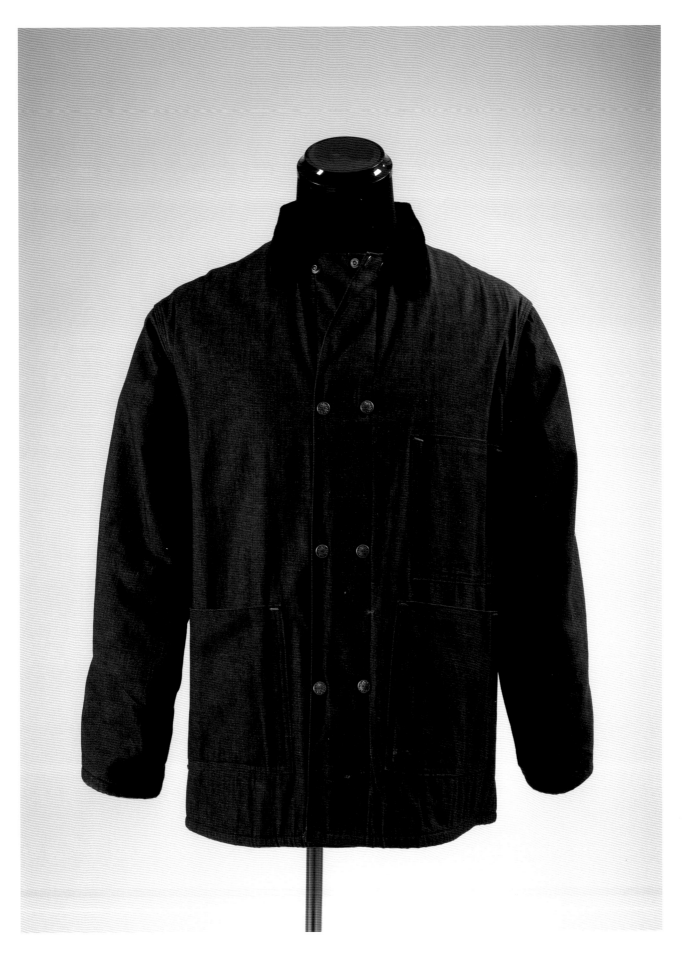

Eve Arnold, photograph of Marilyn
Monroe wearing a Lee "Storm
Rider" jacket on the set of *The
Misfits*, 1960. © Eve Arnold/
Magnum Photos.

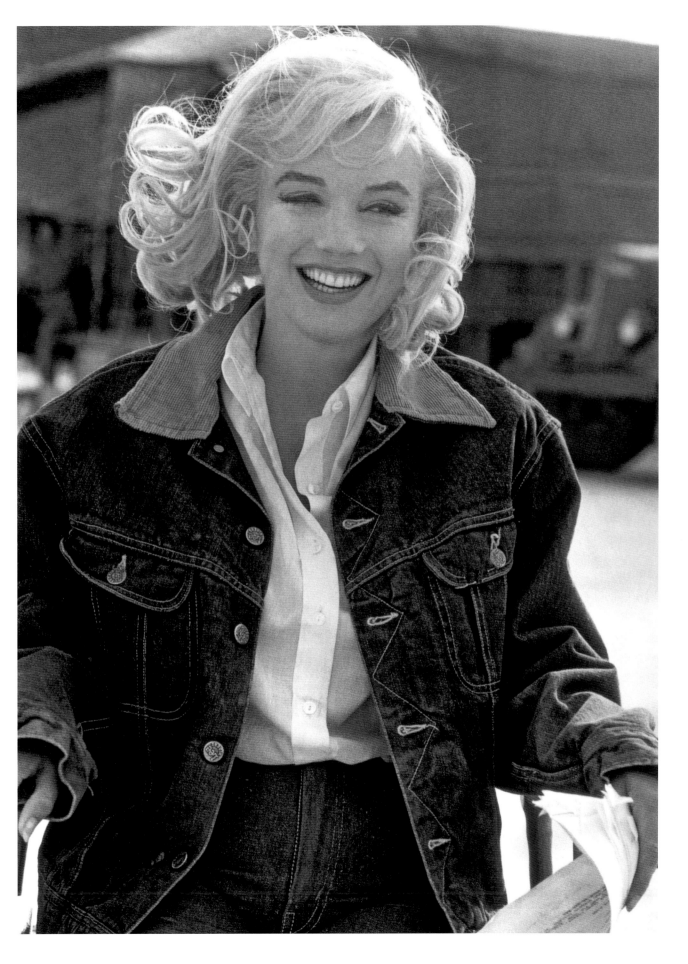

Customized Levi Strauss & Co. jeans.
Blue denim, embroidery, leather, appliqué, beads, ca. 1969, USA

The worn, torn, patched, and embroidered pair of Levi's® jeans seen here is a prime example of a shift that occurred in denim as a result of the 1960s counterculture movement. "Hippies" and "flower children" would go to thrift stores and flea markets and buy pre-owed clothes, which they would then patch and embroider by hand. The personalized garments functioned as political statements against the material-driven consumer culture of postwar America. Denim was particularly sought after for its working class connotations, natural cotton fibers, durability, and ease-of-care. As the counterculture movement spread, the hippies' hands-on treatment of denim established the idea of denim as a blank canvas – a surface to act on, personalize, and decorate. As an article in the counterculture magazine *Rags* declared, "Work clothes, don't you see, are an empty canvas…They don't insinuate themselves on you – you insinuate yourself on them. The more they *become* you, the more they become *you*. Think of it. Something that looks better the older it gets."[1] This view continues to prevail over much denim production today.

1 "Work Clothes: The More They Become You, The More They Become You," *Rags*, November, 1970, pp. 18–19, accessed in FIT's Special Collections Library.

Serendipity skirt.
Repurposed denim jeans,
ca. 1972, USA

The skirt seen here is made from a recycled pair of pre-owned jeans that have been cut along the inseam and then sewn together using a panel of denim fabric. Constructing a skirt in this manner originated in the hippie movement – the skirt retains the original lines of the pants it was made from, making it a wearable symbol of the movement's devotion to recycling and sustainable methods of production. It is an anti-fashion statement that underscores the hippies' approach to clothing as a frontier for political activism.

This style of skirt eventually spread into mainstream fashion via trendy boutiques like Serendipity, who made this skirt. The hippies' distinctive use of pre-owned jeans gave rise to a more fashionable vogue for soft and faded denim. This has led to the development of countless pre-washing and distressing techniques still employed by the denim industry today. These various techniques (not least of which is the practice of pre-washing denim multiple times) are detrimental to the environment, and today, denim is viewed as one of the least sustainable products of the apparel industry – particularly in terms of its water waste.

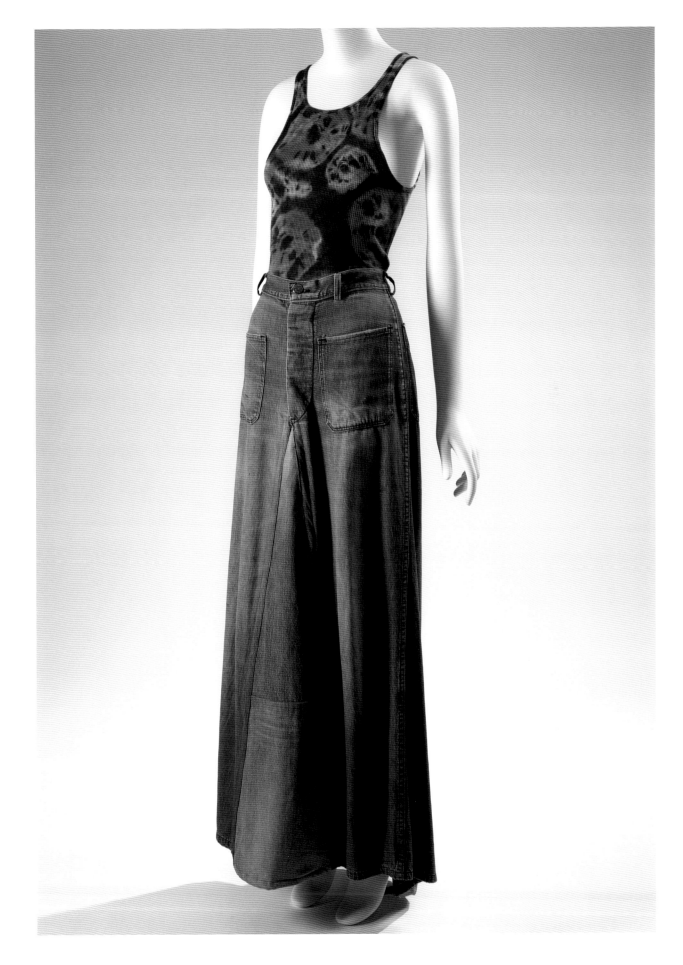

Man's shorts.
Photo-printed denim,
ca. 1969, USA

By the start of the 1970s, the counterculture movement had exploded into a mainstream cultural phenomenon. Fashion designers and retailers alike were looking to the hippies' politicized style as a source of inspiration and appropriation. These printed denim shorts are a flagrant example of the commercialization of the counterculture movement. Across the entire garment is a print generated from a photograph of the Woodstock Art & Music Fair in 1969. The motif of the shorts has not recreated any particular construction technique or silhouette used by the hippies; instead, it has appropriated hippies themselves as a decorative device.

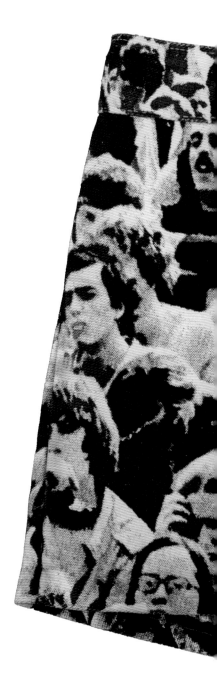

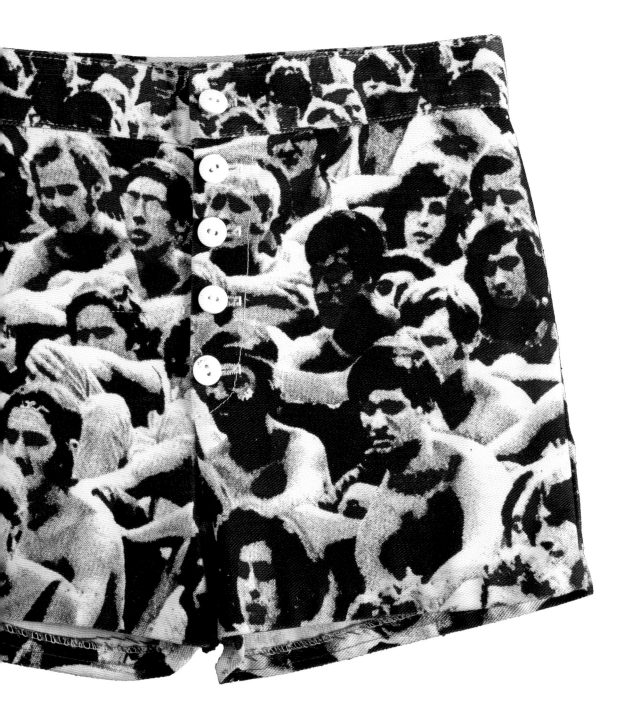

UFO man's overalls.
Blue denim,
ca. 1973, USA

--

"Bib overalls," such as the style seen here, have been a workwear fixture since the late nineteenth century. At the start of the twentieth century, denim versions were one of the most popular styles of workwear in the U.S., and Walker Evans's Depression-era photographs of the American Dust Bowl immortalized the figure of the overall-clad farmer. While jeans started to crossover into mainstream fashion as early as the dude ranch era of the 1930s, overalls stayed firmly planted in workwear. It was not until the counterculture movement began adopting the style during the 1960s – precisely for its working-class associations – that the overall finally transitioned out of workwear.

This particular pair was made by the company UFO. UFO was established in the early 1970s to capitalize on the booming denim market. UFO garments came pre-made in many of the DIY silhouettes popularized by the hippies. For example, this particular pair boasts flared or "bell-bottom" legs and the back straps have been decoratively threaded through each other. The owner of this pair took the counterculture associations one step further and embroidered colorful starbursts across the front, effectively "personalizing" them, although such details were becoming ubiquitous by the mid-1970s.

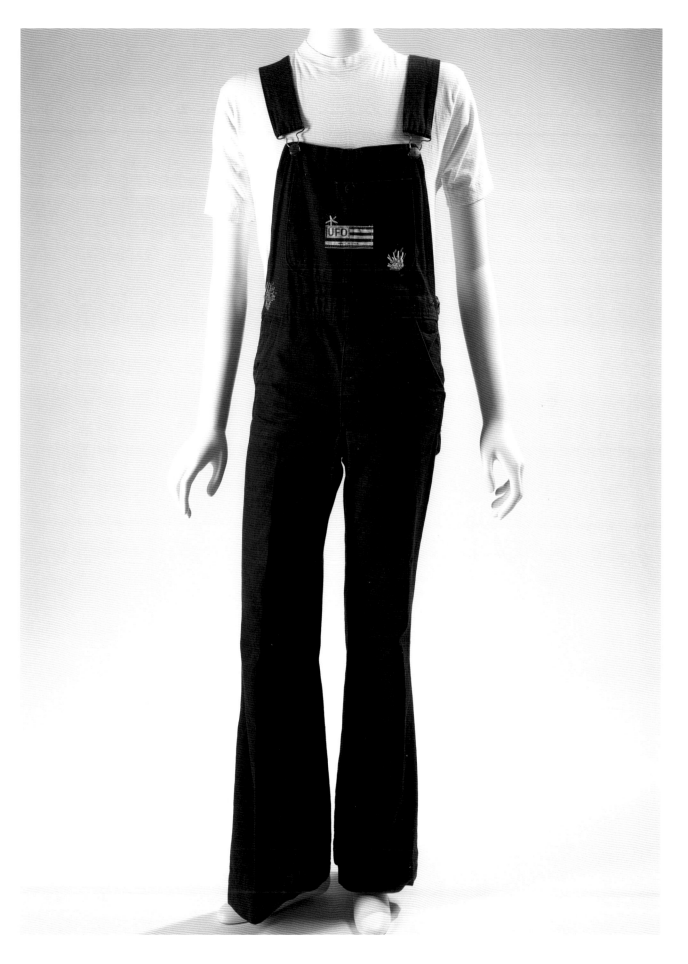

Pinky and Dianne man's jacket.
Repurposed denim,
1973, USA

--

One of the most widespread styles that originated in the counterculture movement (aside from the general popularity of denim itself) was the patchwork aesthetic. Originally used to repurpose pre-worn garments, patches became a decorative element within the movement to personalize one's denim and also to link one's style to the traditions of folk art. By the early 1970s, decorative patchwork had grown into a full-blown fashion trend. Retailers began patching denim jeans, skirts, jackets, and vests with a myriad of colored or printed fabric to create a folkloric effect. In its most extreme cases, however, the patchwork would make up the entire garment, as is the case with the denim jacket seen here. Made for the New York boutique Pinky and Dianne, the jacket is constructed entirely from square pieces of denim, most likely repurposed from several different pairs of jeans. The front pockets that adorn the wearer's chest show remnants of Lee's "Lazy-S" stitches, and the center buttons, likewise, bare the distinctive "Lee" moniker. This square-patch look made a resurgence on the runways in the work of Tom Ford, Tommy Hilfiger, and Jeremy Scott for Moschino for the Spring 2015 season.

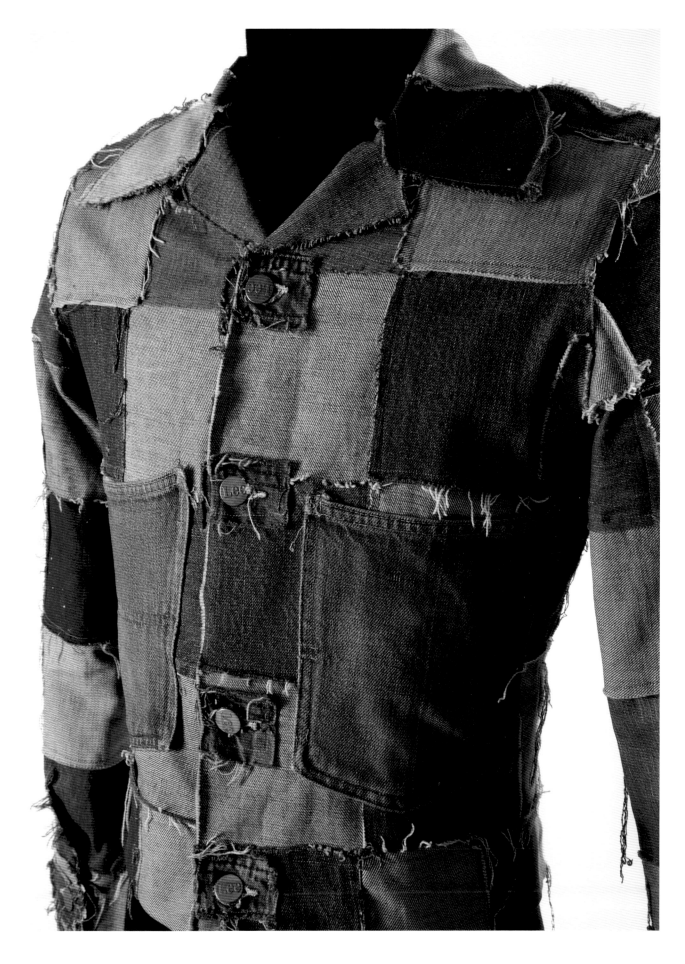

Young Dimensions clogs.
Blue denim, wood,
ca. 1973, USA

- -

The patchwork effect spread all the way down to footwear, as seen here in these denim clogs. By 1973, denim clogs were a must-have fashion item. As one trend report advised footwear retailers, "the word that echoes incessantly is denim – denim clogs … give the denim devotee that 'total look[.]'"[1] A different trend report particularly recommended styles that left "the ragged edges on."[2] This "ragged" look immediately aligned the shoes with the pre-worn, repurposed, hippie aesthetic, despite the fact that they were brand new commercial items. While the "distressed" effect was immensely popular with younger consumers, older women were not as open to the trend. The trade publication *Boot and Shoe Recorder* recognized this divide on its November 1973 cover, which shows a perplexed older woman holding up a "ragged-edged" denim clog as an excited younger woman tries to grab it from her.

Cover of *Boot and Shoe
Recorder* magazine, November
1973, vol. 3, The Denim Council
Papers, image courtesy of
Fashion Institute of Technology
| SUNY, FIT Library Special
Collections and College
Archives.

1 Barbara Lewis, "Femininity
 Forecast For Spring," *Shoe*, Los
 Angeles, October, 1973, vol. 3,
 The Denim Council Papers,
 Fashion Institute of Technology
 | SUNY, FIT Library Special
 Collections and College Archives.

2 "Women's: conJEANial," *Footwear
 News*, New York, November 1,
 1973, vol. 3, The Denim Council
 Papers, Fashion Institute of
 Technology | SUNY, FIT Library
 Special Collections and College
 Archives.

Sara Shelburne ensemble.
Multi-color striped denim and silk,
ca. 1970, France

As denim moved from counterculture into the mainstream, high fashion designers on both sides of the Atlantic began experimenting with the textile. This ensemble from Paris-based designer Sara Shelburne is made entirely from a striped denim. Interestingly, the care instructions dictate that it must be dry cleaned only. This is because Shelburne chose to line the coat fully in silk, treating denim as any other luxury material. The ensemble also boasts flared denim pants – with leg openings measuring a staggering 28 inches each. This style of flared pants, or bell-bottoms, grew out of the counterculture movement, but the silhouette reached its full extreme in the fashion industry. In fact, as the style spread around the world during the 1970s, trade publications began warning about possible denim shortages because mills could not produce the textile fast enough to keep up with the demand for such large flares.[1]

1 Margarita Fichtner, "Demand For Blue Jeans Creates Denim Shortages" in *The Cincinnati Enquirer*, August 21, 1973; Mike Moore, "Denim supplies are real tight," *The Cleveland Press*, August 20, 1973; "The Jean Industry Nightmare," *Men's Week*, Los Angeles, January 1, 1973, all accessed in vol. 3, The Denim Council Papers, Fashion Institute of Technology | SUNY, FIT Library Special Collections and College Archives.

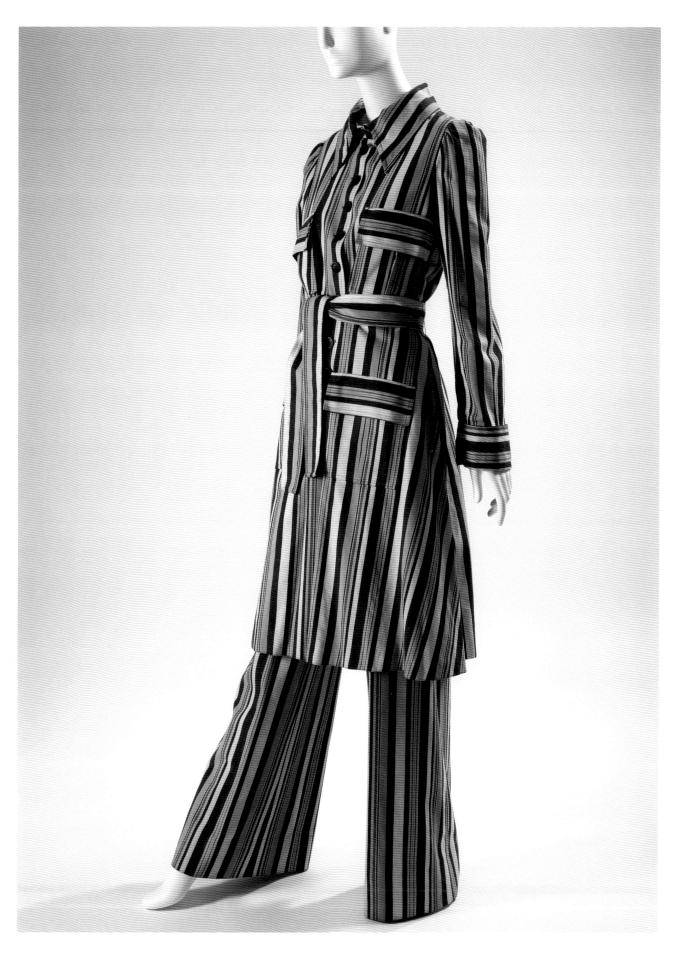

Yves Saint Laurent "Safari" jacket.
Blue denim,
ca.1970, France

- -

Yves Saint Laurent began introducing denim looks into his Rive Gauche ready-to-wear line during the late 1960s. He translated many of his signature styles into denim, such as this "safari" jacket, which typically would have been produced in a cotton khaki. Here, Saint Laurent swapped the khaki for denim but left many "safari" elements unchanged, including the front pockets and belted waistband. Saint Laurent also launched a line of satin jeans around this time that played on the model of the Levi's® classic five-pocket, riveted pant. Although Saint Laurent is remembered today more for his wildly extravagant haute couture collections, his love of denim and jeans was so well known by 1970 that the counterculture magazine *Rags* declared, "Levi Strauss with a French accent is Yves Saint Laurent."[1] Saint Laurent's fascination with denim was directly related to his interest in what young people were wearing on the street. As he declared at the time, "Fashion would be a sad business if all it did was put clothes on rich women."[2] For Saint Laurent, denim acted as a conduit between the worlds of high fashion and street style.

1 Mary Ann Crenshaw, "Levi Strauss with a French accent is Yves Saint Laurent," *Rags*, November, 1970, p.18–19, accessed in FIT's Special Collections Library.

2 Yves Saint Laurent, quoted in Pierre Bergé, "Yves Saint Laurent Ventures into the Social Arena," *Saint Laurent Rive Gauche: Fashion Revolution*. New York: Abrams, 2012, p. 9.

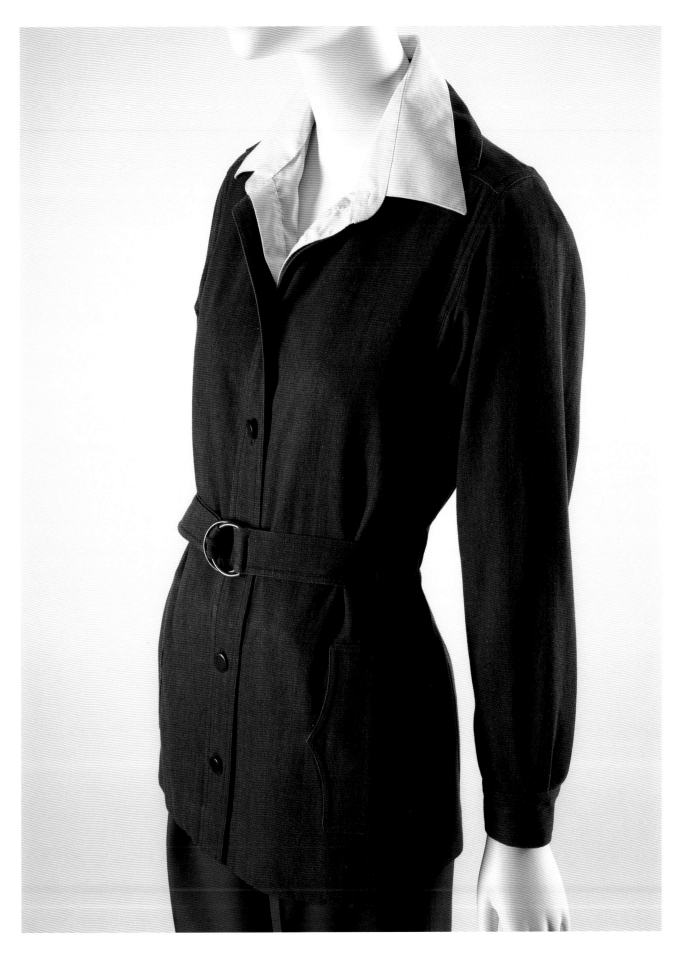

Raphael suit.
Blue denim,
ca. 1973, Italy

--

During the 1970s, denim made its debut as a popular suiting material. At the same time, the "leisure suit" also emerged as a fixture of the fashionable man's wardrobe. Leisure suits were characterized by their relaxed, elongated jackets, and they were often paired with flared pants. The all-denim leisure suit seen here is by designer Raphael, but it is a clear homage to Yves Saint Laurent's unisex safari suits and jackets. The unisex trend was an important development in fashion during the 1970s, and denim was probably the most popular unisex textile. Overall, the emergence of leisure suits and unisex dressing, as well as denim's migration from workwear into suiting, indicate the decade's increasing relaxation of traditional dress codes.

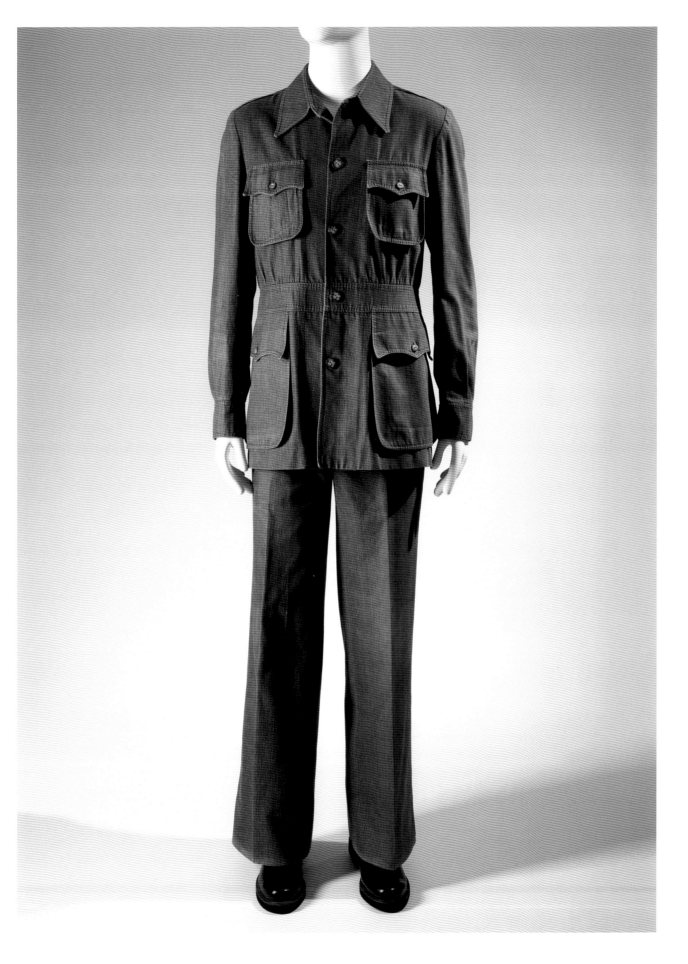

Man's swimsuit and woman's swimsuit.
Bleached and tie-dyed denim,
ca. 1973, USA

The trend for unisex styles and denim proliferated across every fashion category, including swimwear. Here are two bathing suits, one for a man and one for a woman, produced from a bleached denim and constructed to mimic a loincloth. The pre-washed treatment of the denim in both suits foreshadows the elaborate washing and bleaching treatments manufacturers would apply to denim in the decades to come.

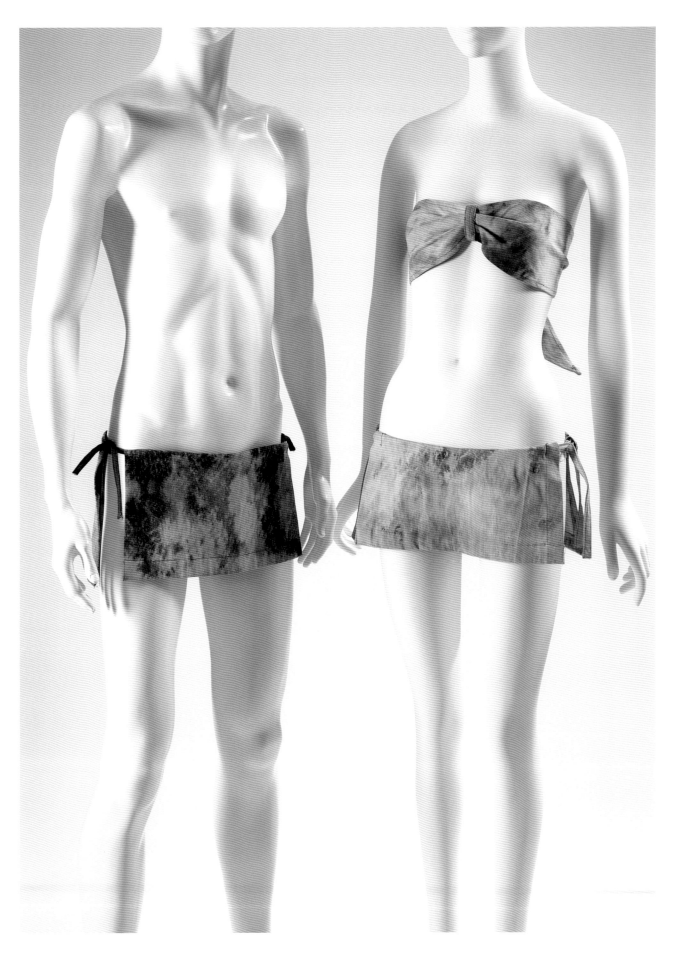

John Weitz suit.
Blue denim and red cotton,
Summer 1972, USA

As Cathy Horyn once observed, "If John Weitz wasn't the first American designer to make a big name for himself, he was certainly the most dashing…"[1] The former World War II spy, historian, novelist, and fashion designer had been working in womenswear and accessories for more than a decade by the time he launched his menswear line in the mid-1960s. As his reason for switching gears, Weitz said that he was "bored to tears" by what was on offer in the menswear industry.[2] He quickly garnered a reputation as an iconoclast for his experiments with color, workwear influences, and new cuts. Here, he created a man's leisure suit using denim and red bandana fabric in lieu of traditional suiting materials. The fusion of the two fabrics links the ensemble to the cowboy and "Old West" folklore surrounding them both, yet the leisure silhouette gives them a modern update.

1 Cathy Horyn, "Legacy; Growing up Weitz" in the *New York Times*, Feb 20, 2000, p. SM264.

2 John Weitz, quoted in Leonard Sloane, "Designer Decries Men's Styles" in the *New York Times*, November 2, 1965, p. 45.

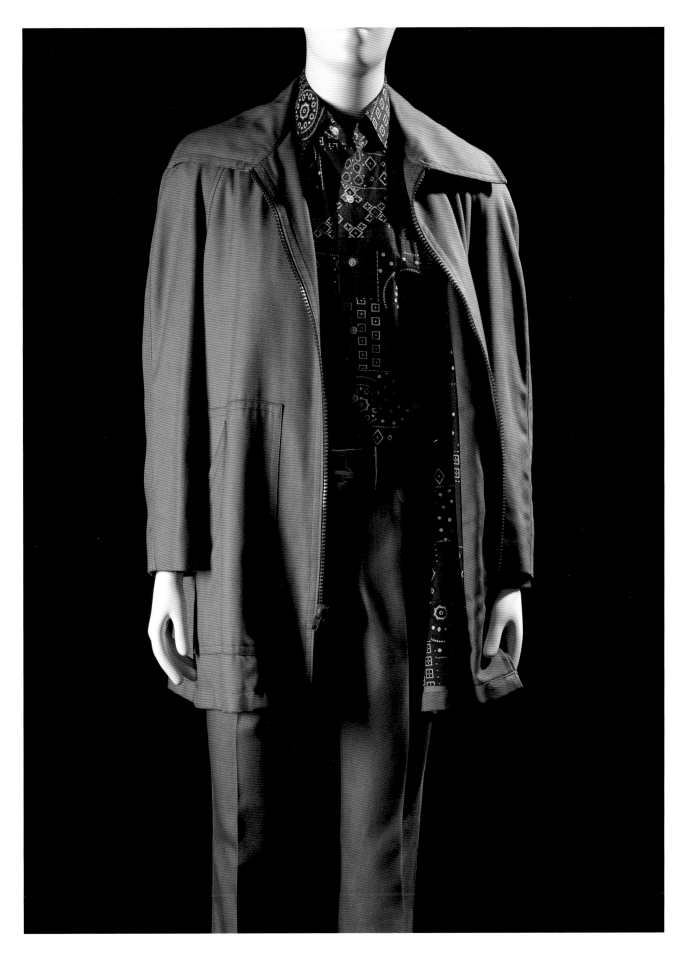

Faded Glory vest.
Blue denim,
ca. 1975, USA

--

Founded in 1972, Faded Glory was one of a number of new denim labels that hoped to capitalize on the growing market for stylized jeans. It set itself apart by offering a wider range of denim separates, which it sold at trendy boutiques around the country. Denim vests generally fall into one of two categories: Western wear styles, and "cut-offs." Western-wear-inspired vests, such as the one seen here, follow the silhouette of men's nineteenth-century waistcoats. Western wear as a clothing genre in general had developed during the earlier twentieth century out of fantasy-driven nostalgia for the nineteenth-century "Wild West" depicted in early Hollywood films. Such nineteenth-century inspired vests as this were a signature element of the Western wear wardrobe, but they were not exclusively rendered in blue denim – vests often appeared in suede and colored denim, heavily embellished with ornate embroidery and rhinestones. The renaissance of such styles during the 1970s grew in tandem with denim's mainstream popularity and a new generation of Hollywood "cowboy" stars that included Clint Eastwood, Steve McQueen, Paul Newman, and Robert Redford.

In contrast, the "cut-off" – or "battle jacket," as it is sometimes called – was first created by motorcycle gangs during the 1950s and 1960s. Gang members would make their own vests by literally cutting off the sleeves of denim jackets and then decorating them with patches, embroidery, chains, and the emblems of their groups. These garments represented acts of rebellion rather than nostalgia. During the 1970s, the original "punks" adopted the cut-off as part of their anti-fashion style, sometimes translating it into leather versions.

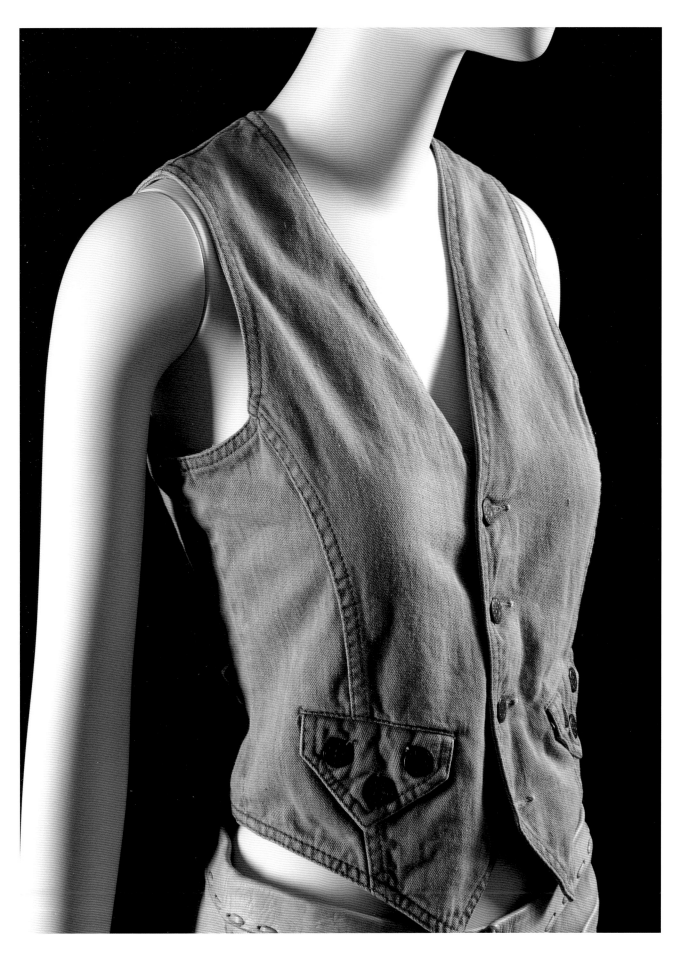

Wrangler "Flare Leg" jeans.
Multi-color printed denim,
ca. 1973, USA

During the 1970s, the "big three" of American heritage brands – Lee, Levi's®, and Wrangler – began abandoning their traditional product styles for a new wave of fashionable denim looks, such as these Wrangler "Flare Leg" jeans.

The Wrangler name was first put into wide use by Blue Bell Corp., when it purchased the name from its initial holder during the 1940s.[1] Wrangler soon became the moniker of Blue Bell Corp.'s line of "cowboy" styles, including the quintessential five-pocket jeans. These styles were marketed for rodeo riders, ranch hands, and suburban dwellers in search of "Old West" romance. Rendered in a bright red, white, and blue patchwork-print denim, these 1970s Wrangler's still include the signature "W" stitch work and leather label on the back pockets. These are the only traditional details that remain on the jeans to link them back to their "cowboy" predecessors. Otherwise, they are completely in line with the hip-hugging, flare-legged, and patchwork styles of the counterculture movement.

1 Graham Marsh and Paul Trynka, *Denim: From Cowboys to Catwalks*. London: Aurum Press Limited, 2002, p. 63.

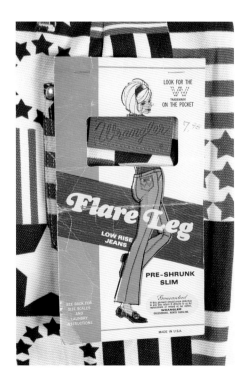

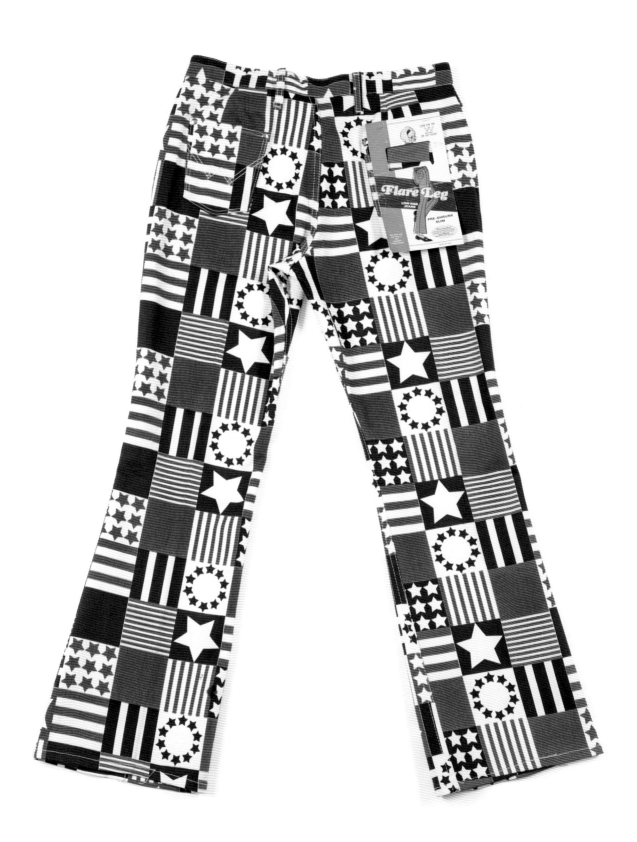

Levi Strauss & Co., "Movin' On" jeans.
Blue denim,
ca. 1976, USA

--

Just as Wrangler had developed a style of flared jeans to capitalize on the new denim market that emerged during the 1970s, Levi Strauss & Co. also introduced its own line of hip-hugging, flared jeans for men called "Movin' On." The new slim-fit, flared styles came in lighter blues and even colored denim. Instead of the signature Levi's® double-arches (or "arcuate") stitched on the back pockets, the "Movin' On" jeans came with a variety of decorative pocket styles. Many of the new jeans also had no metal rivets or leather label. Furthermore, the color of the Levi's® tab that had been affixed to all Levi's® products since 1936 was changed from red to orange for the new range. In 1980, the "Movin' On" line was made with a Lycra blend fabric to give it a closer fit, pushing the label even further away from its workwear roots.[1]

1 "Movin' On" advertisements, 1978–1981, accessed in the Levi Strauss & Co. archive, July 14–15, 2015.

Elio Fiorucci "Safety Jeans".
Black denim,
1979, Italy

Elio Fiorucci established his namesake brand in 1967. It began as a single boutique in Milan that sold a variety of products, but in 1970 he began concentrating on his own ready-to-wear line that specialized in denim pieces.[1] By 1979, Fiorucci had stores in London, New York, and Los Angeles, in addition to Milan, and his jeans retailed for around $50 (a staggering sum to pay for denim at the time).[2] Situated in key locations within each city, Fiorucci's boutiques became "hot spots" for fashion industry insiders, and his five-pocket "Safety Jeans" became *de rigeur* with the fashionable set at Studio 54. This particular pair was given to The Museum at FIT by former supermodel Naomi Sims.

The "Safety Jeans" style was a clear homage to the original five-pocket Levi's® model, down to the leather label on the back waistband – which even included an illustration of cowboys, referencing the famous Levi's® logo. The fit of the jeans highlighted the curves of the female body. They were high-rise and extremely tight, in line with the new, hyper-sexualized "European" styles pioneered by brands like Sasson, and New York boutique The French Jeans Store, in addition to Fiorucci. Fiorucci incorporated Lycra into his "Safety Jeans" during the early 1980s. They are often credited as being the first designer stretch jeans. Although Levi's® had done this with its "Movin' On" styles, Fiorucci's use of the technology marked a shift in the high fashion denim market. Fiorucci's work in denim paved the way for later Italian mega-brands, such as Diesel.

1 Alessandra Turra, "Italian Fashion World Mourns Elio Fiorucci," *Women's Wear Daily*, July 20, 2015.

2 Leslie Bennetts, "Blue Jeans Were Never Like This," *New York Times*, by Feb. 27, 1979, p. C10

Calvin Klein jeans.
Blue denim,
1979, USA

- -

In 1978, Calvin Klein introduced a line of "designer" jeans under his own name. The jeans themselves were relatively simple – dark wash, straight-leg, high-waisted, and *tight*, as was the dominant denim trend of the time. They also featured a distinctive stitch pattern on the back pockets, along with a "Calvin Klein" label that branded the jeans as a status symbol. According to Klein, he came up with the idea to start a jeans line while at the seminal 1970s nightclub Studio 54.[1] Skin-tight European jeans from companies like Fiorucci had become fixtures of the club scene, and in fact, Klein cited Fiorucci's jeans as an inspiration for his own line.[2] But while the jeans themselves were relatively simple, Calvin Klein's advertising campaigns were anything but.

Following the example of his European predecessors, Klein imbued his jeans with sex (when asked about his marketing approach, Klein himself famously declared, "Jeans are sex".[3]) Klein's most famous advertisements were shot by legendary fashion photographer Richard Avedon in 1980, and showed a 15-year-old Brooke Shields seductively sprawled across the page. The television commercials similarly showed Shields in a variety of seductive (verging on acrobatic) poses as she cooed phrases like "Reading is to the mind, what Calvins are to the body." In the most famous commercial, however, the camera pans up Shields' Calvin-clad legs as she whistles the tune of the American Western folk song "Oh My Darling, Clementine." Once the camera reaches her face, Shields stares out and says, "You want to know what comes between me and my Calvins? Nothing." The commercial was considered scandalous for insinuating that Shields was not wearing any underwear, and it was banned from several television networks.[4] Although hyper-sexualized, the Shields commercial builds on denim's Western tradition, essentially fusing the cowboy iconography of heritage brand jeans with the sexualized nature of the contemporary denim industry.

1 Calvin Klein, in interview for "The Mike Douglas Show" on CBS, 1979, in *Blue Gold*, film, directed by Christian D. Bruun (2015: New York: Light Cone Pictures).

2 Elio Fiorucci, quoted in *Blue Gold*, film, directed by Christian D. Bruun (2015: New York: Light Cone Pictures).

3 Calvin Klein, quoted in Graham Marsh and Paul Trynka, *Denim: From Cowboys to Catwalks*. London: Aurum Press Limited, 2002, p. 106.

4 "Sultry Jeans Ad Banned By WABC, WCBS-TV," *New York Times*, November 20, 1980, p. D1.

Calvin Klein Jeans advertisement featuring Brooke Shields, 1980. Photograph by Richard Avedon. © The Richard Avedon Foundation.

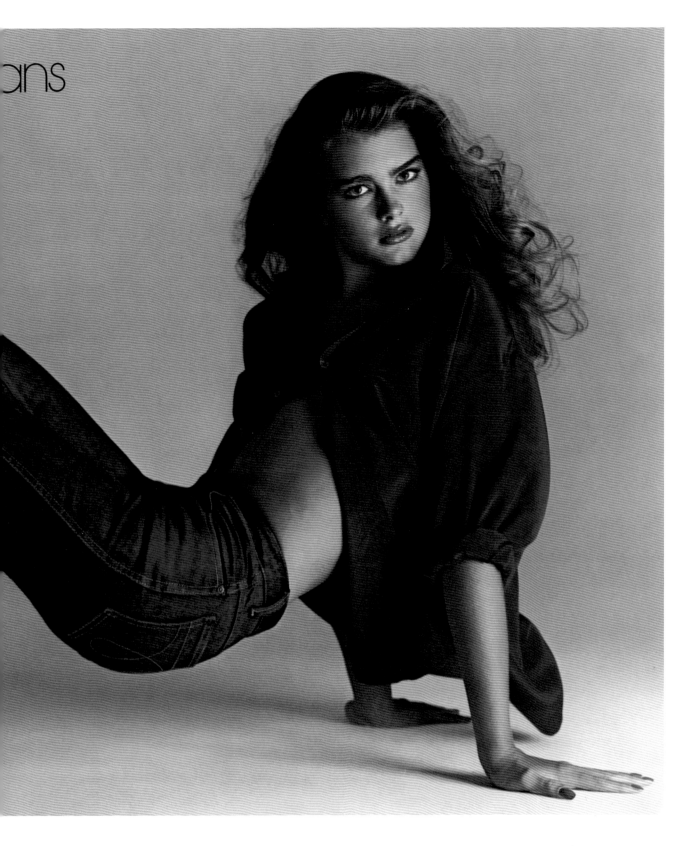

Jordache jeans.
Blue denim,
ca. 1979, USA

- -

Following on the booming success of the ultra-tight European styles and Calvin Klein's new "status jeans," the three Israeli brothers behind the company Jordache launched a special jeans line. Jordache jeans were dark with a straight-leg, high rise, and slim fit – similar to those of Fiorucci and Calvin Klein – and each pair was decorated with a distinctive back pocket design that would be immediately recognizable, making the "status" of the jeans even more obvious. Each of these patterns was meticulously trademarked to deter copyists. When it launched its jeans line, Jordache set aside 10 percent of its revenue for advertising (a huge sum at the time), acknowledging the importance of marketing in the designer jeans business.[1] Similar to Fiorucci and Klein, Jordache used the sexualized female body to sell their jeans. The company's signature commercials put their distinctive back-pocket designs (and the model's posterior) front-and-center. The first ad, set to a catchy jingle, depicted Jordache jeans as the ideal look for the fashionable woman to wear out to a bar, disco, or even at a fashion shoot (with many strategically angled shots focused on the model's backside). Jordache would run these commercials at least 30 times a week, and at the time that was a significant amount of exposure.[2] The commercials were so familiar that they (and the jingle) were spoofed by Gilda Radner in what has become one of Saturday Night Live's most famous skits.

1 Barbara Ettorre, "Status Jeans: Lucrative Craze," *New York Times*, June 25, 1979, p. D1.

2 Ibid.

Ralph Lauren "Prairie" ensemble.
Blue chambray, wool, painted leather, and metal, 1981, USA

One of Ralph Lauren's most profound impacts on the fashion industry was to relaunch interest for vintage Americana within the fashion industry. Before Lauren, the bastions of American workwear, from Levi's® to Wrangler, had turned away from their heritage roots to produce hip-hugging flares and European-style stretch jeans. Lauren was fascinated by America's own unique fashion legacy. He began collecting vintage pieces from companies like Levi's®, Lee, Eddie Bauer, and Pendleton when they were at their least fashionable, and only interested Japanese buyers. He also looked to early Western films, Native American culture, and historic imagery of the West for inspiration. This led to his famous "Prairie" collection of 1981. A look from the collection can be seen here. In the ensemble, we can see how Lauren integrated the classic vocabulary of the "Old West," such as the blue chambray dress, fringed leather gloves, and Navajo jewelry, but he has given the pieces an updated silhouette, in line with the oversized trend prevalent in early 1980s fashion. In stark contrast to the overtly sexualized advertisements of other denim purveyors at the time, Lauren set his models outside, in overgrown fields, seemingly against the background of an open plain – further aligning his collection with the romance of the "Old West."

Donna Karan ensemble.
Blue denim,
1986–1987, USA

Donna Karan first made a name for herself with her "seven easy pieces" collection in 1985. This collection was designed to give the working woman a fully coordinated wardrobe of (primarily black) separates that she could mix and match in a variety of different ensembles to wear through the work week. The ensemble shown here, though made in denim, falls perfectly within Karan's established lexicon of style. It features a blue denim skirt and blue denim body suit that, when worn with the skirt, resembles a man's button-front shirt. These styles could have been integrated into a coordinated Karan wardrobe to offer further options. The ensemble could also be considered a modern update to Claire McCardell's initial "Popover" dress from 1942, given the design's level of practicality, functionality, and style.

Moschino Jeans dress.
Black stretch denim,
ca. 1988, Italy

--

Italian designer Franco Moschino was known for his playful approach to fashion. Fashion was not merely about creating clothing, but facilitating a witty and sometimes flirtatious repartee between the wearer and his or her observers. The denim dress seen here from his "Moschino Jeans" line plays on the vocabulary of the traditional five-pocket jean with its dark denim fabric, top-stitching, and the inclusion of brass-finished snaps. The overall silhouette of the dress fits within key trends of 1980s fashion, complete with its body-conscious form and puffed sleeves. But the complex seam work across the entire dress, punctuated by prominent top-stitching, acts as its own form of embellishment, drawing the eye to the curves of the wearer's body. The sensual nature of this dress is further emphasized by two strategically placed brass snaps over pocket flaps on the wearer's bust. The dress becomes an embodiment of Calvin Klein's statement that "jeans are sex."[1]

1 Calvin Klein, quoted in Graham Marsh and Paul Trynka, *Denim: From Cowboys to Catwalks.* London: Aurum Press Limited, 2002, p. 106.

Vivienne Westwood jacket.
Blue-ribbed denim,
ca. 1984, England

- -

Vivienne Westwood has reigned as the unofficial queen of London counterculture for decades. She sold (and wore) ripped denim jeans and battle jackets in her groundbreaking boutiques that helped establish the punk movement of the 1970s. Therefore, it seems only natural that she would further experiment with denim when she transitioned her fashion collections to the runway. Although denim has appeared in Westwood's work many times, this particular example dates from the mid-1980s. Here, Westwood played on the construction of a Levi's® 507 jacket – but she redesigned and elongated the proportions in a disorienting way. For example, the patch pockets that would traditionally be placed over the wearer's chest have been enlarged and moved to the wearer's shoulders, almost like epaulettes. She has also used a denim that is woven like a corduroy, giving the jacket a rough texture.

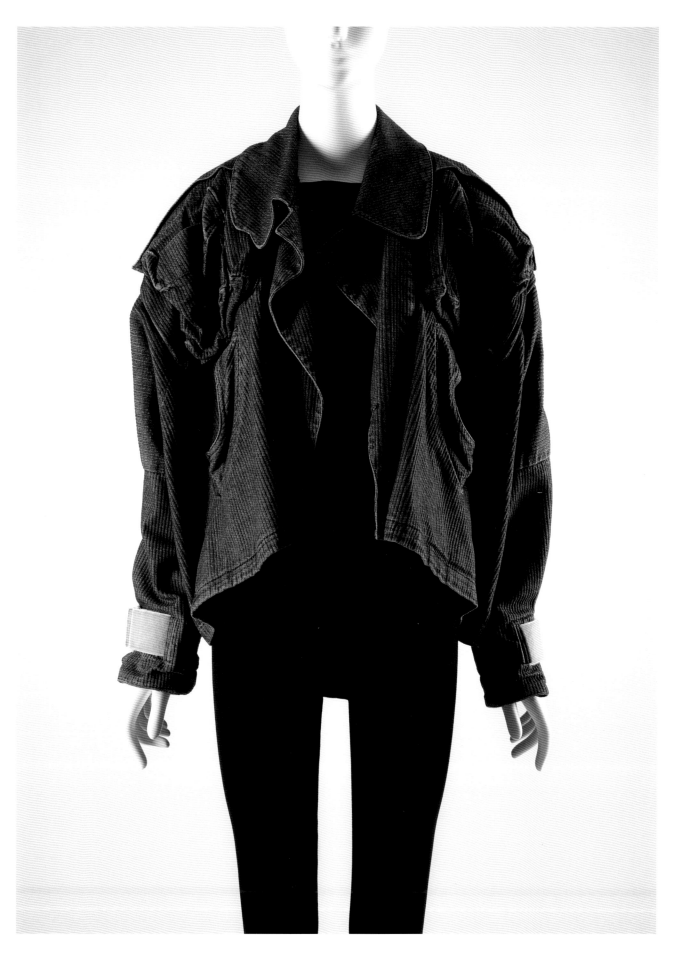

Marithé + François Girbaud jeans.
Stonewashed denim,
ca. 1985, France

Marithé Bachellerie and François Girbaud are often credited with bringing stonewashed jeans to the masses. Based in France, they first began experimenting with pre-washing jeans during the late 1960s. The goal was to pre-distress denim before selling it so that it would feel softer, as if it had been worn for years. The desire for pre-worn denim grew out of the hippies' penchant for buying pre-owned jeans at thrift stores and then wearing them to tatters. The Girbauds recognized that the average consumer did not have the patience to wait for jeans to fade and soften naturally. By developing a method of pre-distressing, they could market their jeans at a higher rate – and the stonewashed craze of the 1980s was born.

"Stonewashed" became a prime selling point for the Girbaud line, appearing on the company's labels. The Girbauds applied their experimental vision to the design of their jeans as well. Not content with simply reproducing the classic five-pocket style, the duo came up with the signature "X-pocket" seen in the pair of jeans here. The slashed front pockets form an X shape that intersects at the wearer's front fly (for all intents and purposes right at the crotch). Drawing further attention to that area, the Girbauds placed a diagonal label across the fly right at the point where the pockets intersect. The raunchy quality of the style earned the Girbauds a cult following.

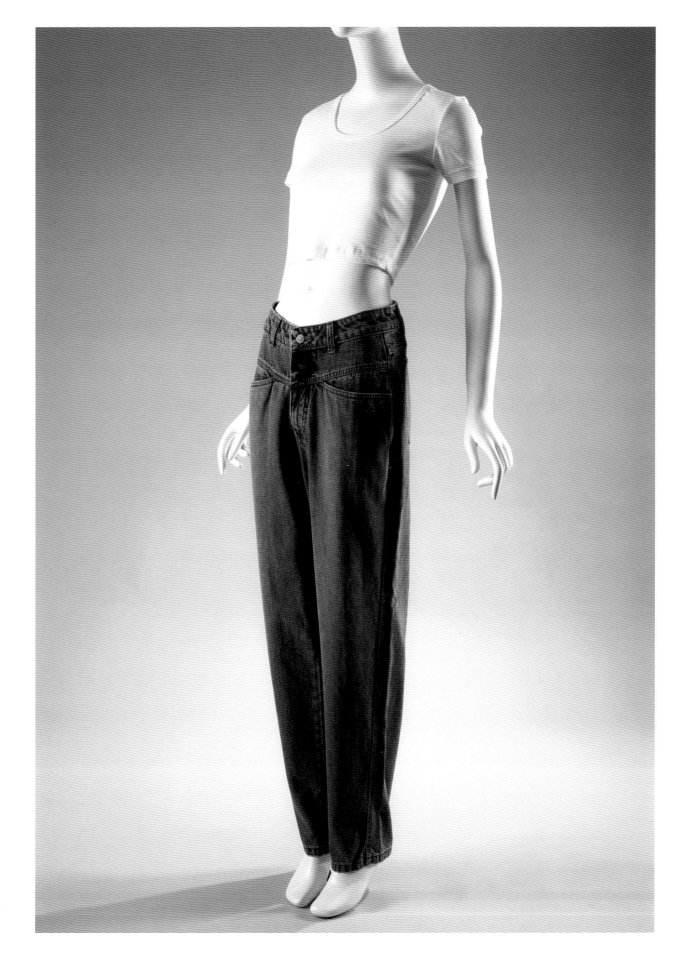

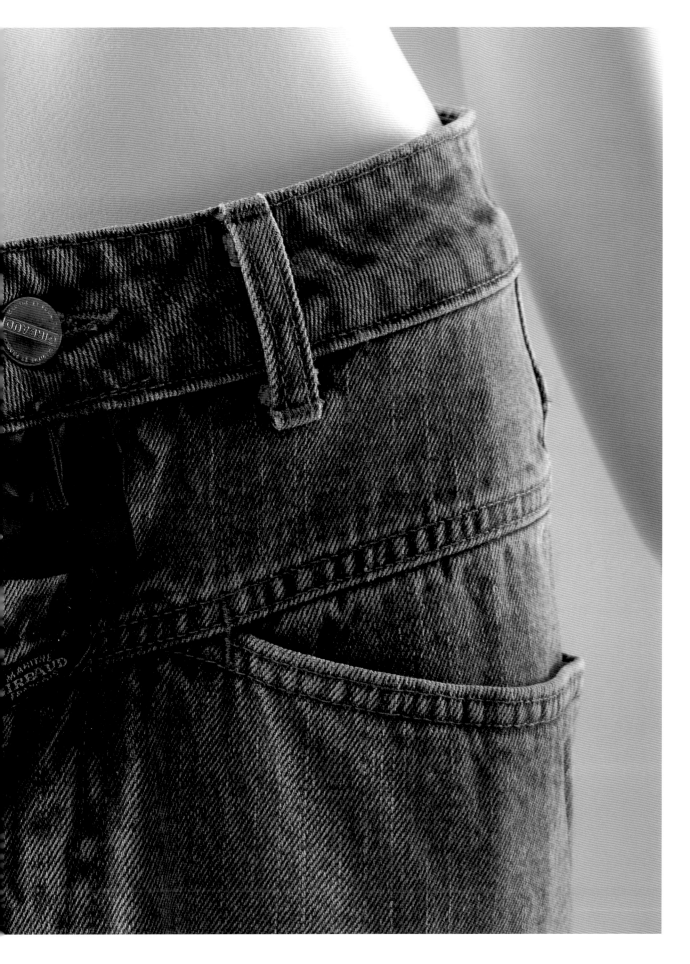

Guess? jeans.
Bleached and stonewashed denim, ca. 1986, USA

In the early 1980s, the four Marciano brothers moved from France to Los Angeles and established a new denim company – Guess? – that was an immediate hit. The Guess line started on a mere $100,000 investment, but by 1984 had ballooned into a nearly $160-million-business.[1] Recognizing the market for softer denim that felt as if it had been worn for years, Guess employed the same stonewashing techniques the Girbauds had used. Similar to the Girbauds' approach, Guess jeans were distinctive in their cut: high-waisted with tapering legs that sometimes got so tight toward the bottom that they required a side-zip at the ankle to get in and out. Guess also became known for its sexy advertising campaigns that would often play on references to Marilyn Monroe and "Old West" cowboy movies.

Guess introduced a variation on stonewashing that became another megatrend – acid-washing. In acid-washing, jeans are washed with the same type of stones, or pumice, as in stonewashing, but the stones have been presoaked in bleach to help break the fabric down even further. By the late 1980s, Guess was renowned for its signature seven-hour stonewash, which is now considered to be incredibly detrimental to the environment.[2] At the time, stonewashing and acid washing were in such high demand across the industry that other manufacturers (including heritage brands, such as Lee, Levi's®, and Wrangler) attempted their own versions, but the new experimental processes did not come without problems. As one executive told the *Wall Street Journal*, "When we first got into stone washing we said, 'What hath God wrought?'"[3] The stones, tire scraps, and golf balls that the company experimented with would destroy machines, and sometimes the jeans as well.

1 "It's all Guess? Work," *Women's Wear Daily*, March 1985, p. WY32.
2 Alix M. Freedman, "Jeans Makers Batter Denims into Tatters, Take a Beating Too," *Wall Street Journal*, 29 May, 1987, p. 1.
3 Eddie McMicken of Zena Jeans Inc., quoted in Freedman, p. 1.

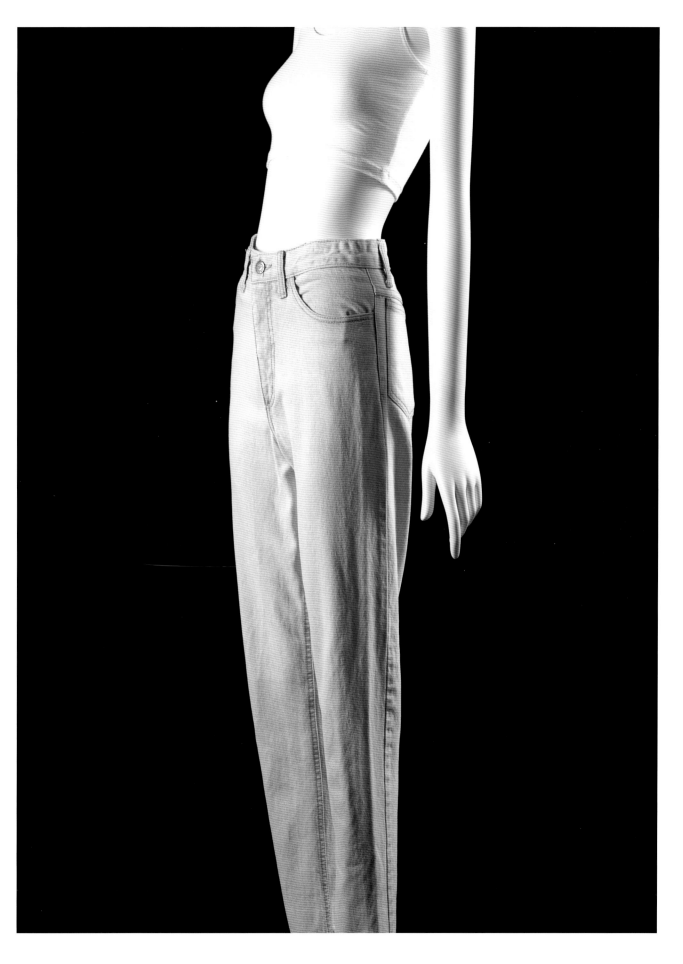

Kenzo Ensemble.
Repurposed Levi Strauss & Co. jacket
blue denim, appliqués, sequins, 1986, USA

- -

This embellished ensemble was made entirely from a Levi's® denim jacket. The designer Kenzo Takada created it for the November 1986 "Decorated Denim AIDS Benefit," which was held at Barney's Downtown in New York. The event featured a runway show with celebrity models – such as Madonna – showing off unique denim pieces created by various artists and designers. In addition to Kenzo, the list of participants included Andy Warhol, Jean-Michel Basquiat, and Karl Lagerfeld. Each was given a classic Levi's® jacket and told to turn it into something of their own. Kenzo took the man's workwear garment and entirely deconstructed it before reconstructing it into a sexy cropped top and ultra-mini skirt. Kenzo even went so far as to take off the long sleeves of the jacket and reform them into short, puffed, princess sleeves. The silhouette of this ensemble, its ostentatious decoration, and the deconstruction/reconstruction method used to create it link the look to the trends dominating high fashion during the mid-1980s.

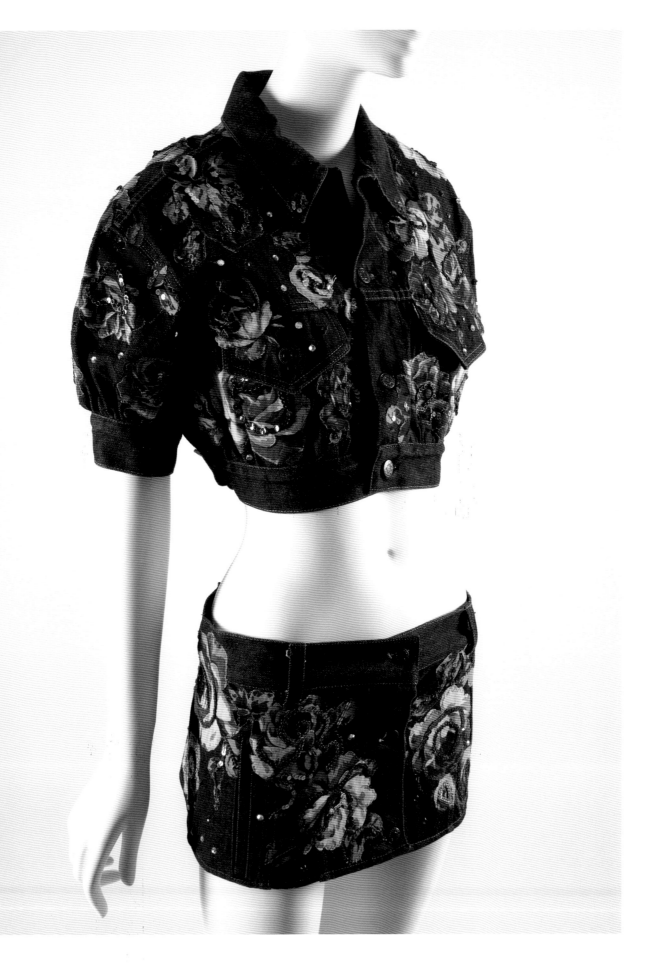

Shail Upadhya man's blazer.
Hand-painted denim,
1988, USA

- -

This jacket by Shail Upadhya clearly takes inspiration from the work of artist Keith Haring. Made in the late 1980s, it is one of Upadhya's earliest creations. Upadhya was probably best known as a fixture of the New York street style scene and Bill Cunningham's famed "On the Street" column in the *New York Times* until his death in 2013. However, it would be difficult to classify Upadhya as a fashion designer in the traditional sense – technically, he did not make any of his pieces himself, nor did he sell them to clients. Rather, he would "design" jackets and suits, like the one seen here, from painted canvas or denim to wear himself. He would do this by buying blank fabric, asking an artist to paint a design he described, and then have a tailor construct the physical garment. A United Nations diplomat, Upadhya did not start actively creating pieces until he retired from his post at the age of 58 in the late 1980s.[1] His work builds quite literally on the idea of denim as a blank canvas for self-expression, taking it to an extreme.

1 Alec Wilkinson, "Nice Pants" in *The New Yorker*, September 5, 2012, first accessed online July 1, 2016 via < http://www.newyorker.com/culture/culture-desk/nice-pants>

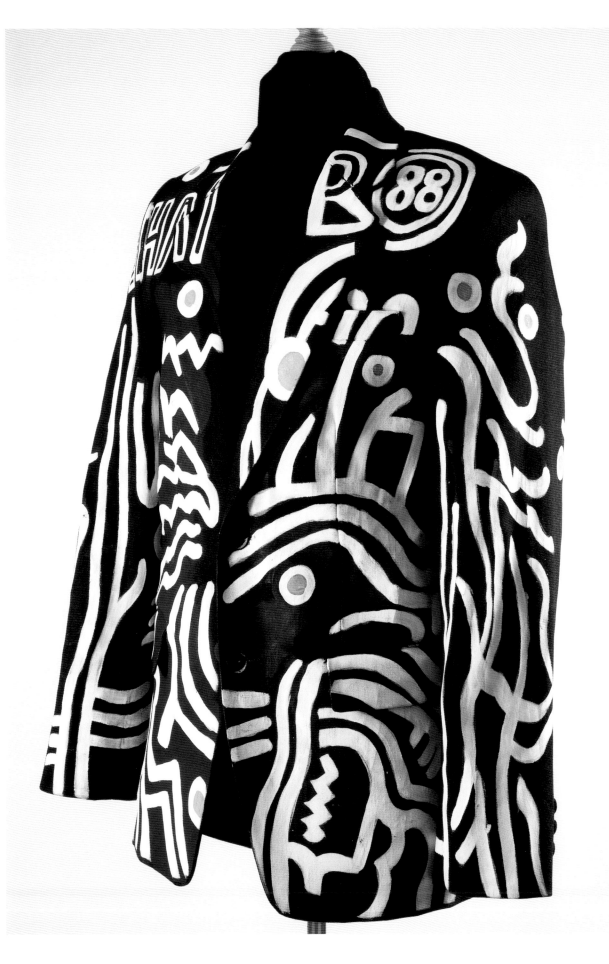

Nicola Bowery ensemble for
John Joseph Lydon (Johnny Rotten).
Repurposed jacket and jeans
Blue denim, paillettes, beads, 1989, USA

--

This ensemble was crafted by Nicola Bowery, wife of Leigh Bowery, for John Joseph Lydon (also known by his stage name "Johnny Rotten") to wear to the first Love Ball in 1989 – a gala benefit that brought New York's fashionable uptown set together with the downtown, underground party scene to raise money to fight AIDS. The event was characterized by the fantastical fashions worn by many of the guests. The ensemble seen here was made entirely from repurposed denim pieces by Levi's® and The Gap, covered in iridescent sequins, beads, and paillettes. It plays on the cut-off, or "battle jacket," of motorcycle gangs with a DIY denim vest that was made by cutting off the arms of a jacket. Taken in tandem with the repurposed Levi's® jacket by Kenzo and Shail Upadhya's painted jacket, this ensemble is representative of an approach to clothing in general, and denim in particular, as a medium of personal expression that proliferated in the street style and club culture of the 1980s.

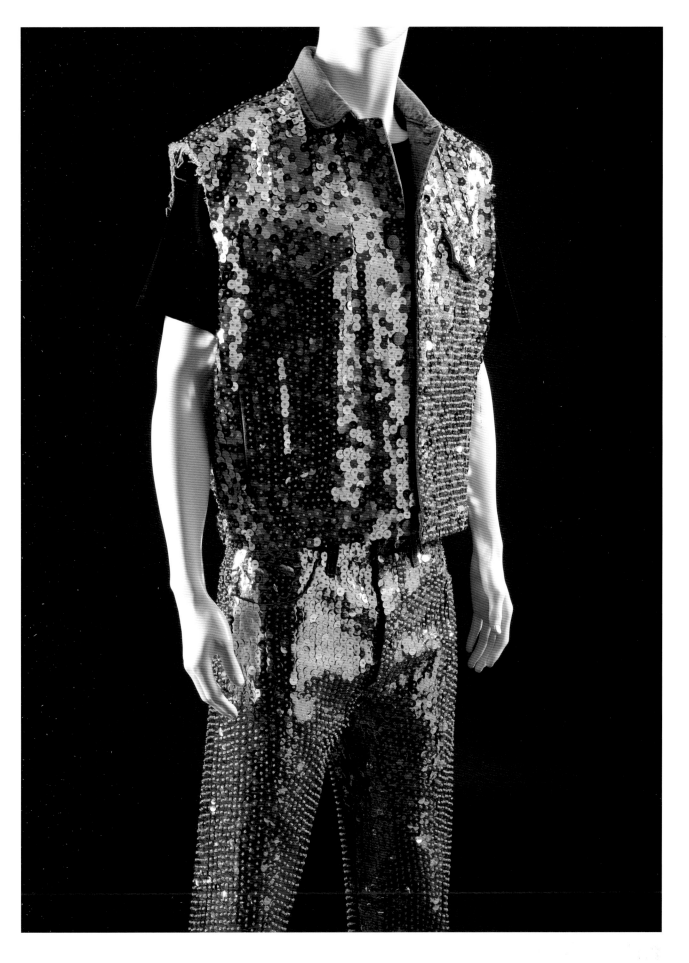

Exhaust ensemble.
Painted and shredded blue denim
and cotton, 1991, USA

This ensemble from the company Exhaust is an example of a "click suit"
worn by male members of the street-style subculture "Raggamuffins"
during the late 1980s and early 1990s. Fans of "Ragga" music, the
"Raggamuffins" emerged in Kingstown, Jamaica and their style spread
to hubs of Jamaican expatriates, such as those in New York and London,
and other parts of the world. "Ragga" formed from "Reggae" during the
1980s by keeping the same dancehall beat, but replacing the traditional
instruments with electronic music and infusing the lyrics with hip-hop
influences. The "Raggamuffins" developed a unique style of constructing
garments that combined a variety of textiles and techniques. Denim played
a particularly important role. As fashion historian Ted Polhemus explains,
"click suits" would be "made of an intricate patchwork of shredded or
stonewashed denim decorated with appliqué or rich brocade."[1] Exhaust
was one of the key brands that supplied this group. This example shows
the shredding technique, but it has been layered with scenic patches that
appear hand-painted.

[1] Ted Polhemus, *Street Style: From
Sidewalk to Catwalk*. London:
Thames and Hudson, 1994,
p. 109–110.

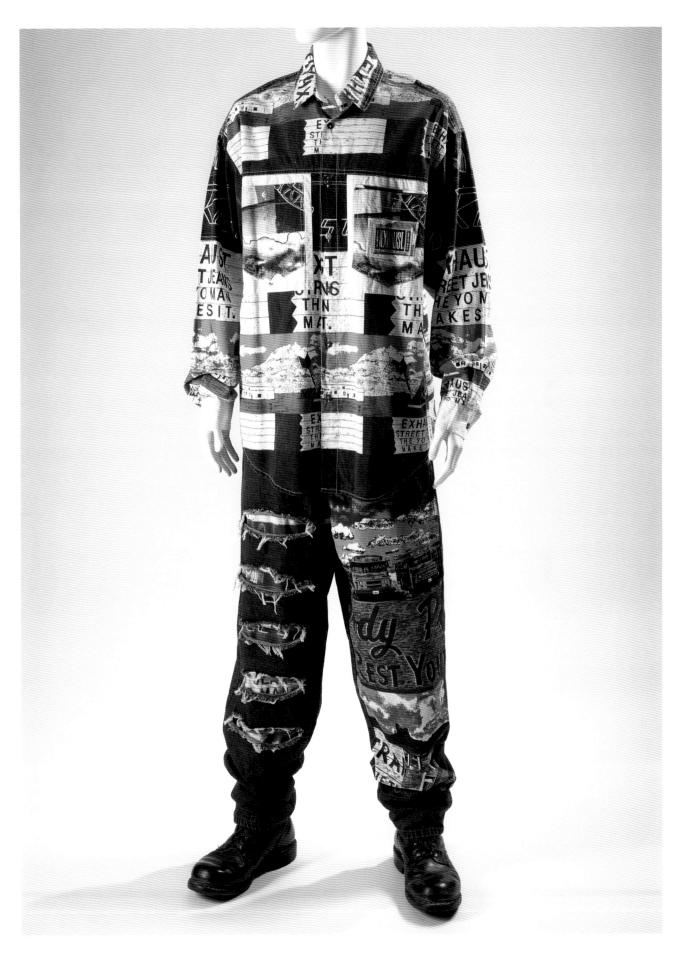

Moschino Jeans jeans.
Printed denim, early 1990s, Italy

Moschino Jeans sweatshirt.
Cotton, 1990, Italy

- -

"Logomania" was one of the biggest fashion trends of the 1990s. Brand names and logos made their way from interior labels to the outsides of garments as a form of embellishment. Moschino was known for using his designs to issue biting commentary on the fashion industry, and branding was a prime target. He caused a stir by embellishing pieces with phrases like "Signed Garment" and "Waist of Money."[1] Here we can see how the designer applied this approach to his "Jeans" line with the contrasting black and white columns of printed "MOSCHINO" logos that adorn these jeans. The printed columns create an ombré effect that mimics the distressing patterns and bleaching treatments typical of designer denim at the time. The "Moschino Jeanius" phrase on the sweatshirt also makes a self-aware play on logo T-shirts.

1 Rebecca Arnold, *Fashion, Desire and Anxiety: Image and Morality in the 20th Century.* London: I.B. Tauris & Co, Ltd, 2001, p. 1.

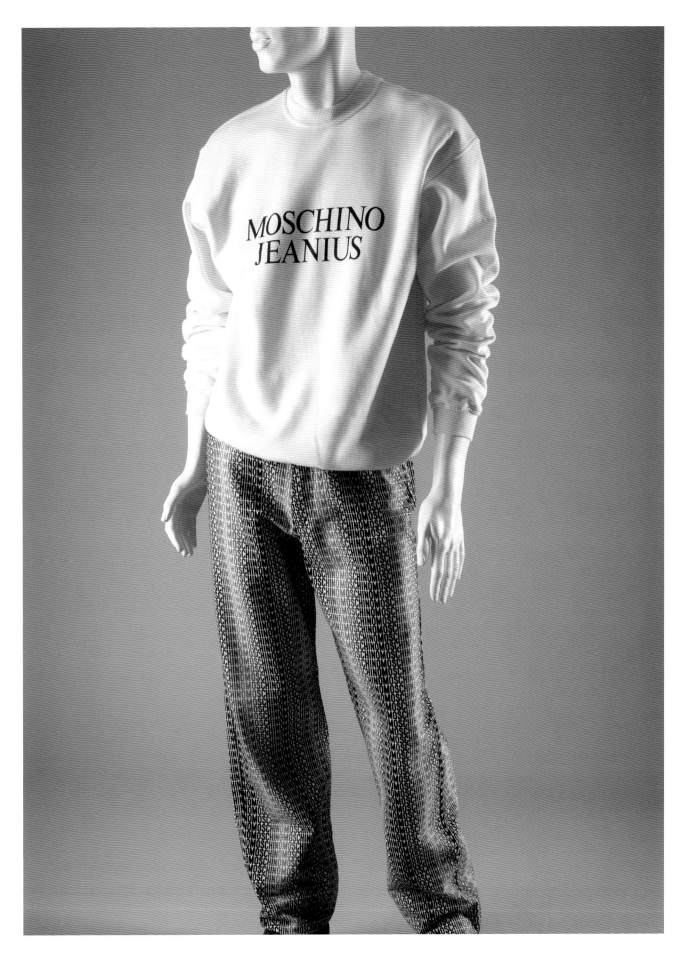

Studio D'Artisan "WWI Model" jeans.
Blue denim,
2015, Japan

--

Studio D'Artisan was founded in 1979 by Shigeharu Tagaki. It is the oldest brand of the "Osaka Five" – a group of denim companies (Studio D'Artisan, Evisu, Denime, Warehouse, Fullcount) from the Osaka region of Japan renowned for their faithful reproductions of historic denim garments, known as "new vintage." Levi's® is particularly revered within this circle as the ultimate jean manufacturer – it is the original, the most authentic, and, therefore, the most important to replicate. This interest in Levi's® can be seen in Studio D'Artisan's branding elements, such as the slanted play on the signature Levi's® "arcuate" back-pocket stitching, as well as the whimsical homage to the famous Levi's® leather label – here, two pigs pull apart a pair of jeans in place of the two Levi's® horses.

Of course, Studio D'Artisan's attention to authenticity goes deeper than the surface, to the physical structure of the fabric itself. The denim used in this pair of jeans was woven on a shuttle loom and features a red line along the selvedge – a trademark of Levi's 501® jeans before the 1960s – and they are a limited edition reproduction based on a pair of World War I-era Levi's®. They include such general historic details as the cinch-back strap, high-rise watch pocket, suspender buttons inside the waistband, and a rivet at the base of the fly. Studio D'Artisan's painstaking replication of the World War I original is even evident in the signs of rationing included in the garment, such as the use of mismatched metal rivets and buttons, as well as the fact that the slanted "arcuate" on the back pocket has been painted rather than stitched (thread would have been an important commodity during the war and could not be used purely for ornamentation). In this way, these jeans are simultaneously a product of the present Japanese denim industry and a meticulous preservation of past American denim.[1]

1 For further information on Studio D'Artisan please see: Philomena Keet, "Making New Vintage Jeans in Japan: Relocating Authenticity," *Textile*, vol. 9, issue 1, Oxford: Berg, 2011, p. 44–61; Kyle Robinson, "The History of the Osaka 5," *RAWR DENIM*, March 17, 2014, URL < http://www.rawrdenim.com/2014/03/history-osaka-5/>.

STUDIO D'ARTISAN & SA.
Precious Limited Edition Model
DESIGEN··ONLY·ORIGINAl
LAST GENERATION··DENIM O△X
SINCE COTTON 100% 1979
Every Time Interesting Brand
Lot WW1 MODEL S L

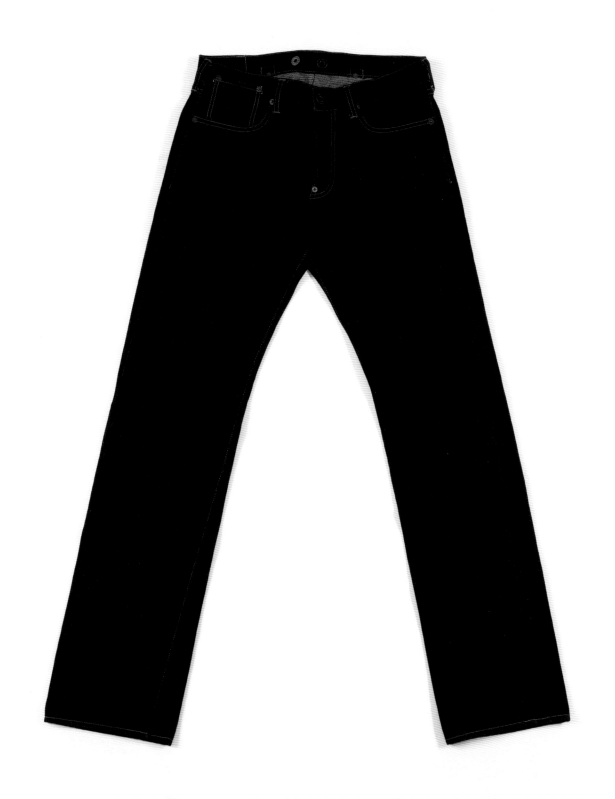

Jean Paul Gaultier, corset.
Blue denim,
ca. 1992, France

Street style and youth culture have always been important influences on French designer Jean Paul Gaultier. Therefore, it is not surprising that denim has often appeared on his runways – as fashion historian Ted Polhemus has pointed out, denim has "become the most ubiquitous street style garment."[1] In his work, Gaultier has reworked denim jackets and denim jeans, and used patchworked denim to created crinolated ball gowns. He has even used denim to fabricate a corset, as seen in the example here. Gaultier was one of the pioneers of the underwear-as-outerwear trend that took form during the 1980s, going so far as to adopt the figure of a girdle-clad female torso as his brand's emblem. He became a household name when he made Madonna's cone-shaped bras and bustiers for her "Blonde Ambition" tour. By fabricating the corset here in denim – complete with laces up the back – he has seamlessly fused the street style and erotica sides of his aesthetic.

1 Ted Polhemus, *Street Style: From Sidewalk to Catwalk*. London: Thames and Hudson, 1994, p. 24.

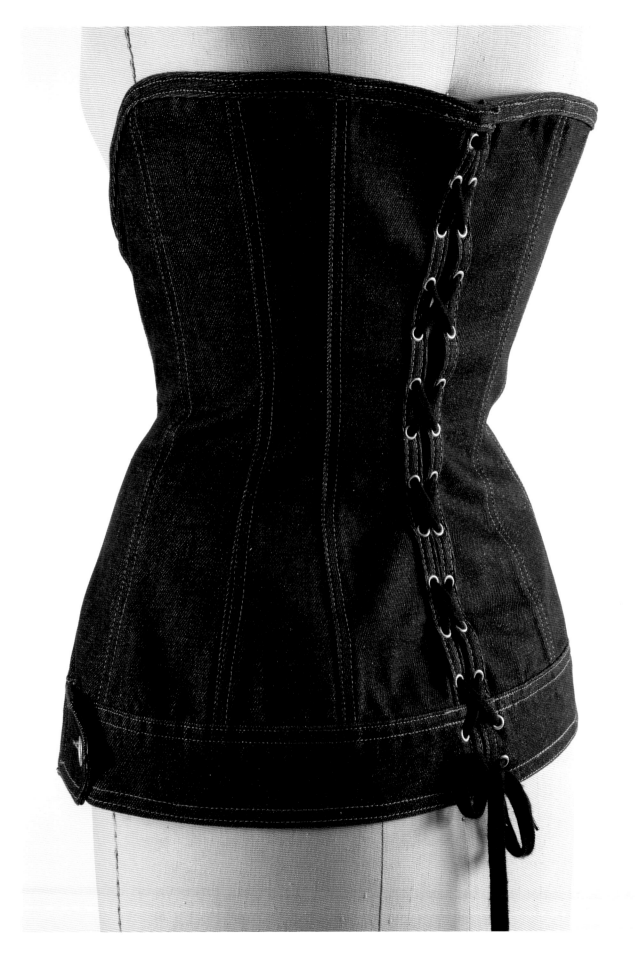

Diesel jeans.
Bleached and stonewashed denim,
ca. 1995, Italy

- -

Italian denim brand Diesel was first launched in 1978 by Renzo Rosso and Adriano Goldschmied. Today, Rosso owns 100% of the label and has created a holding company named Only The Brave, which owns majority stakes in European fashion houses Viktor & Rolf, Maison Martin Margiela, and Marni, making Diesel a denim-fashion empire. Diesel first made a name for itself during the 1980s and 1990s, selling jeans that looked and felt like vintage denim. The Diesel approach went beyond stonewashing and featured more obviously "distressed" details. In fact, Diesel is considered to be a pioneer of the now common practice of distressing denim and then selling it at premium prices.

Like the Japanese brands, Diesel revered Levi's 501® jeans as the ultimate vintage jean, which is reflected in the five-pocket, riveted styling of the "Modern Basic" model seen here, complete with a faux leather label on the back waistband. Diesel opened its first U.S. store in 1996, and by 1998 it was hailed as the "brand of the moment" by the *Wall Street Journal*. The same article described Diesel's innovative approach: "Diesel denim comes in exotic shades of blue and styles that would look at home on Austin Powers. Some Diesel outfits are futuristic and shiny enough to look suitable on the cast of Star Trek…Metal is an ingredient of one Diesel fabric."[1] This pair dates from around the same time in the 1990s, when Diesel was at the height of its popularity, and features an unconventional finish. The jeans have been stonewashed and then bleached, but the bleach patterns cover the entirety of the pants, apart from patches along the top and back of the thighs and the base of the back pockets. In effect, this reverses the typical look of wear patterns on jeans where faded patches are often added to the top of the thighs and around the wearer's posterior. This finish highlights Diesel's playful approach. The result is bold and graphic.

1 Kevin Helliker, "Diesel Is the Label of the Moment, but Not Everyone Can Afford It," *The Wall Street Journal*, December 9, 1998.

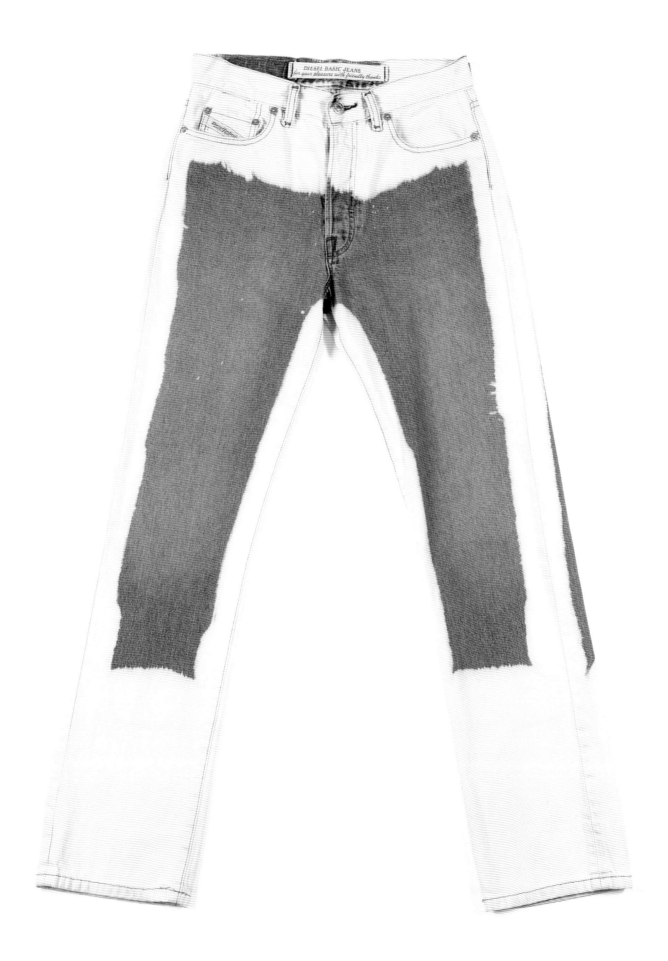

Tommy Hilfiger man's ensemble.
Black denim, cotton, nylon,
1999, USA

--

Designer Tommy Hilfiger has worked with denim since the start of his career. In fact, his first foray into fashion was in 1969 as one of the founders of a boutique called People's Place, which specialized in counterculture products, particularly denim jeans. More than twenty years later, his eponymous denim line became a household name from its association with a different counterculture movement – hip-hop music. As hip-hop began to take over the American music industry during the early 1990s, Hilfiger enjoyed tremendous success from the exposure many of hip-hop's most prominent artists gave to his label. Raekwon of Wu-Tang Clan and Snoop Doggy Dogg are just a couple of the figures who were known for sporting oversized "Tommy" or "H" logo T-shirts and sweatshirts paired with oversized Tommy brand jeans that sagged around the hips. With hip-hop's absorption into mainstream culture, "sagging" jeans became a hotly debated topic. The "sagging" trend was so named for the way primarily male members of the hip-hop community wore their jeans oversized with the waistband tightened low around their hips, exposing the tops of their underwear. Although the exact origins of this style remain a topic of debate, "sagging" became heavily associated with prison and gang culture, and remains so today. In recent years, counties in Florida and New Jersey have successfully outlawed the style, with fines ranging from $50 to $500 for wearing jeans in the "sagging" fashion.[1]

1 Gene Demby, "Sagging Pants And The Long History of 'Dangerous' Street Fashion" for National Public Radio (NPR), September 11, 2014, accessed online on July 18, 2015 via < http://www.npr.org/sections/codeswitch/2014/09/11/347143588/sagging-pants-and-the-long-history-of-dangerous-street-fashion>

A "Stop the Sag!" billboard as seen on the side of a building on Sterling Place and Franklin Avenue in Brooklyn, New York in April, 2010, bearing a message from the New York State Senator Eric Adams asking people to stop wearing their pants sagging below their waistline. (AP Photo/Robert Mecea)

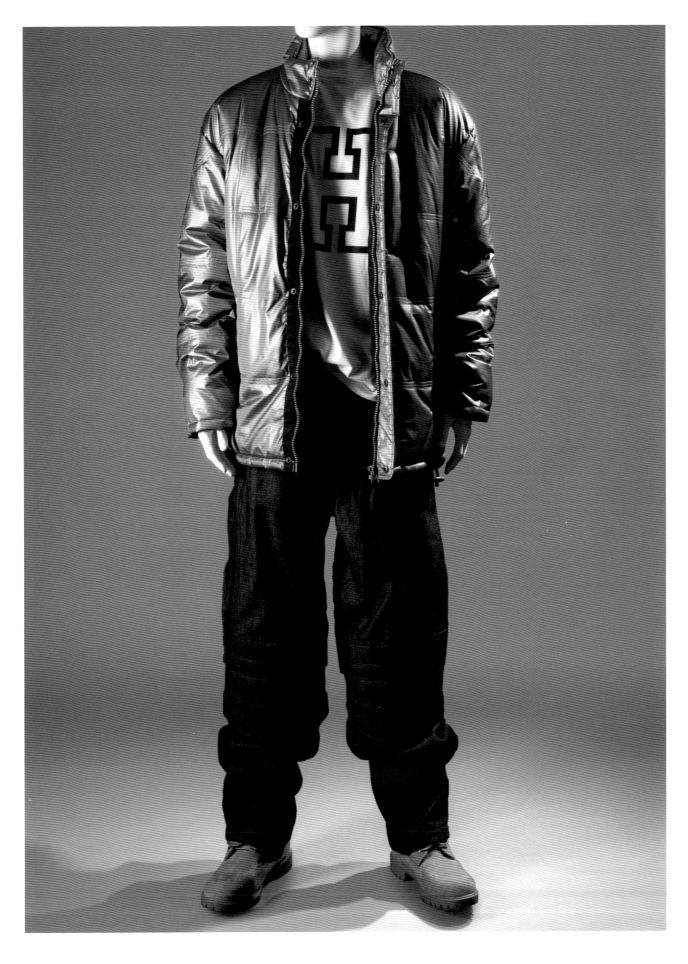

Claude Sabbah man's ensemble.
Embroidered blue denim and cotton,
2000, USA

--

New York-based designer Claude Sabbah became known during the late 1990s and early 2000s for outfitting hip-hop artists such as Lil' Kim, Eve, and Eminem. His unique designs pulled references from street style, military uniforms, and the dress of his native Morocco. For the ensemble here, Sabbah embroidered a pair of baggy, sagging jeans with a white motif reminiscent of the stars on the American flag. A bungee cord has also been threaded through the cuff of each pant leg in order to cinch it – an element taken directly from the style of jeans worn by skater kids and ravers of the time. To complete the look, Sabbah paired the jeans with a top adapted directly from the design of a bulletproof vest. Styled in this way, the ensemble has an immediate political charge. Eminem was photographed wearing a similar look in *Hip-Hop Connection* magazine in 2000.

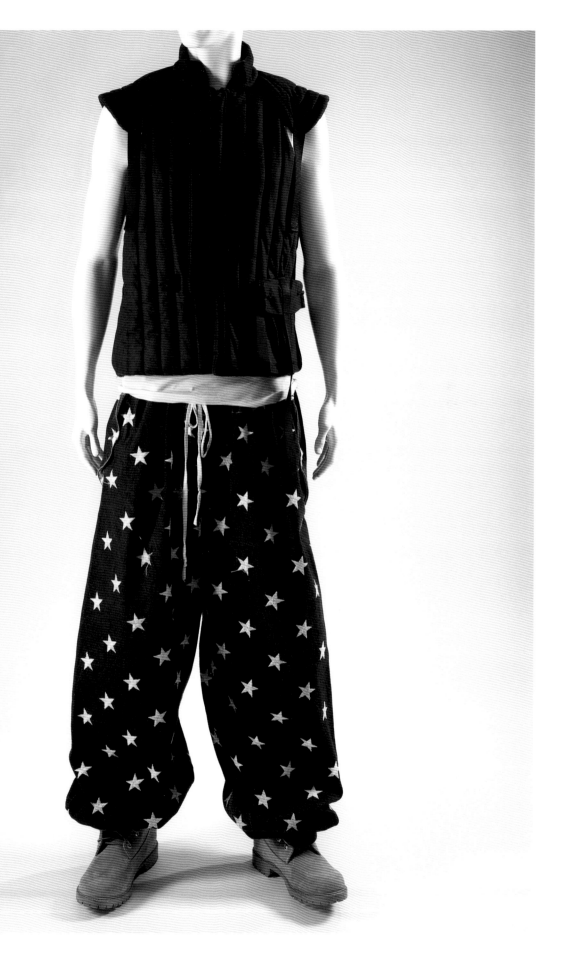

Levi Strauss & Co. "Engineered" jeans, loose-fit model.
Blue denim, 2000, USA

During the 1990s, Levi Strauss & Co. attempted to capitalize on the hip-hop denim market dominated by companies like Tommy Hilfiger and FUBU. The company unveiled new styles of wide-leg or "loose fit" jeans, and developed a new advertising campaign specifically targeting this market. As in the style seen here, some of the new models revived the cinch-back strap at the waistband from the early twentieth century – presumably to make sagging the pants around the hips a little easier.

Levi's® continued these styles into the "Engineered" line it unveiled in 1999. The new "Engineered" styles were the company's attempt at redefining the riveted five-pocket jean it had pioneered more than a century earlier. The goal of the line was to create a jean that was ergonomically designed to accommodate the movements and lifestyle of the modern consumer. Some of the modifications included changing the construction of the legs to give a greater range of motion, altering the placement of the back pockets to give better access, and enlarging the watch pocket so that wearers could store pagers and cellphones.[1] Also, the back yoke was removed, along with the signature leather label. Levi's® released "engineered" versions of many of its styles, including the "loose fit" model seen here. While the range pushed the denim market in a new direction, ultimately the "Engineered" jeans produced by Levi's® "never quite caught on with U.S. shoppers" as reported by *Women's Wear Daily*, and the company refocused its brand around heritage elements.[2]

1 Miles Socha, "Debating Levi's Big New Look," *Women's Wear Daily*, August 19, 1999, pp. 6–7.

2 Scott Malone, "Levi's at 150: Evolution of An Icon," *Women's Wear Daily*, May 1, 2003, pp. 10–11.

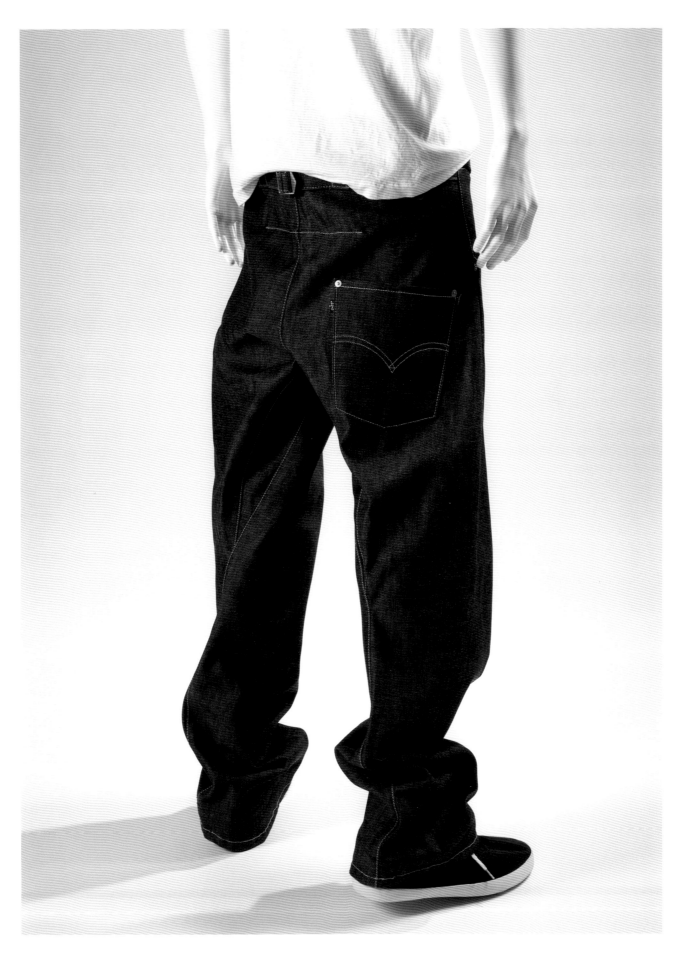

Katharine Hamnett ensemble.
Blue denim and leather,
Spring 1997, England

- -

Katharine Hamnett rose to prominence during the mid-1980s by using clothing as a platform for social commentary. Her collections would combine anti-nuclear T-shirts with playfully embellished and ripped denim. Indeed, denim was a key element of her line from its inception. In 1984, her shredded and distressed denim looks caused a sensation, but in this later ensemble from Spring 1997, the denim now has a sleek, tailored finish. For this collection Hamnett played with seductive lingerie fabrics and body-revealing styles, such as hot pants, bandeau tops, and cropped tops, combining them with menswear elements, including the blazer and fedora seen here.

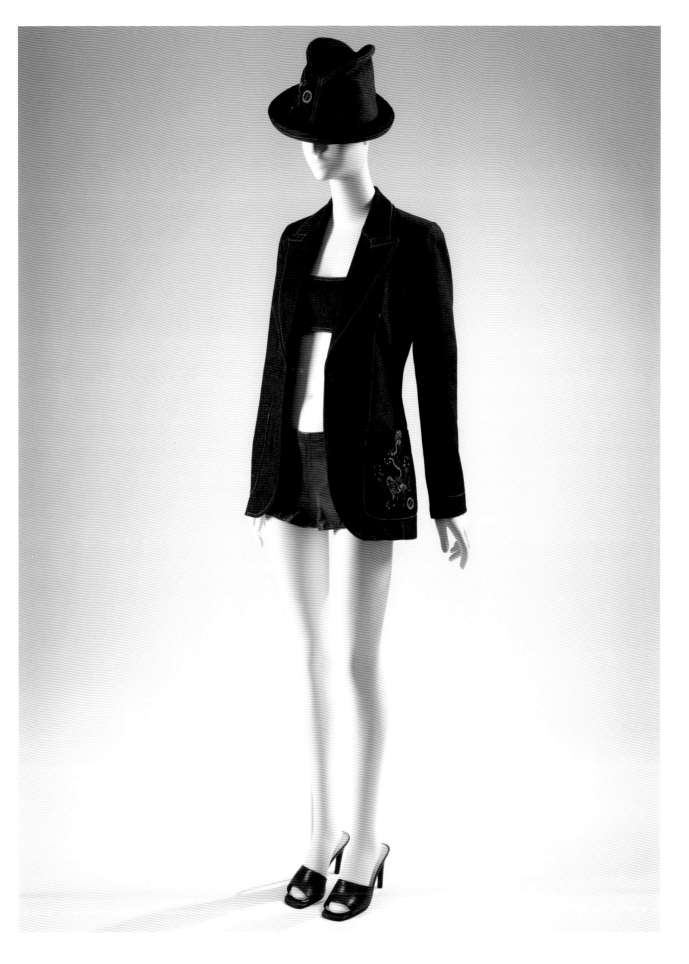

Gianfranco Ferré ensemble.
Dark blue silk,
Spring 1999, Italy

This ensemble from Italian designer Gianfranco Ferré mimics the look of denim, but it is made entirely from a luxurious silk. Ferré has created this illusion by using a silk that blends dark blue and white threads. He has also included orange-yellow topstitching along the seams throughout the ensemble – a design feature Levi Strauss & Co. pioneered on its riveted jeans during the late nineteenth century. Ferré was known as "L'architetto della moda" (or "the architect of fashion") for the way he applied his formal architectural training to clothing.[1] He became renowned for his bold suits accentuated by unique details, particularly in the seam work.

1 Patricia Mears, "Gianfranco Ferré," *Fashion A–Z: The Collection of the Museum at FIT*, New York: Taschen, 2013, p. 229.

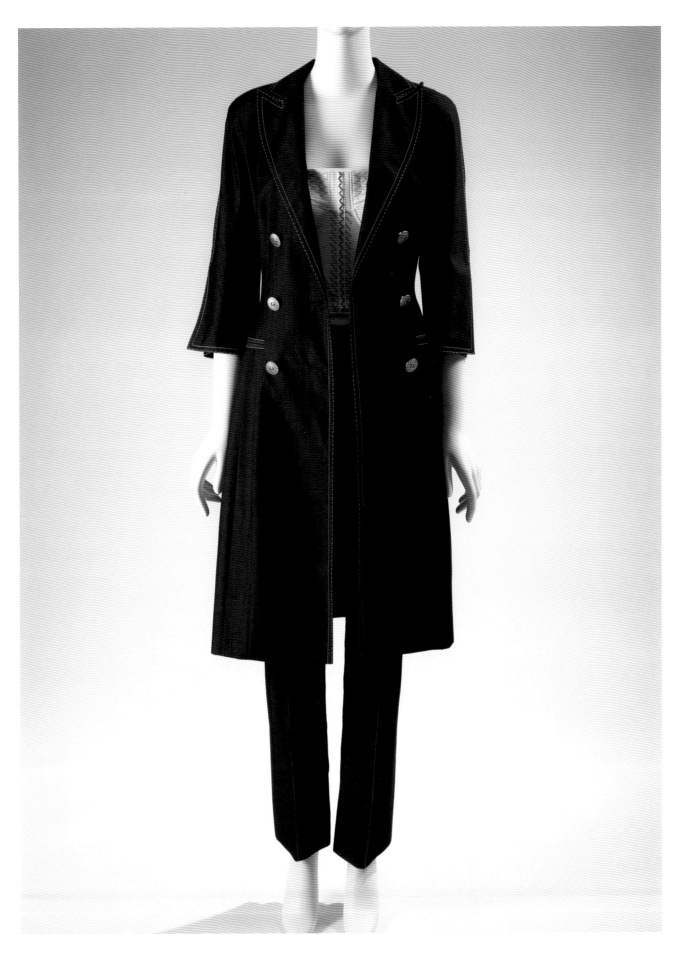

Gucci (Tom Ford) ensemble.
Blue denim, feathers, beads, and cotton jersey, Spring 1999, Italy

In 1998 Tom Ford showed this pair of jeans on the runway as part of his Spring 1999 collection for Italian luxury brand Gucci. Ford built the entire collection around references to the 1960s counterculture movement. In keeping with this theme, he had the jeans distressed with rips and tears and adorned with beads along the pockets. He also added over six inches of feathers around the hem of each pant leg. When these feathered jeans reached stores they carried a price tag of up to $3,800,[1] which stunned customers and industry insiders alike. More shocking, however, was that the first shipment of the jeans sold out before they even reached the stores. As the *New York Times* declared, "The absolute fetish for spring is…a pair of faded, feathered, beaded and hole-ridden hip-hugger jeans…Denim by Gucci is the cure for whatever ails the fashion elite."[2] The article goes on to describe the sheer frenzy to obtain these jeans, and the struggle one had to endure to locate and order a pair – even for celebrities, such as Lauryn Hill and Madonna, as well as department directors at Sotheby's. Such stories of impossible-to-get-items are more commonly associated with "It" bags and shoes today, but with Tom Ford, jeans officially arrived as a true luxury item.

1 Miles Socha, "Gucci: The Hole Truth," *Women's Wear Daily*, February 25, 1999, p. 12.

2 Penelope Green, "Jean Therapy: The Haves," *New York Times*, Feb 21, 1999, p. FT60.

[facing page] Runway shot of Gucci by Tom Ford, ensemble, denim, feathers, beads, cotton jersey, Spring 1999, Italy. The Museum at FIT 2015.7.1, Gift of Gucci.

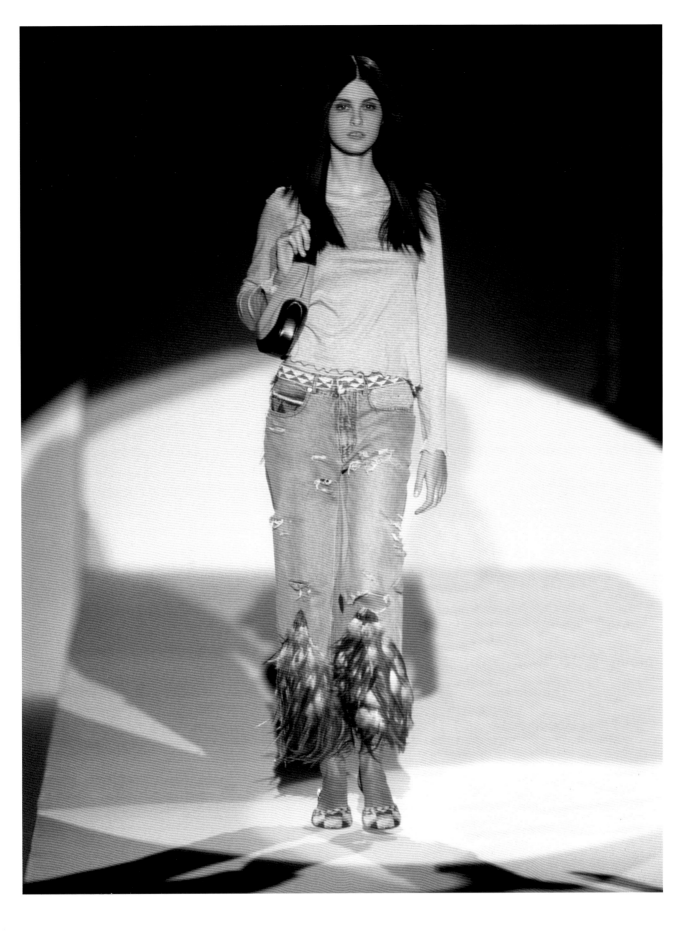

7 For All Mankind "bootcut" jeans.
Blue denim,
ca. 2004, USA

--

While Tom Ford's feathered jeans stood out as an extreme, a new group of denim companies established a broader market for "premium" jeans during the early 2000s. This new category was pioneered by the company 7 For All Mankind (7FAM), which was founded in 2001 and became a household name when its jeans surpassed the $100 price-tag threshold.[1] When 7FAM first launched, the company only made one style of jeans – bootcut for women – recognizable by the distinctive stitching on the back pocket, pinstripe down the center calf, and two cloth tabs precisely positioned on the rear pocket and waistband. The jeans also contained stretch fibers for better fit and comfort. 7FAM now offers a wide variety of denim styles for men, women, and children, demonstrating how quickly the premium market has expanded. 7FAM's jeans are made entirely in Los Angeles, down to the hand distressing of each pair. The company's growth has helped to position Los Angeles as one of the world's most important denim hubs, and its success has spawned countless spinoffs. One of the company's original founders left to start his own company – Citizens of Humanity – in 2003. Likewise, 7FAM's original fit model, Paige Adams-Geller, went on to create her own eponymous denim label – Paige Premium.

1. Guy Trebay, "No Small Price to Pay for Denim Perfection," *New York Times*, April 27, 2004, p. B8.

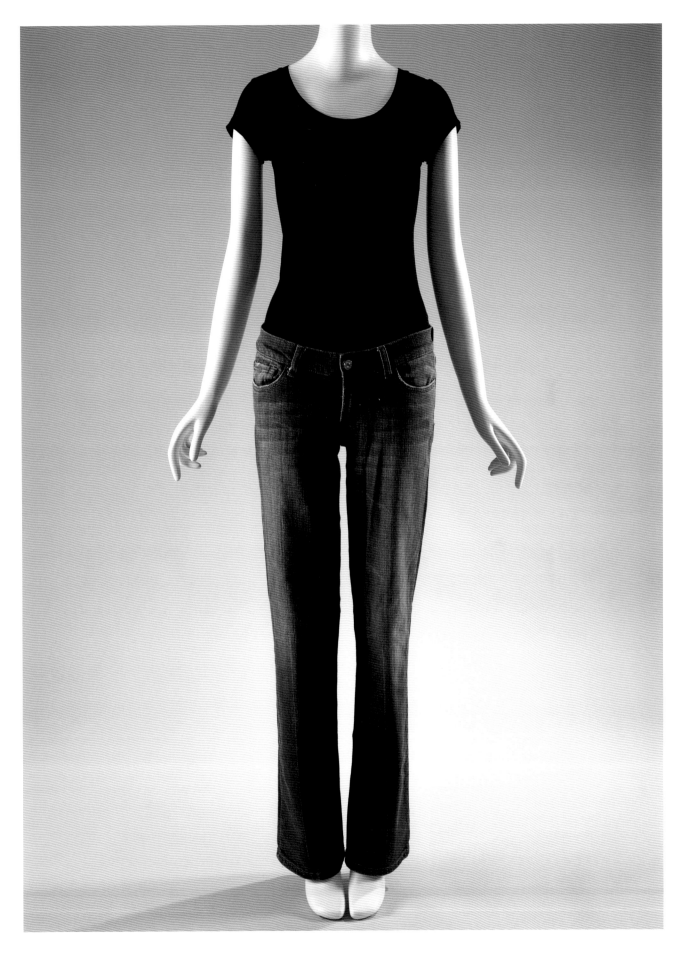

Roberto Cavalli ensemble.
Embroidered blue denim and silk,
2002–2003, Italy

The design of this coat mimics an eighteenth-century man's cut-away coat in both its overall silhouette and the elaborate floral embroidery that encircles its edges. By rendering the look in a faded denim and pairing it with a matching embroidered denim mini skirt and seductive bustier, Roberto Cavalli created a look perfectly in line with the high-low opulence of the early 2000s. Called the "King of Sex" by *Women's Wear Daily*, Cavalli had been working in fashion since the late 1960s, but he did not gain international fame until the start of the twenty-first century.[1] Between 2000 and 2003, Cavalli's U.S. sales boomed, going from $2 million to $40 million.[2] This is thanks to the shift in high fashion's dominant aesthetic from the minimalism of the 1990s to the sex-charged excess of the early 2000s. For his Spring 2003 collection, Cavalli used the bustier as a central theme to build seductive homages to different historical and exotic silhouettes – each with his signature blend of sexy, and sometimes unlikely, tweaks.

1 Alessandra Ilari, "Movers And Shakers: Cavalli's Cavalcade" in *Women's Wear Daily* supplement *WWD The Magazine*, November 2002, p. 104.

2 Ibid.

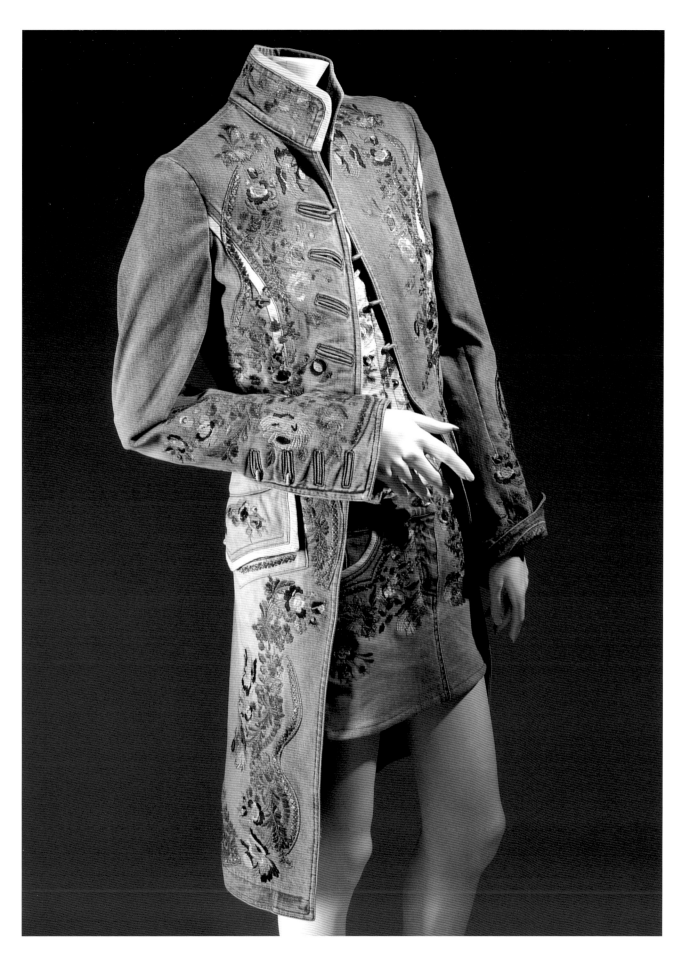

Junya Watanabe dress.
Repurposed blue denim jeans,
Spring 2002, Japan

--

This dress has been crafted entirely from pre-owned denim blue jeans. For Spring 2002, this dress and other denim creations formed the centerpiece of Japanese designer Junya Watanabe's 1970s-themed collection. While the dress here clearly draws on the hippies' use of repurposed denim, in the words of *Women's Wear Daily*, "[T]his was not the same-old, same-old hippie chick procession we have seen ad naseum."[1] This was a unique exploration into the fashion methodologies established by the counterculture of 1970s America. Watanabe fully immersed his models in the vocabulary of the hippie aesthetic, from faded and patched denim to floral peasant blouses, but in each look he expanded on the style with feats of construction. For this dress, the repurposed jeans have been draped and reconstructed so that the top-stitching of the jeans' seams forms a sweeping, swirled effect around the wearer's torso that mimics the look of a nineteenth-century boned bodice.

1 "Bow Regard: Frills and Thrills" in *Women's Wear Daily*, October 9, 2001, pp. 4–9.

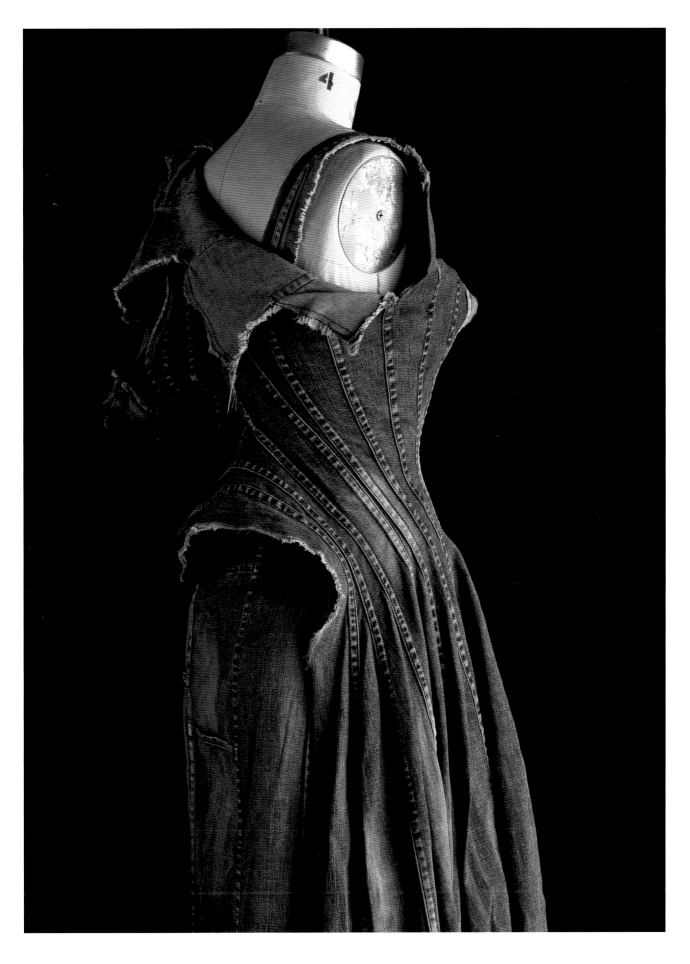

Susan Cianciolo dress.
Cone Mills denim, cotton tape, 2006, USA

This dress is from a collection of unique, one-of-a-kind pieces New York based artist/designer Susan Cianciolo created in collaboration with Cone Mills, the most widely renowned denim producer in America. The collection, titled "The Woman of the Crowd" was shown in 2006. It featured pieces in which Cianciolo combined raw and pre-washed Cone denim with scraps of historic denim from Cone's archives.

Cone Mills was founded in 1891 in Greensboro, North Carolina, and opened its White Oak plant dedicated to denim production in 1905. By the 1920s, the White Oak plant was the exclusive supplier of denim for Levi's 501® jeans, and the largest denim mill in the world. According to company lore, "White Oak was so large that it took two days to call a meeting of management."[1] Today, though substantially smaller than in its heyday, the White Oak weaving room is still the size of four football fields combined. There, Cone produces a variety of types of denim, including "vintage"-inspired selvedge on a fleet of forty of the plant's original shuttle looms from the 1940s.

In this particular dress, the selvedge edge of the denim creates a decorative line down the center front of the dress. To add further texture, Cianciolo has adorned the right sleeve with scraps from Cone's archive and cotton tape, which have all been applied by hand. Each scrap of vintage fabric carries its own history and heritage. As Patricia Mears has described it, Cianciolo's work is known "for garments with organically-rendered construction and naively-applied ornamentation that celebrate the traditions of handwork and craft."[2] By combining her aesthetic with old and new Cone denim, Cianciolo transformed her collection into a living archive of American craftsmanship.

1 Quote from *Still Made in America: Cone Celebrates 110 Years of White Oak*, film, directed by Chris Minori (2015: Greensboro, North Carolina, Cone Denim LLC, International Textile Group).

2 Patricia Mears, *Woman of the Crowd: Susan Cianciolo and Cone Denim*. New York: Sears Peyton Gallery, 2006, p. 29.

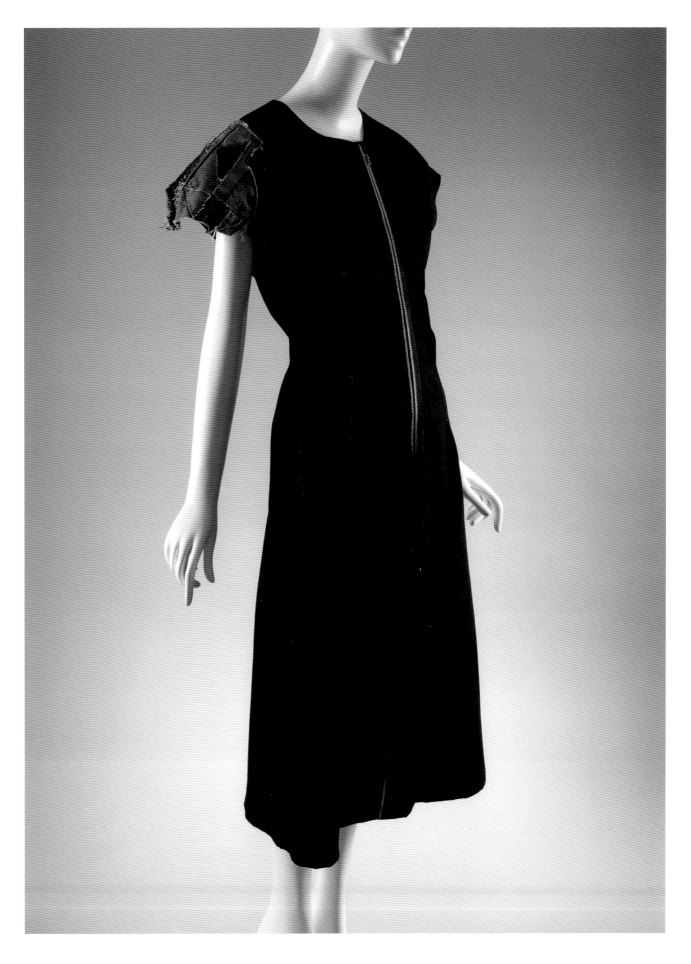

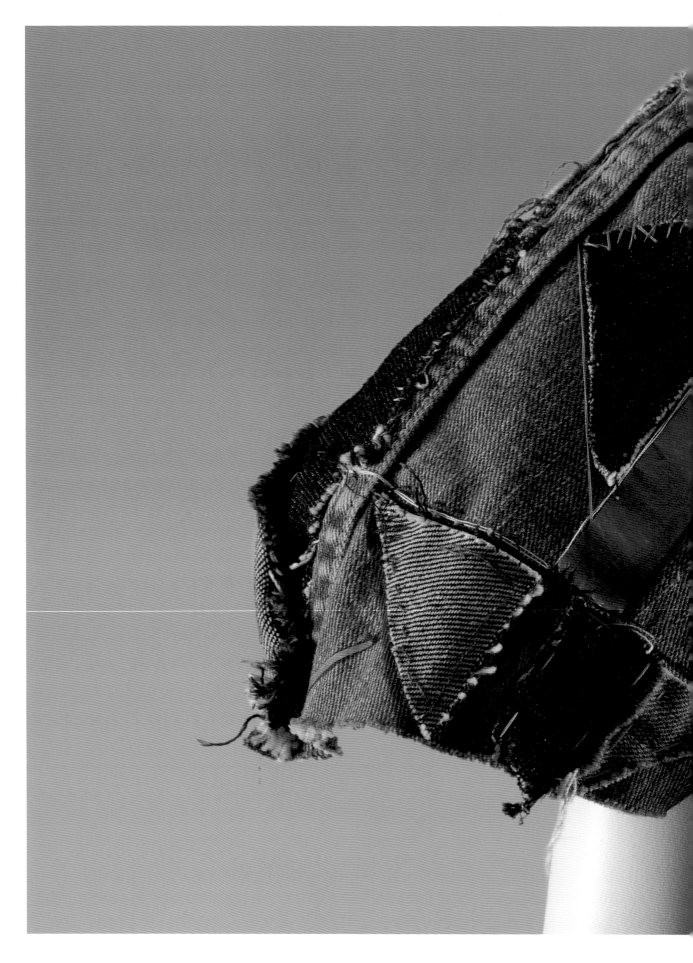

American Draper X3 shuttle looms, White Oak Mill Weave Room, 1941. A small section of these looms still operates at the mill today producing vintage selvage denims, replicating styles from the early 1900s. Courtesy of Cone Denim LLC, a division of International Textile Group.

EDUN dress.
White and black denim,
2007, USA

Fashion label EDUN was founded in the early 2000s by U2 front man Bono and his wife, Ali Hewson. The company's business goal was to offer a sustainably sourced option within the fashion industry. The duo concocted the name for the label from the inverse of NUDE, an ethically sourced food chain they had opened in Dublin years earlier. With EDUN, the two endeavored to bring jobs to the developing world of the African continent and ethically sourced clothing to the fashionable set. As Hewson described, "I want to be able to buy clothes for me and for my family knowing that no one was exploited en route from initial concept to the finished product."[1] The principle source of EDUN's material initially came from nonsubsidized organic cotton farms in western and southern Africa.[2] With cotton as the label's backbone, denim was an important textile from the beginning. The evening gown seen here is entirely made from black and white organic cotton denim.

1. Ali Hewson quoted in Rosemary Feitelberg, "Bono's Garden of Edun," *Women's Wear Daily*, February 5, 2005, p. 14.

2. Rosemary Feitelberg, "Bono's Garden of Edun," in *Women's Wear Daily*, Feb 5, 2005, p. 14.

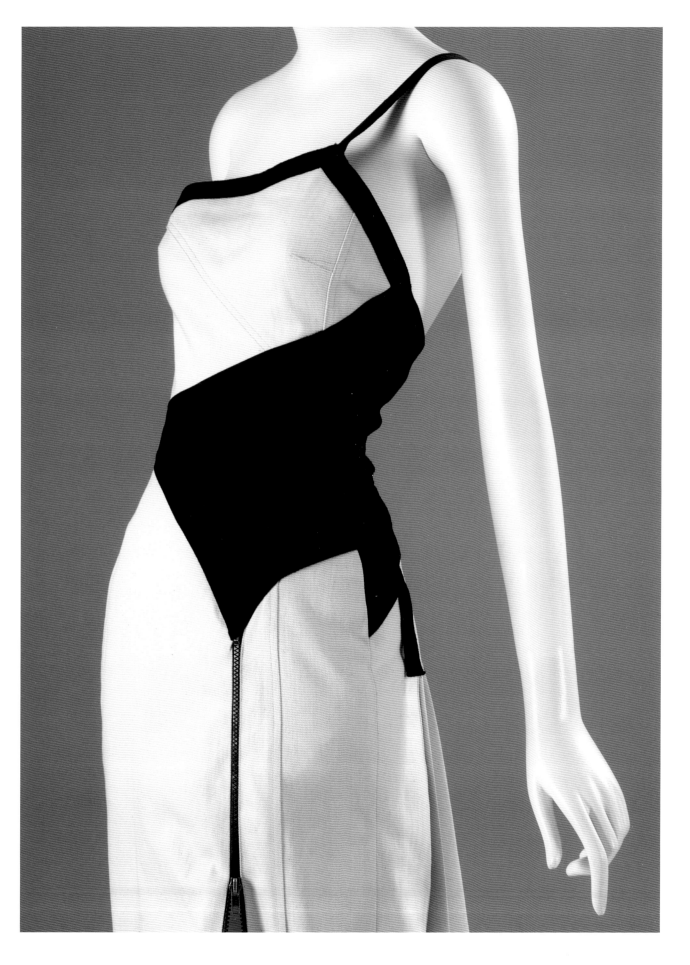

Fendi "Spy" bag.
Embroidered grey denim, rhinestones, leather, Spring 2007, Italy

--

Italian luxury company Fendi first opened its doors in 1925. The firm specialized in high-end leather goods, luggage, and furs, but the company became a household name with its "Baguette" bag during the 1990s. The bag was the brainchild of Silvia Venturini Fendi – granddaughter of Fendi founder Adele Fendi – who entered the family business in 1992 as creative director of accessories. Often hailed as the first "It" bag, the "Baguette" – with its 18 carat gold hardware and luxurious brocade and jacquard fabrics – brought the luxury handbag to a new level. Given this heritage, the choice of denim for the "Spy" bag model seen here seems a bit out of character, but Silvia is known for her playful approach to accessories. She is not afraid to experiment with high-low combinations. This version of the "Spy" bag was produced from a stonewashed denim that was then hand-embroidered with depictions of squirrels. The squirrels have been further embellished with rhinestones carefully placed by hand. The "Spy" bag was so-named for its two hidden compartments – one within the shaft of the closure, and the other at the top of the closure where a coin pouch opens.[1]

1 For more information on Fendi see: Jennifer Farley, *"Fendi," Fashion A–Z: The Collection of the Museum at FIT.* New York: Taschen, 2013, p. 221.

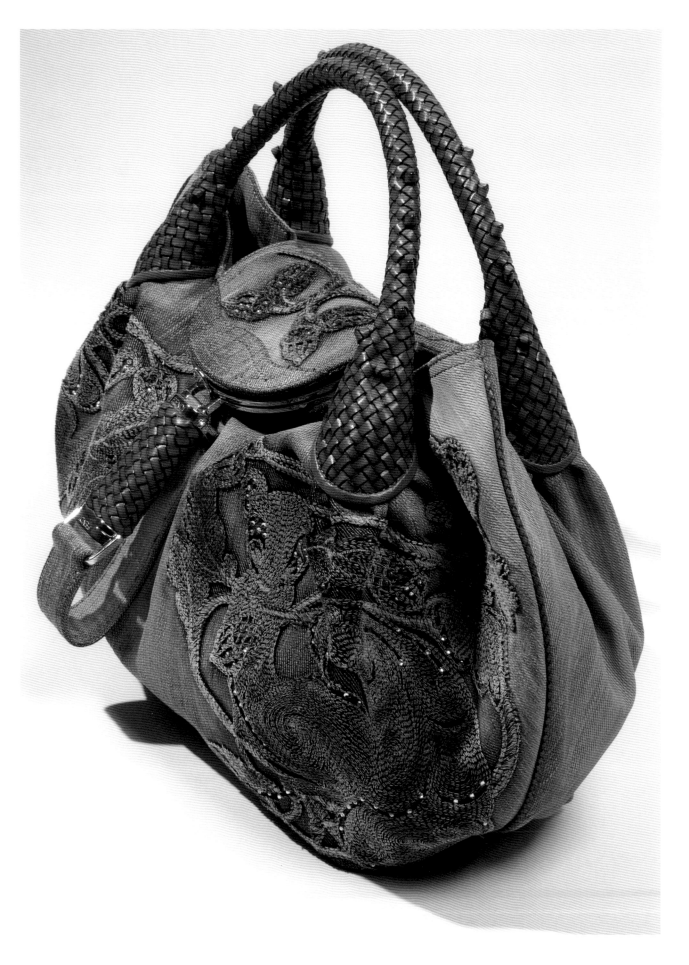

Acne Studios, "HEX" jeans.
Black stretch denim,
2007, Sweden

ACNE, now known officially as Acne Studios, first launched in 1997 in Stockholm, Sweden, as a creative collective and consulting firm. However, Jonny Johansson, one of the company's founders, quickly pushed Acne into fashion with a line of premium denim. With no formal fashion training, Johansson says his decision to use jeans as a launch pad "came down to basically…that five-pocket jeans are the Coca-Cola of fashion… It's never in, it's never out, that's the beauty of it."[1] In the decades since, denim has remained a significant part of Acne's business. The company takes a "no frills" approach – forgoing over-the-top branding details and trendy silhouettes in favor of classic cuts and minimalist washes, such as the "Hex" style seen here, featuring a straight leg and monochromatic dark wash.

1 Jonny Johansson, quoted in Nicole Phelps "Acne Studio's Jonny Johansson on Getting Out of the Denim Box" for *Style.com*, August 19, 2014, first accessed June 30, 2015 via URL <http://www.style.com/trends/industry/2014/jonny-johansson-acne-feature>

Sacai ensemble.
Blue denim, red velvet, black net, and ribbon,
Spring 2015, Japan

- -

Chitose Abe founded her fashion label Sacai in 1998. Over nearly two decades, she has built her company's reputation around her distinctive aesthetic of complex layering that fuses sporty and feminine styles. Often, she disassembles recognizable garments of western fashion and reassembles them in fascinating ways – a skill she developed while working for Comme des Garçons. Here, for her 2015 collection, Abe uses her signature technique of layering and juxtaposition to play with the traditional denim vest, shorts, and jeans. By layering them with more luxurious, feminine fabrics, such as shears and velvets, she has given the look a sense of romanticism that engages with the hard-edged heritage of the denim "cut-off" vest, while also playing on the flirtatious nature of ultra-short denim shorts.

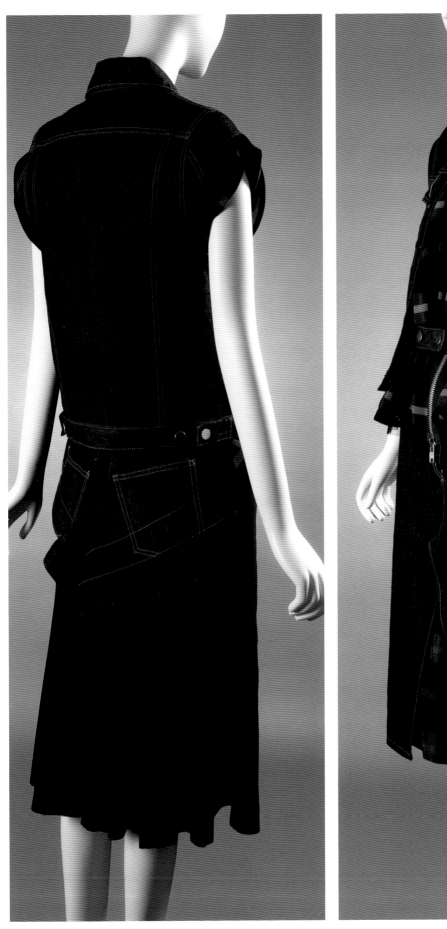
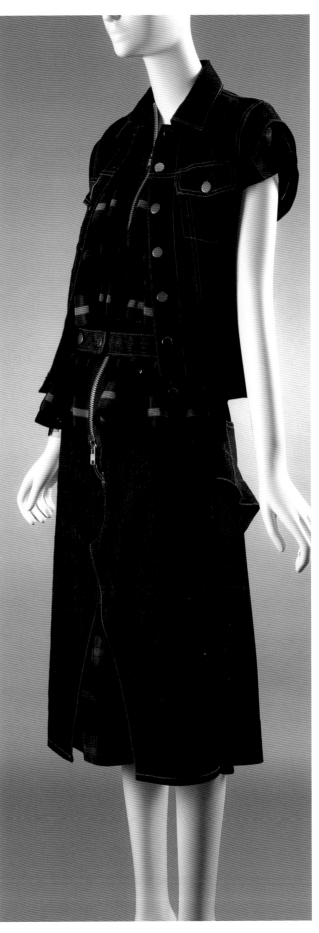

Dries Van Noten ensemble.
Blue and gold denim and silk,
Spring 2015, Belgium

Belgian designer Dries Van Noten is one of the most renowned members of the Antwerp Six, a group of designers who first entered the international fashion scene in the 1980s. He is particularly well known for his unique approach to textiles. He will often revive intricate techniques and layer unconventional combinations of prints, colors, and textures in one look. Van Noten has experimented with denim sporadically throughout his career, but primarily in his menswear. For his Spring 2015 womenswear collection, he looked back to the fashions of the 1970s for inspiration, but gave the decade's signature styles a few contemporary twists that were perfectly in line with his *oeuvre*. A case-in-point is the distinctive denim he showed as both jeans and jackets on the runway. To create it, Van Noten replaced the traditionally white weft threads of the denim with a gold lurex, giving the textile a subtle glow. The cuffs of the jeans were turned up on the runway to reveal the denim's gold backing. In the jacket seen here, Van Noten sewed a strip of the denim horizontally across the chest, weft-side out, to reveal the same brilliant gold color. From a distance, the gold band almost appears printed. Overall, the design of the jacket plays on the legacy of Yves Saint Laurent's safari jackets. Van Noten further developed his 1970s theme with diaphanous florals and exotic prints, as well as his decision to have the entire collection shown on a moss-covered runway. For the show's finale, the models processed out and then sat or lay down across the grassy floor, transforming the presentation into a Woodstock-ian affair.[1]

1 "Spring 2015 Paris Collections: Nature Girls," *Women's Wear Daily*, September 25, 2014, p. 1, pp. 4–7.

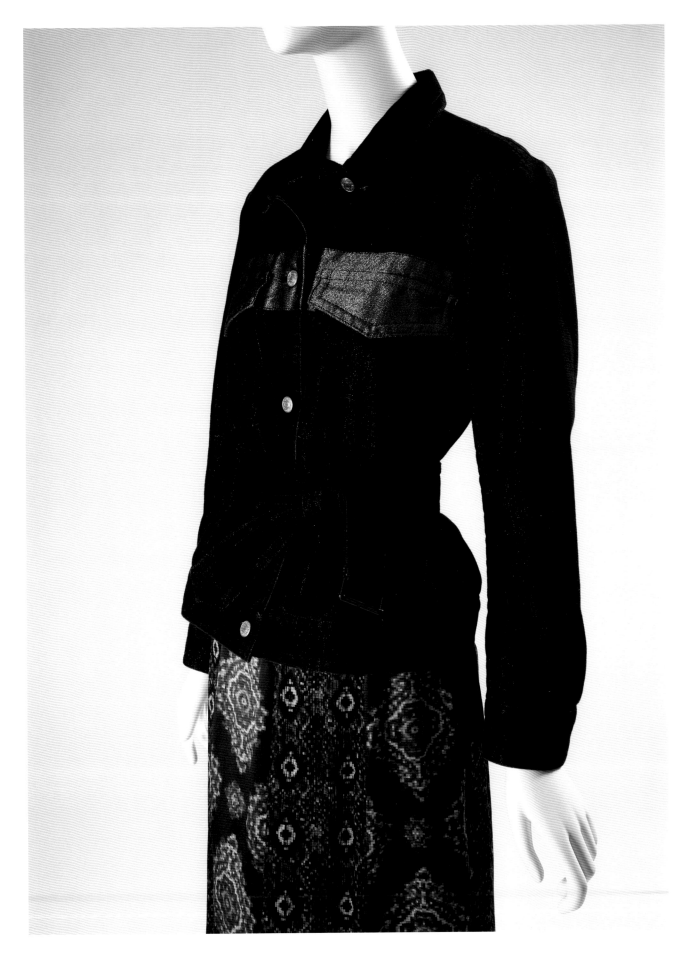

Ralph Lauren, three-piece suit.
Blue denim, cotton, and silk,
Spring 2015

Ralph Lauren included this denim suit in his Spring 2015 Purple Label menswear collection. It fuses a modern, slim silhouette with the classic three-piece suit. Rendered in denim, it evokes the tradition of the 1970s denim leisure suit, but it also has a late nineteenth-century/early twentieth-century feel in the way it has been accessorized – complete with a watch fob chain. In essence, this one look brings together several disparate historical references. This highlights a postmodern approach to denim dominating the fashion industry at the moment, which is particularly prevalent when the suit here is considered in tandem with the Junya Watanabe, Dries Van Noten, and Sacai ensembles discussed earlier. High fashion and mainstream designers alike employ denim as a vehicle for pastiche. They pull design elements and details from vintage styles and past historical periods and then meld them, "dressing up" contemporary styles with references to the past.[1] The resulting looks are evocations of both denim's cultural history and their own contemporary moment. This underscores denim's ability to "[take] on the role of expressing something about the changing world that no other clothing could achieve."[2]

[1] Hal Foster describes the practices of postmodern architects as the "use of neoclassical elements like columns… to dress up the usual modern building," in *Art Since 1900*, ed. Hal Foster, Rosalind Krauss, Yve-Alain Bois, and Benjamin H. D. Buchloh, London: Thames & Hudson, 2004, p. 597.

[2] Daniel Miller and Sophie Woodward, "Introduction," *Global Denim*. Oxford and New York: Berg, 2011, p. 4.

[facing page] Ralph Lauren Purple Label, three-piece suit, denim, cotton, silk, spring 2015, USA. The Museum at FIT 2015.47.2, Gift of Ralph Lauren Corporation. Image courtesy of Ralph Lauren.

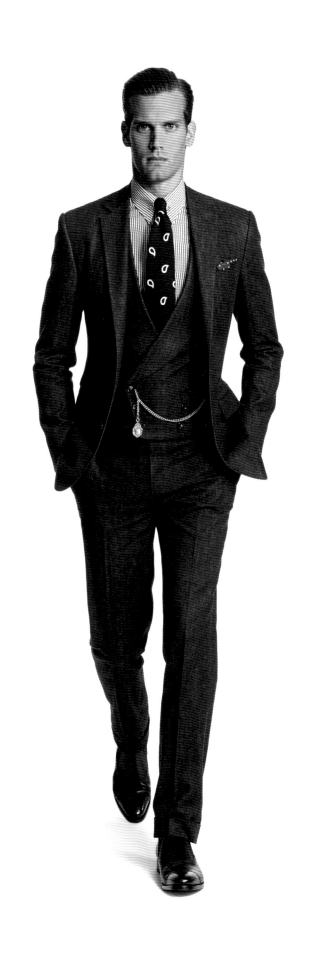

KAPITAL "Century Denim" jeans.
Sumi and indigo dyed cotton,
2015, Japan

Japanese company KAPITAL is renowned within the denim industry for its fusion of American heritage details with traditional Japanese aesthetics and methods of production. These jeans are made from what KAPITAL calls "Century Denim," which the company first introduced in 2012. "Century Denim" has a distinctive look and texture, because it is created using a form of Japanese stitching known as *sashiko* and dying methods known as *kakishibu* and *sumi*. These techniques were developed during the Edo period in Japan to impart stability and strength to a garment while also adding decorative elements. In the case of *sashiko*, Japanese craftsmen would use white or red threads to make a series of running stitches through indigo-dyed fabric, creating intricate patterns against the blue cloth (almost like embroidery) while simultaneously reinforcing the fabric. Similarly, the dying techniques *kakishibu* (which uses fermented persimmon) and *sumi* (which uses fermented charcoal) give fabric a brownish or greyish-blue hue respectively, but they also reinforce the strength of a textile. Both dyes are applied as a coating – painted on – so that they do not penetrate the thread fibers, but rather sit on top of them, forming a protective layer. The color of this layer will fade over time, not unlike the effect achieved through rope-dying traditional denim threads. In this way, "Century Denim" is an entirely new take on denim, but also, not denim at all. KAPITAL has replaced the fading effect of indigo rope-dying with the effects of *kakishibu* and *sumi*, and the durability of a warp-faced twill with that of *sashiko* stitching, to create a fabric that functions in the same manner as denim. Constructed into a traditional, cinch-back, five-pocket jean, KAPITAL's "Century Denim" jean is a true fusion of two histories.[1]

1 Jonathan Lukacek, "KAPITAL Century Jeans – Just Released," *RAWR DENIM*, August 21, 2012, first accessed August 20, 2015 via URL <http://www.rawrdenim.com/2012/08/kapital-century-jeans-just-released/>

[facing page] KAPITAL designer Kazuhiro "Kiro" Hirata applying kakishibu (persimmon tannin juice) to a pair of Century Denim jeans, 2015. ALL ABOUT CENTURY DENIM / SWITCH vs. KAPITAL.

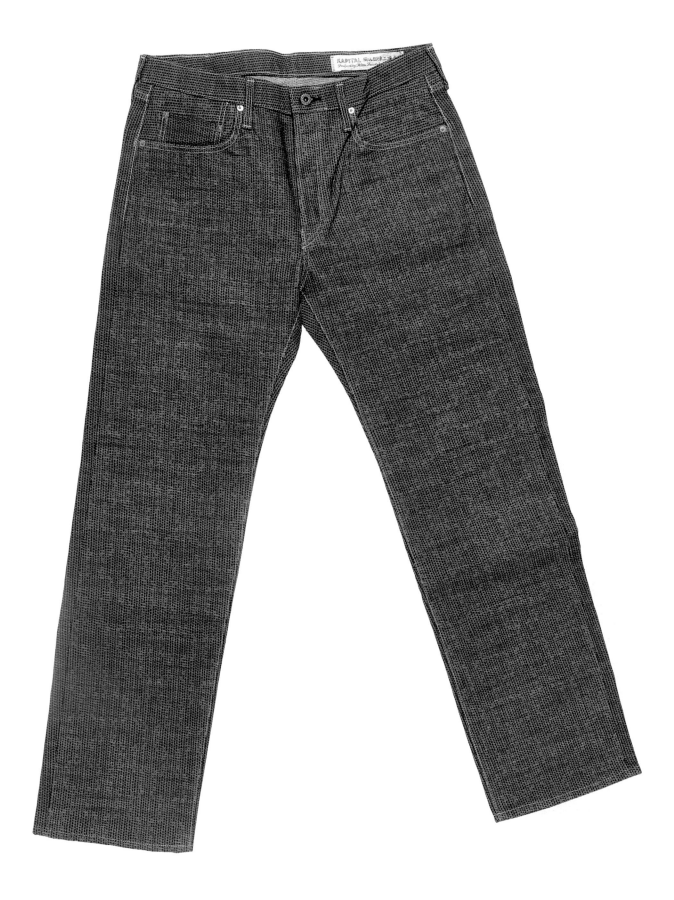

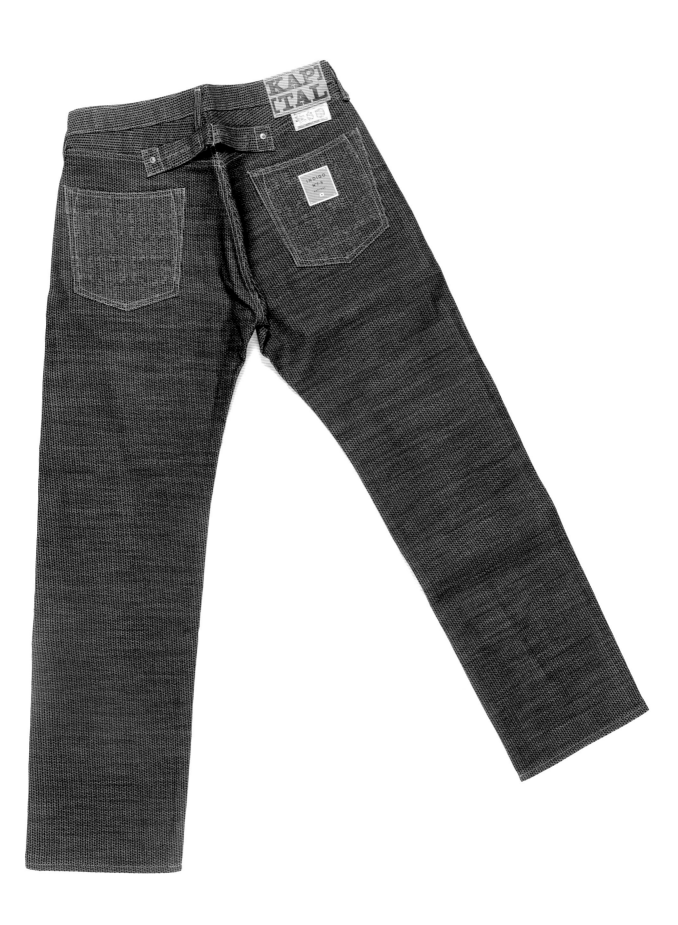

Chloé (Clare Waight Keller) ensemble.
Blue denim and pink suede,
Spring 2015, France

Denim featured prominently in Clare Waight Keller's Spring 2015 collection for French ready-to-wear label Chloé. The ensemble seen here plays on the silhouette of the "Union All" jumpsuit first pioneered by Lee during the early twentieth century. Designed as womenswear, the look immediately evokes associations with the World War II folk heroine "Rosie the Riveter." However, unlike its workwear predecessor, this Chloé ensemble is actually comprised of a shirt and pants, negating the functionality but retaining the aesthetic of the original, all-in-one, "Union All" jumpsuit. In her Spring 2015 collection, Keller played with raw and one-wash denim so that each piece would "becom[e] personal to the wearer – it is immediate and honest."[1] Paired with pale pink, suede "gladiator" sandals, the ensemble combines denim's tough, workwear heritage with a feminine and bohemian element more in line with the textile's countercultural past. It is another example of a denim pastiche – Keller has used denim's own history to create a look that is reminiscent of the past while firmly planted in the present.

1 Clare Waight Keller, quoted in Jo-Ann Furniss, "Spring 2015 Ready-To-Wear: Chloe Review," *Style.com*, September 28, 2014, first accessed March 15, 2015 via URL http://www.style.com/fashion-shows/spring-2015-ready-to-wear/chloe.

[facing page] Runway shot of Chloé by Claire Waight Keller, ensemble, blue denim and pink suede, spring-summer 2015, France. The Museum at FIT 2015.39.1, Gift of Chloé. © Etienne Tordoir

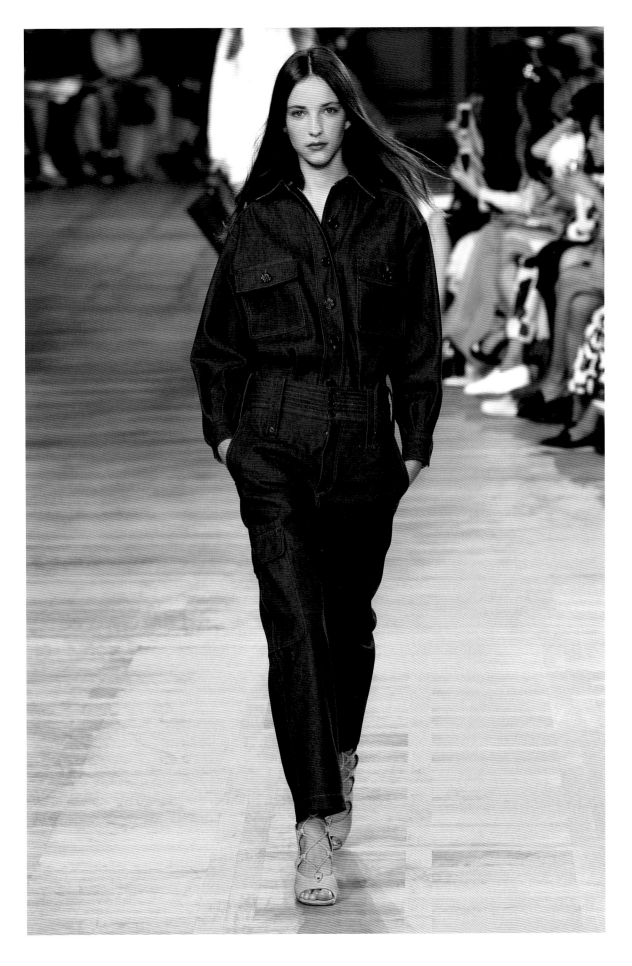

Full catalogue image captions.

[Listed in order of appearance]

Levi Strauss & Co., 501® jeans, blue denim, ca. 1953, USA. The Museum at FIT, 89.50.2, Gift of Richard Martin. Photograph by Eileen Costa.

Levi Strauss & Co., 501® jeans, blue denim, ca. 1953, USA (back). The Museum at FIT, 89.50.2, Gift of Richard Martin. Photograph by Eileen Costa.

"Arcuate" back-pocket stitching on Levi Strauss & Co., 501® jeans, blue denim, ca. 1953, USA (detail). The Museum at FIT, 89.50.2, Gift of Richard Martin. Photograph by Eileen Costa.

"Two horse" leather label on back waistband of Levi Strauss & Co., 501® jeans, blue denim, ca. 1953, USA (detail). The Museum at FIT, 89.50.2, Gift of Richard Martin. Photograph by Eileen Costa.

Handsewn man's work pants, blue brushed cotton and denim, ca. 1840, USA. The Museum at FIT P86.64.3, museum purchase. Photography by Eileen Costa

Handsewn woman's work jacket, blue denim, ca. 1850, USA. The Museum at FIT, P87.43.3, museum purchase. Photograph by Eileen Costa.

Handsewn woman's work jacket, blue denim, ca. 1850, USA (back). The Museum at FIT, P87.43.3, museum purchase. Photograph by Eileen Costa.

Prisoner uniform, grey denim and linen, 1913, USA. The Museum at FIT 93.26.1, Gift of Lithgow Osborne. Photograph by Eileen Costa.

Prisoner uniform, grey denim and linen, 1913, USA (detail). The Museum at FIT 93.26.1, Gift of Lithgow Osborne. Photograph by Eileen Costa.

Walking suit, off-white striped denim, ca. 1916, USA. The Museum at FIT P85.35.2, museum purchase. Photograph by Eileen Costa.

Work ensemble, blue chambray, 1912–15, Canada. The Museum at FIT 2015.22.3, museum purchase. Photograph by Eileen Coasta.

Sailor ensemble, blue denim, ca. 1925, USA, museum purchase. Photograph by Eileen Costa.

Man's work shirt, blue chambray, ca. 1940, USA, museum purchase. Photograph by Eileen Costa.

H. D. Lee Mercantile Co.,"Lee Riders" jeans, blue denim, ca. 1946. The Museum at FIT 85.62.2, Gift of Phyllis Feldkamp. Photograph by Eileen Costa.

H. D. Lee Mercantile Co.,"Lee Riders" jeans, blue denim, ca. 1946 (back). The Museum at FIT 85.62.2, Gift of Phyllis Feldkamp. Photograph by Eileen Costa.

"Lazy-S" stitch on back pocket of H.D. Lee Mercantile Co.,"Lee Riders" jeans, blue denim, ca. 1946 (detail). The Museum at FIT 85.62.2, Gift of Phyllis Feldkamp. Photograph by Eileen Costa.

Levi Strauss & Co., "507" model jacket, blue denim, ca. 1955, USA. The Museum at FIT 89.50.1, Gift of Richard Martin. Photograph by Eileen Costa.

Red tab on front pocket of Levi Strauss & Co., "507" model jacket, blue denim, ca. 1955, USA (detail). The Museum at FIT 89.50.1, Gift of Richard Martin. Photograph by Eileen Costa.

"Play" ensemble, blue striped denim, ca. 1940, USA. The Museum at FIT P92.25.3, museum purchase. Photograph by Eileen Costa.

Brooks Brothers, man's shirt, blue denim, ca. 1940, USA. The Museum at FIT P91.55.4, museum purchase. Photograph by Eileen Costa.

Elsa Schiaparelli, blouse, blue cotton and pearl, ca. 1947, France. The Museum at FIT 70.57.36, Gift of Mr. Rodman A. Heeren. Photograph by Eileen Costa.

Jumpsuit, blue denim, ca. 1942, USA. The Museum at FIT 2007.63.7, Gift of David Toser. Photograph by Eileen Costa.

Reproduction of Claire McCardell, "Popover" dress, blue denim and red cotton, ca. 1942, USA. The Museum at FIT 72.54.1, Gift of Bessie Sustersic for the McCardell Show. Photograph by Eileen Costa.

Reproduction of Claire McCardell, "Popover" dress, blue denim and red cotton, ca. 1942, USA (detail). The Museum at FIT 72.54.1, Gift of Bessie Sustersic for the McCardell Show. Photograph by Eileen Costa.

Claire McCardell, beach coordinates, blue chambray, 1945, USA. The Museum at FIT 85.174.2, Gift of Dorothy Carr. Photograph by Eileen Costa.

Claire McCardell, jacket, blue denim, ca. 1953, USA. The Museum at FIT 72.61.75, Gift of Mr. and Mrs. Adrian McCardell. Photograph by Eileen Costa.

Woman's skirt, blue denim and stuffed appliqués, ca. 1952, USA. The Museum at FIT 90.26.1, Gift of Beatrice A. Feingold. Photograph by Eileen Costa.

(Left) Phelps Deep Country Clothes, wrap skirt, navy striped denim, ca. 1950, USA. The Museum at FIT 77.33.106, Gift of Mrs. Billie Bernard; (right) Phelps Deep Country Clothes, shorts, navy striped denim, ca. 1954, USA. The Museum at FIT 85.62.1, Gift of Phyllis Feldkamp. Photograph by Eileen Costa.

Levi Strauss & Co., "Ranch Pants," blue denim, ca. 1955, USA. The Museum at FIT 74.44.17, Gift of Mrs. Burton Tremaine. Photograph by Eileen Costa.

Bonnie Cashin, beach ensemble, blue denim, leather, cotton, and straw, 1960, USA. The Museum at FIT 90.72.17, Gift of the Estate of Bonnie Cashin. Photograph by Eileen Costa.

Bonnie Cashin, beach ensemble, blue denim, leather, cotton, and straw, 1960, USA (detail). The Museum at FIT 90.72.17, Gift of the Estate of Bonnie Cashin. Photograph by Eileen Costa.

Man's jacket, blue denim, wool, and black corduroy, ca. 1959, USA. The Museum at FIT 87.130.1, Gift of Leo Lerman. Photograph by Eileen Costa

Customized Levi Strauss & Co. jeans, blue denim, embroidery, leather, applique, and beads, ca. 1969, USA. The Museum at FIT 80.176.1.

Serendipity, skirt, repurposed denim jeans, ca. 1972, USA. The Museum at FIT 78.100.14, Gift of Stephan Bruce. Photograph by Eileen Costa.

Man's shorts, denim with photo print of crowd at the Woodstock Art & Music Fair, 1970, USA. The Museum at FIT P89.57.57, museum purchase. Photograph by Eileen Costa.

UFO, man's overalls, blue denim, ca. 1973, USA. The Museum at FIT 78.103.2, Gift of Antonio Capparelli. Photograph by Eileen Costa.

Pinky & Dianne, man's jacket, repurposed denim, 1973, USA. The Museum at FIT 79.25.1, Gift of Ms. Terry Mayer. Photograph by Eileen Costa.

Young Dimensions, clogs, blue denim, ca. 1973, USA. The Museum at FIT 79.25.23, Gift of Ms. Terry Mayer. Photograph by Eileen Costa.

Sara Shelburne, ensemble, multi-color striped denim and silk, ca. 1970, France. The Museum at FIT 81.24.24, Gift of Mrs. Sally Iselin. Photograph by Eileen Costa.

Yves Saint Laurent, "safari" jacket, blue denim, ca. 1970, France. The Museum at FIT 82.183.4, Gift of Alida Miller. Photograph by Eileen Costa.

Rafael, man's suit, blue denim, ca. 1973, Italy. The Museum at FIT 85.161.8, Gift of Chip Tolbert. Photograph by Eileen Costa.

Man's and woman's swimsuit, bleached and tie-dyed denim, ca. 1973, USA. The Museum at FIT 78.100.2 (left) and 78.100.1 (right), Gift of Stephan Bruce.Phtograph by Eileen Costa.

John Weitz, suit, blue denim and red cotton, Summer 1972, USA. The Museum at FIT 93.12.1, Gift of John Weitz, Inc. Photograph by Eileen Costa.

Faded Glory, vest, blue denim, ca. 1975, USA. The Museum at FIT 2015.51.4, Gift of Pepper Hemingway. Photograph by Eileen Costa.

Wrangler, "Flare Leg" model jeans, multi-color printed denim, ca. 1973, USA. The Museum at FIT P92.47.1, museum purchase. Photograph by Eileen Costa.

Back label and leather patch on Wrangler, "Flare Leg" jeans, multi-color printed denim, ca. 1973, USA (detail). The Museum at FIT P92.47.1, museum purchase. Photograph by Eileen Costa.

Levi Strauss & Co., "Movin' On" model jeans, blue denim, ca. 1976, USA. The Museum at FIT P92.57.31, museum purchase. Photograph by Eileen Costa.

Back pocket on Levi Strauss & Co., "Movin' On" model jeans, blue denim, ca. 1976, USA (detail). The Museum at FIT P92.57.31, museum purchase. Photograph by Eileen Costa.

Elio Fiorucci, "Safety Jeans," black denim, 1979, Italy. The Museum at FIT 81.145.20, Gift of Naomi Sims. Photograph by Eileen Costa.

Calvin Klein, jeans, blue denim, 1979, USA. The Museum at FIT 80.94.2, Gift of Mr. Calvin Klein. Photograph by Eileen Costa.

Jordache, jeans, blue denim, ca. 1980, USA. The Museum at FIT 2015.32.1, museum purchase. Photograph by Eileen Costa.

Trademarked stitch pattern on back pocket of Jordache, jeans, blue denim, ca. 1980, USA (detail). The Museum at FIT 2015.32.1, museum purchase. Photograph by Eileen Costa.

Ralph Lauren, "Prairie" ensemble, chambray, wool, leather, and metal, 1981, USA. The Museum at FIT 2000.93.1, Gift of Lisa Battista Giglio. Photograph by Eileen Costa.

Ralph Lauren, "Prairie" ensemble, chambray, wool, leather, and metal, 1981, USA (detail). The Museum at FIT 2000.93.1, Gift of Lisa Battista Giglio. Photograph by Eileen Costa.

Donna Karan, ensemble, blue denim, 1986–87, USA. The Museum at FIT 95.80.8, Gift of Linda Tain. Photograph by Eileen Costa.

Moschino Jeans dress, black stretch denim, ca. 1988, Italy. The Museum at FIT 93.159.99, Gift of Ady Gluck-Frankel. Photograph by Eileen Costa.

Vivienne Westwood, jacket, blue-ribbed denim, ca. 1984, Enlgland. The Museum at FIT 94.162.2, Gift of Ms. Martha Abraham. Photograph by Eileen Costa.

Marithé + François Girbaud, jeans, stonewashed denim, ca. 1985, France. The Museum at FIT 2015.63.1, Gift of Marithé + François Girbaud. Photograph by Eileen Costa.

Back label on Marithé + François Girbaud, jeans, stonewashed denim, ca. 1985, France (detail). The Museum at FIT 2015.63.1, Gift of Marithé + François Girbaud. Photograph by Eileen Costa.

Guess?, jeans, bleached and stonewashed denim, ca. 1986, USA. The Museum at FIT 90.150.20, Gift of Janet Waring. Photograph by Eileen Costa.

Guess?, jeans, bleached and stonewashed denim, ca. 1986, USA (detail). The Museum at FIT 90.150.20, Gift of Janet Waring. Photograph by Eileen Costa.

Kenzo ensemble, repurposed Levi's® denim jacket, sequins, appllqués, USA. The Museum at FIT 86.151.1, Gift of Mr. and Mrs. Peter Bernstein. Photograph by Eileen Costa.

Shail Upadhya, blazer, hand-painted denim, 1988, USA. The Museum at FIT 2013.36.2, Gift of The Estate of Shail Upadya. Photograph by Eileen Costa.

Nicola Bowery for John Joseph Lydon (Johnny Rotten), man's ensemble, repurposed The Gap jacket and Levi's® jeans, denim, pailettes, beads, 1989, USA. The Museum at FIT 2012.19.1, Gift of Freddie Leiba. Photograph by Eileen Costa.

Exhaust, man's ensemble, painted and stonewashed denim, and cotton, 1991, USA. The Museum at FIT 92.10.2, Gift of Richard Martin. Photograph by Eileen Costa.

Moschino Jeans jeans, printed denim, early 1990s, Italy. The Museum at FIT 2010.74.29, Gift of Michael H. Harrell; Moschino Jeans sweatshirt, cotton, 1990, Italy. The Museum at FIT 91.256.2, Gift of Richard Martin. Photograph by Eileen Costa.

Moschino Jeans jeans, printed denim, early 1990s, Italy (detail). The Museum at FIT 2010.74.29, Gift of Michael H. Harrell. Photograph by Eileen Costa.

Studio D'Artisan, "WWI Model" jeans, blue denim, 2015, Japan. The Museum at FIT 2015.67.1, museum purchase. Photograph by Eileen Costa.

Studio D'Artisan, "WWI Model" jeans, blue denim, 2015, Japan (back). The Museum at FIT 2015.67.1, museum purchase. Photograph by Eileen Costa.

Leather label on back waistband of Studio D'Artisan, "WWI Model" jeans, blue denim, 2015, Japan (detail). The Museum at FIT 2015.67.1, museum purchase. Photograph by Eileen Costa.

"Red line" selvedge of Studio D'Artisan, "WWI Model" jeans, blue denim, 2015, Japan (detail). The Museum at FIT 2015.67.1, museum purchase. Photograph by Eileen Costa.

Jean Paul Gaultier, Junior Gaultier, corset, denim, ca. 1992, France. The Museum at FIT 99.80.2, museum purchase. Photograph by Eileen Costa.

Diesel, jeans, bleached and stonewashed denim, ca. 1995, Italy. The Museum at FIT, Gift of Pepper Hemingway. Photograph by Eileen Costa.

Diesel, jeans, bleached and stonewashed denim, ca. 1995, Italy (back). The Museum at FIT, Gift of Pepper Hemingway. Photograph by Eileen Costa.

Tommy Hilfiger, man's ensemble, black denim, cotton, nylon, 1999, USA. The Museum at FIT 99.122.2, Gift of Tommy Hilfiger USA. Photograph by Eileen Costa.

Claude Sabbah, man's ensemble, embroidered blue denim and cotton, 2000, USA. The Museum at FIT 2013.62.8, Gift of Kelly Mills and Claude Sabbah. Photograph by Eileen Costa.

Levi Strauss & Co., "Engineered Jeans" loose-fit model, blue denim, 2000, USA. The Museum at FIT 2000.86.1, Gift of Levi Strauss & Co. Photograph by Eileen Costa.

Katharine Hamnett, ensemble, denim and leather, Spring 1997, England. The Museum at FIT 98.83.1, Gift of Katharine Hamnett Ltd. Photograph by Eileen Costa.

Gianfranco Ferré, ensemble, dark blue silk, Spring 1999, Italy. The Museum at FIT 99.83.6, Gift of Gianfranco Ferré S.p.A. Photograph by Eileen Costa.

Gianfranco Ferré, ensemble, dark blue silk, Spring 1999, Italy (detail). The Museum at FIT 99.83.6, Gift of Gianfranco Ferré S.p.A. Photograph by Eileen Costa.

7 For All Mankind, bootcut jeans, blue denim, ca. 2004, USA. The Museum at FIT 2015.66.1, museum purchase. Photograph by Eileen Costa.

Roberto Cavalli, ensemble, embroidered blue denim and silk, 2002–03, Italy. The Museum at FIT 2003.45.2, Gift of Roberto Cavalli. Photograph by Eileen Costa.

Junya Watanabe, dress, repurposed blue denim jeans, Spring 2002, Japan. The Museum at FIT 2010.37.12, museum purchase. Photograph by William Palmer.

Susan Cianciolo, dress, Cone Mills denim, cotton tape, 2006, USA. The Museum at FIT 2015.41.2, Gift of Anonymous. Photograph by Eileen Costa.

EDUN, dress, white and black denim, 2007, USA. The Museum at FIT 2010.7.1, Gift of EDUN. Photograph by Eileen Costa.

Fendi, "Spy" bag, embroidered grey denim, leather, rhinestones, Spring 2007, Italy. The Museum at FIT 2007.25.2, Gift of Fendi. Photograph by Eileen Costa.

Acne Studios, "Hex" jeans, black stretch denim, 2007, Sweden. The Museum at FIT 2007.19.2, Gift of ACNE Jeans. Photograph by Eileen Costa.

Sacai, ensemble, blue denim, red velvet, black net, and ribbon, Spring 2015, Japan. The Museum at FIT 2015.37.2, museum purchase. Photograph by Eileen Costa.

(back) Sacai, ensemble, blue denim, red velvet, black net, and ribbon, Spring 2015, Japan. The Museum at FIT 2015.37.2, museum purchase. Photograph by Eileen Costa.

Dries Van Noten, ensemble, blue and gold denim and silk, Spring 2015, Belgium. The Museum at FIT 2015.43.1, Gift of Dries Van Noten. Photograph by Eileen Costa.

Ralph Lauren Purple Label, three-piece suit, denim, cotton, silk, Spring 2015, USA. The Museum at FIT 2015.47.2, Gift of Ralph Lauren Corporation. Image courtesy of Ralph Lauren.

KAPITAL, "Century Denim" jeans, sumi- and indigo-dyed cotton, 2015, Japan. The Museum at FIT 2015.69.1, Gift of KAPITAL. Image courtesy of KAPITAL.

KAPITAL, "Century Denim" jeans, sumi- and indigo-dyed cotton, 2015, Japan. The Museum at FIT 2015.69.1, Gift of KAPITAL. Image courtesy of KAPITAL.

KAPITAL, "Century Denim" jeans, sumi- and indigo-dyed cotton, 2015, Japan. The Museum at FIT 2015.69.1, Gift of KAPITAL. Image courtesy of KAPITAL.

Etienne Tordoir, runway photograph of Chloé ensemble by Clare Waight Keller, Spring-Summer 2015. ©Etienne Tordoir.